AMERICAN INDIAN ARTS

A Way of Life

JULIA M. SETON

THE RONALD PRESS COMPANY • NEW YORK

Library of Congress Catalog Card Number: 62–15439

PRINTED IN THE UNITED STATES OF AMERICA

To

Julie Anne

Granddaughter, Namesake, Co-natalist
and half of my hope for immortality

Preface

It is the purpose of this book to present in one convenient place a summary of the artistic accomplishments of the North American Indian as reflected in his native skills and crafts.

Without attempting to be all-inclusive, the author has drawn upon a wide variety of sources in selecting the representative handiwork of the various tribes, from earliest days to the present. Not least among these sources were the writings and drawings of the author's late husband, Ernest Thompson Seton. Founder in 1902 of the Woodcraft Indians and the Woodcraft League of America, Mr. Seton followed the folkways and industries of the American Indian with avid interest throughout his long life. His well-known sketches—a number of which are reproduced here—are the product of countless hours of watching the performance of Indian crafts and drawing the various processes from life.

The Bureau of American Ethnology, whose Annual Reports form the broadest background for these chapters, deserves the author's deep gratitude for permission to use its materials freely. The author's own earlier writings on Indian arts in the monthly Bulletin of the Woodcraft League of America are also included here. Through the interest they aroused they clearly demonstrated the need for recording all the major Indian handicrafts in permanent book form.

It is hoped that the pages that follow will prove more than a "how-to" guide to American Indian crafts. Although there are sufficient instructions for the reader to re-create clothing, jewelry, pottery, and even habitations—and although the author has personally tested the directions for each craft, step by step—the end goal is a larger one: to convey the fundamental soundness and strength of the Indian tradition.

To the individual tribesman, art for art's sake was incomprehensible. What he learned and practiced and passed on to his successors was a combination of skills born of his social, economic, and spiritual existence. If this volume helps give recognition to the innate artistry of these skills, a vital purpose will be served. Such recognition will go far to insure that the Indian is accorded his rightful place in America as the creator of our only truly indigenous folk art.

JULIA M. SETON

Santa Fe, New Mexico
 April, 1962

Contents

AMERICAN
INDIAN ARTS

I

Native American Art

Though we may or may not approve, people's leisure time is increasing through effective production. The whole industrial population must reorganize its world, as more and more people find themselves with fewer working hours to the day and fewer days of labor to the week.

And it is coming so suddenly fast that the rest of the world finds difficulty in making the necessary adjustments. The movie and TV producers are doing their best to turn out enough pictures to fill the vacant hours; the radio is doing its part to entertain, and even contract bridge helps out in certain circles. But there is always the majority of the population who cannot find compensation in such externals, who feel the desperate need of extracting from their own inner consciousness the means of fulfilling the dreams which have lived in them through the ages and which come pulling and tearing at their hearts now that the time to express themselves has been given.

Of all things which give eternal satisfaction to the spirit, "making things" is perhaps the most universal. So many of the old skills have been displaced by machinery that they have fallen into the category of hobbies. The human race cannot endure, cannot exist, without handicraft, and now when so many of us are what might be termed "head-workers," we turn to the arts and crafts for relief and for balance.

Some years ago, I heard a talk by Moses Saenz, the Minister

of Education in Mexico at that time. He gave the sequence of life—"God, land, man, craft." He deified the skillful hand and spoke of craft as a link with divinity. No one can doubt the effect of a craft experience on the human mind who has watched with insight the students we have taught to make a Sioux feather headdress, a flint arrowhead, a Haida spoon, or a rawhide rattle. It is manual dexterity, yes. But it is something so much higher, deeper, soul-stirring, spirit-uplifting. Perhaps it is that the work enshrines a little of the primitive life in its making; perhaps it is only the esthetic joy in a beautifully finished piece of work. I know only that the maker is a better person after this experience has come into his life.

Apparently the general public is beginning to appreciate this. During recent years, enough books dealing with arts and crafts have been put on the market by the best publishers to flood any library. I know, for I have reviewed them. I started out on this group of books with the enthusiasm of the natural lover of craftsmanship. I settled down, anticipating months of enjoyment in the new ideas to be presented; but after a dozen books or so, I found myself bored by the sameness of the material. After all, there are only so many shapes one can fashion with tools and so many ideas which can form the basis for these shapes, if one proceeds along the old lines of manual training fostered by schools and clubs.

Even the authors seemed to recognize the monotony of their books, and each one offered what amounts to an apology before starting off with his instructions.

Have these men not overlooked the fact that nothing endures longer or strikes in deeper than a folk interest? It must be something that has been handed down to us through generations, something which began in our ancestors as a result of their environment. Folk art is the source of all life for a nation, the thing which came out of the soil and which still holds us close to the heart of the earth.

And it must be from one's own soil, not an engrafted folk art brought from another world, but an art evolved from the inner consciousness of those who lived here before us.

Until lately, we lamented the dearth of American folk art and

culture. All our experience in this line had to come from the Old World, because we knew of no indigenous American art. However, because Old World art was not native to our country, it was not entirely satisfying. It was a good art, but it was in an environment not its own. It merely served to exaggerate the need we felt for our own native culture.

Then, when it was almost too late, our artists began to find what we were all unconsciously seeking—the native art of America, which is the art of the Indian. Older than any European art, so deep-rooted that, in spite of hundreds of years of close contact with others, in spite of persecution by the ignorant scoffers, in spite of so-called education in the ways of the invaders, the Indian art stands in its old glory still among those who have cherished it and worked in it for perhaps 10,000 years. Here we can find at least remnants of arts and crafts which will fill the needs of our hearts.

We had better record and foster these crafts while we may, for already outside influences are having their effect. As Sloan and La Farge (Ref. 8) have said, "The Indian is not an ethnological specimen, any more than he is a curio, but a live man with his own initiative. His arts must grow; he cannot be kept from adapting to his own uses such of our materials as suit him."

These crafts may develop into something even better than they are now by merging with the Spanish in the Southwest, with the French in Canada, with the English and Dutch in the eastern United States. But the art will no longer be purely Indian. It will be the folk art of America, distinctive, alive, and real; indicative of the people who created it; worthy to be counted among the great arts of the world; and based in its foundations on a spiritual culture never equaled in any other race, and as enduring as the earth itself.

The Function of Indian Art

Though the Whiteman would like to take credit for introducing arts and industries to the Indian, it has been definitely established that, in aboriginal days, the Indian was well advanced in simple, widely diversified handicrafts. Otis T. Mason (Ref. 6) points out that the arts and industries of the Indians were called

forth and developed for utilizing the mineral, vegetal, and animal products of nature, and were modified by the environmental wants and resources of each group.

The arts and crafts in primitive times were not limited in purpose to the material conditions of life. They were employed for religious purposes, as well as for the daily routine of living. In all the arts, a primary aim seems to have been to gratify the esthetic sense so strong in the race. It was not enough merely to fashion a garment; the garment had to be embroidered with quillwork or beads. It was equally necessary to put a pattern into the clay of a pot or into the weave of a basket. This principle was adhered to in all tribes, however separated in locality or heritage; therefore, it must demonstrate a compelling force in Indian nature. In our Seton museum at Santa Fe, there is a tin cup obtained long ago from a Plains Indian. It is a common tin cup such as can be bought in any hardware shop for 5¢. But when the Indians got this cup, they immediately decorated it with a fringe of colored porcupine-quill embroidery which hides most of the ugly rusted tin and which satisfied the esthetic demand of their souls.

The art of the Indian is an integral part of his everyday life; every act is an art expression. He cannot separate his art from his living any more than he can his religion. For this reason, in treating the arts of the Indian, we must include certain aspects which, in considering the arts of other people, might be omitted; for example, we must treat his habitations and his clothing as well as his music and dance.

A few general principles may be regarded as basic. Just as physically the Indian must be considered racially akin to the Mongolian, so Indian art is allied to that of the Chinese, but with all the local influences of the New World. While we may find resemblances in approach to the primitive arts of other races, the art of the Indian is, in its development, unique and wholly worthy of serious study.

There is no longer any doubt in the mind of the serious student that the Indian is a born artist. He has reserve and dignity which endow him with a capacity for discipline and careful work; he has naturally a fine sense of line and rhythm; and he has evolved an art form peculiarly his own, and one which we

White Americans have been much slower to appreciate than have the Europeans. This may be a commentary on our own art sense.

A good many of us have gotten our ideas of Indian art from the pronouncements of the casual tourist who brings back with him from the Indian country some souvenir of native manufacture. Few of these recognize in the Redman a true artist; they see him as a curio, turning out gewgaws for the passers-by at a uniform rate of perhaps 25¢ per object. The hurrying tourist will not pay the price which any craftsman must ask for his time, labor, and materials, to say nothing of the art impulse itself which is the background. So it is the Whiteman who has forced the Indian to turn out the little sweet-grass baskets, the absurd bows and arrows, the teapots and the raingods, which he never made until the advent of the tourist.

This by no means implies that the art of the Indian should be static, although the purists are averse to any change from the old forms and materials. While we all decry mass production by machinery and factory methods, we accept with approval modern variations and adaptations of old-time arts, new forms for use in present-day life, beautiful in themselves and honestly made in the old Indian manner. A graceful pot is still graceful even when it is used as the base for a lamp; a woven sash is just as fine when worn by a White woman to belt in a modern dress.

Before the Whiteman came to the New World, all Indian art was directed to the decoration of useful objects. Much of it was in connection with his religious ceremonies and rituals. With this I thoroughly agree, but with the added statement that the Indian did not separate his religion from his daily life, and the materials and ideas tied up with religion were accounted among the most useful of all.

This conception of use and beauty in the accompaniments of the Indian's daily life produces art in the broadest sense, not a piece of unnecessary work which can be admired on occasion, but an object of daily usefulness which gives meaning to everything about him.

One characteristic of the arts of the Redman is the philosophy that makes every object live. The animals are drawn with their life lines showing; the pot or bowl has its voice or ring which may be good or bad and which is released when the pot is broken;

the basket must have its circle of design unclosed, conceived of as a breathing space; the house must be sung and blessed into life; the sandpainting must be ceremonially destroyed, or it will go on living. Such an attitude toward the universe is fundamentally different from ours and must produce a broader art than anything conceived by the Whiteman with his material approach to all life.

We are learning that the Indian is not a museum specimen but a live man with all the intellectual power we attribute to ourselves. With this realization, we must appreciate the fact that we cannot keep his art entirely apart from our own; he will adapt our materials to his uses, and our own techniques must influence his products. If the imagination of the Indian craftsman can evolve a new use for his old art instead of continuing to make numerous imitations of the products of his ancestors, he is merely following the inevitable path of all art—a growing awareness of the aim of progress. The Indian must of necessity move with the times and, where he can, make at least a part of his living by his arts. Unless he adapts his old ancestral ideas to modern artistic demands, his products will go unsold.

When the Whites introduced domestic animals, certain metals, and mechanical devices, the arts and industries were made more numerous and more complex.

But there was a vital significance in the primitive approach to the artistic life of the old Indian which has never been surpassed, if indeed it has been equaled.

Now that the Department of the Interior has seen fit to close the Arts and Crafts Departments in most Government Indian schools, it is highly desirable that the techniques and the lore of these only truly American folk be put into permanent form for a later generation which might perhaps be wiser than the present generation in the realization of fundamental values.

One thing stands out certain and sure. It cannot be phrased better than has been done by John Sloan and Oliver La Farge (Ref. 8): "For the guidance of any Whiteman who wants to buy something really Indian—be it basket, necklace, robe or bow, if it be not well and truly made, an evidence of fine workmanship, and in good taste, it is not really Indian."

Bibliography

1. ADAIR, JOHN. "The Changing Economy of Southwestern Indian Arts and Crafts," *New Mexico Quarterly*, Vol. 29, No. 1 (Spring, 1959), pp. 97–103.

2. AMSDEN, CHARLES AVERY. "Arts and Crafts of the Southwestern Indians," *The Masterkey*, Vol. 15, No. 3 (May, 1941), pp. 74–80.

3. APPLETON, LEROY H. *Indian Art of the Americas.* New York: Charles Scribner's Sons, 1950.

4. BOAZ, FRANZ. *Primitive Art.* Oslo: H. Aschehoug & Co., 1927.

5. DOUGLAS, FREDERIC HUNTINGTON, and D'HARNONCOURT, RENE. *Indian Art of the United States.* New York: The Museum of Modern Art, 1941.

6. HODGE, FREDERICK WEBB (ed.). *Handbook of American Indians North of Mexico.* Washington, D.C.: Government Printing Office. Part I, 1907; Part II, 1910.

7. NEW MEXICO ASSOCIATION ON INDIAN AFFAIRS. "Old Art in New Forms," *New Mexico Magazine*, Indian Art Series, No. 8, 1936.

8. SLOAN, JOHN, and LA FARGE, OLIVER. *Introduction to American Indian Art.* New York: Exposition of Indian Tribal Arts, 1931.

9. SPINDEN, HERBERT J. *Fine Art and the First Americans.* New York: Exposition of Indian Tribal Arts, 1931.

Suggested Reading

CASSIDY, INA SIZER. "Indian Art Comes of Age," *New Mexico Magazine*, Vol. 35, No. 2 (February, 1957), pp. 37, 54, and 55.

COOLIDGE, MARY ELIZABETH ROBERTS. *The Rain-Makers.* Boston: Houghton Mifflin Co., 1929.

2

Dwellings

There is, perhaps, no other one product of the art of a people which so clearly defines its mental and cultural status as its habitations. This is a broad truth but subject to qualifications inasmuch as the architecture is influenced by many factors, chief among which is the character of the country in which the tribe lives, which, in turn, determines the habits of the people. In the various environments, we find every kind of refuge from the weather, every type of material, and every variety of shape. We find shelters, simple or complex, as the case may be, made of skins, brush, mud, wood, stone, adobe, and even ice and snow.

The tribes that had to live in a sterile, dry country where game and wood were both scarce were forced to provide themselves with different food and different shelter from those which occupied a well-wooded region abounding in game, where a few skins and poles would quickly produce a house.

In the highlands of the Great Divide and in the vast inland basins of the North, the building arts did not flourish; houses of bark, grass, reeds, the skins of animals, and rough timbers covered with earth gave the necessary protection from winter blasts.

In the arid regions, on the other hand, it was not so easy to find the material necessary for shelter. There was no suitable wood close at hand. It had to be transported long distances and, even after the wood was hauled and assembled, it was not sufficient to provide the necessary shade from the hot sun. Soon,

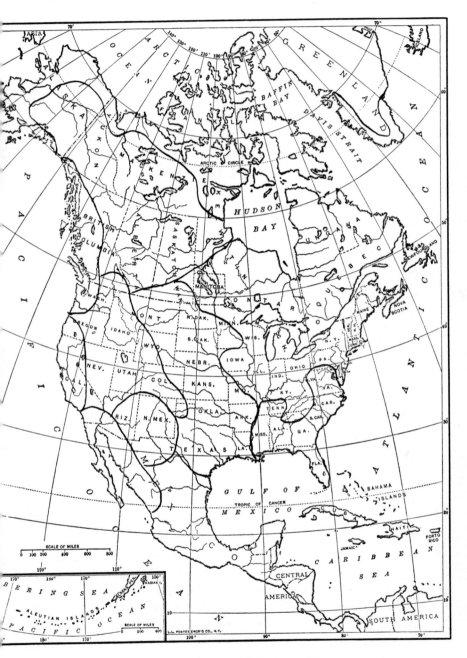

Figure 1. Distribution of Indian tribes.

therefore, these Indians learned to pile up stones or scrape together mud after a rain, or cut the green branches from their native small trees to overlap the trunks of which the foundation was made. As time went on, a degree of skill developed which resulted in a very high class of architecture.

Climate has another effect on house-building besides the production of varied types of accommodation. The cold northern weather forced the natives to build more substantial shelters and also produced a more vigorous man to build them. We therefore find in many cases, as in the Columbia River Valley, strong, husky men and roomy communal dwellings, permanently established; while in the southern lowlands, we find the men of a different temperament and physique, using as house-building materials earth, rocks, caves, rushes, bark, grass, and brush.

Thus we see that the climate and the materials at hand were the chief agencies in determining the architectural skill of the groups in various parts of the country.

To take each type of Indian habitation and accurately describe it would be an interesting study, but the approach would be that of the ethnologist, and such studies have been made many times and in many places. It is our desire to give an accurate account of the various types of dwelling, but to concentrate on those which have a practical value in our present-day camp and recreational life. Thus, we have little more than a passing interest in the building achievements of the ancient Mound Builders of the Mississippi Valley and the Southern States. Likewise, we pass lightly over the cliff dwellings and cavate lodges, tremendously interesting in themselves, but of little worth in application to our present thought.

Snow Houses

The invention of the snow house by the Eskimo (or Innuit, as they call themselves) was one of the greatest triumphs over environment that man has ever accomplished.

In the Arctic Circle, it is not that people lack ability or industry, but the surroundings restrict constructive effort to the barest necessities of existence. This effectually retards progress to higher development.

Agriculture is impossible all along the thousands of miles of

the north shore. The only wood is such as drifts in. Other than this driftwood, the only available building materials are snow, ice, stone, and bones of animals. All of these have been used for dwellings and storage places, differing in various tribes according to the requirements and skill of the workers.

The lack of necessary timbers to build walls and span wide spaces is probably one reason why these tribes construct their houses at least partly beneath the surface of the ground. This device also makes the houses more impervious to the cold.

Most of us are inclined to think that the Eskimo lives always in an igloo or snow house. This is not entirely true. After the long cold winter, the family is very apt to move, when the weather permits, into a tent of sealskin. The actual construction of such tent is similar to that used by other, more southerly tribes and will be described later.

The snow house, however, is an interesting and unique habitation. Our summer campers will not build with snow, but the ingeniousness of the art is worth recording, and some of our winter camps in the mountains might try to make snow houses.

It is essential that the snow itself be of the right kind. It must be taken from a bank formed by a single storm, or the blocks will break when cut. The snow must be very fine-grained but not too hard to be cut with a snow knife. In the old days, these knives were made of ivory and had a slight curve.

A deep snowdrift is chosen. Two parallel cuts are made crosswise into the drift, about 8 inches deep and 2 feet apart. With two vertical cuts, a small block is removed, making it easier to continue the work of sawing and taking out the blocks, which, when ready for use, measure 3 or 4 feet in length, 2 feet in height, and 6 to 8 inches in thickness.

As one man cuts the blocks, another starts building. On a level place, a row of blocks is set up in a circle, slanted inward slightly so as to fit closely together. Then starting at the top corner of one block, an oblique line is cut all around the top of this first row until it ends at the ground where it meets up with the first block, thus forming one thread of a spiral.

Now, round and round the blocks are added, each inclined a little more inward than the previous one and each supported by the surrounding blocks. When the building has progressed to

a considerable height, the builder does the work of fitting from the inside and the blocks are put in place by the man who cuts them outside. The key block and those directly next to it are irregular in shape, cut to fit the hole which is left. This must be very carefully done, or the whole structure is apt to cave in, especially in moderate weather.

The joints between the blocks are closed with scraps and loose snow pressed into the spaces. A piece of thick clear ice from the lake is sometimes set into the side of the dome toward the sun. This admits light, yet keeps out cold.

Lucien M. Turner (Ref. 15) has given us a short but graphic picture of the interior of an igloo.

The interior walls, in severe weather, become coated with frost films from the breath, etc., condensing and crystallizing on the inside of the dome, and often presenting by the lamplight a brilliant show of myriads of reflecting surfaces scintillating with greater luster than skillfully set gems.

A raised bed is made by piling blocks into a solid mass, then covering this with boughs of spruce or dry grass, if obtainable. Otherwise, fine twigs of willow or alder are used, and over these are thrown heavy skins of reindeer or bear. Softer skins of the same animals are used as covers.

At Point Barrow, Alaska, houses of snow are used only temporarily; for example, at the hunting grounds on the rivers, and occasionally by visitors at the village who prefer having their own quarters. These houses are not built in the dome or beehive shape. John Murdoch tells us that here the snow house consists of an oblong room about 6 feet by 12 feet. The walls are made of blocks of snow, high enough so that a person can stand up inside the rooms. Poles are laid across the top and over these is stretched a roof of canvas.

Outside at the south end a low, narrow, covered passage of snow about 10 feet long leads to a low door. Above this is a window made of seal entrail. At the outer end of the passage there is an opening at the top, so that one climbs over a low wall of snow to enter the house.

At the right of the passage close to the house is a small fireplace built of slabs of snow, with a smoke hole in the top and a stick stuck across at the proper height to hang a pot on. When the

first fire is built in this fireplace, there is considerable melting of the surface of the snow, but as soon as the fire is allowed to go out, this freezes to a hard glaze of ice, which afterwards melts only to a trifling extent.

The door of the house is protected by a curtain of canvas. At the other end, the floor is raised into a kind of settee on which are laid boards and skins.

Wickiups

The Arizona wickiup, especially that of the Paiute, is perhaps the simplest type of shelter built by man. It is composed of branches 8 or 10 feet in height, arranged in a semicircle and inclined so that their tops come together but leaving about a third of the circumference open as entrance. Except for this space, the whole is covered with cedar or pine boughs or other convenient brush.

The Menomini build temporary shelters similar to these, but usually only for a single night's occupancy.

The Navajos build several different forms of very simple shelter for summer use. One can be made in half an hour by two men with axes and is hardly enough to be called a building. It is merely a tree felled on the windward side of a selected space. The branches are trimmed from it and piled up 4 or 5 feet in height on three sides of a circle, perhaps 18 feet in diameter. Blankets thrown over outstanding branches here and there afford shade on hot summer days.

Another type of Navaho wickiup consists of a horizontal beam resting on two forked timbers. This beam supports an inclined series of poles, the upper ends of which are placed against it. The whole is covered with cedar boughs laid close together.

Brush Lodges

The previously described habitations have indeed employed brush in their construction, but they are individual shelters, meant at most for a single family. Communal lodges, on the other hand, were the rule in certain tribes. Among the Flatheads, in summer weather or when the people congregated for a short session, the lodge was a single one-sided lean-to with fires built

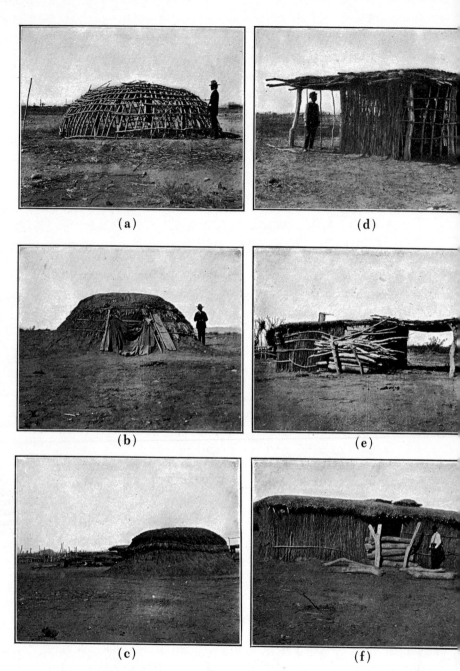

Figure 2. Houses and sheds of the Pima Indians: (a) framework of house; (b) blanket door; (c) earth-covered houses; (d) shed frames; (e) storehouse and wagon shed; (f) shed door.

along the front in the open. Windbreaks of brush or sometimes of mats might be laid across one or both ends.

In cold weather or if the lodge were to be used for a longer period, a similar lean-to would be built facing the first and adjacent to it. Except for an entrance at each end, the space between the two was filled with mats or brush, and the long opening at the top between the two lean-tos was ample as an outlet for the smoke.

For modern purposes in camps, the single lean-to would make an admirable protection from the wind when outdoors cooking was to be done. A row of fires in front of the lean-to would be a picturesque as well as an authentic sight.

Peaked Lodges

Among the Chippewa, peaked lodges were common. These consisted of a long ridgepole resting on a series of shorter poles sloping outward from the ridge to the ground on each of the long sides. This framework was covered with sheets of elm or cedar bark, or, where available, rolls of birch bark. An entrance was provided at each end.

These lodges were long enough to permit three or four fireplaces, but they had no smoke holes. There was sufficient opening at the crossing of the poles to allow the smoke to escape.

In the early days, the Winnebago used a ten-fire gable lodge, rectangular in form. There were two types of this lodge, one built on a platform, one on the ground. They were similar to the Chippewa peaked lodge described above. Beds were placed along both of the long sides on a platform about 2 feet high. This afforded not only a place for resting, but protection from the dampness of the ground and from insects as well.

The skin tent of the Eskimo may be said to be a peaked lodge. The frame structure is similar to the lodge frames we have described for the Chippewa and the Winnebago, except that a few more braces are used in order to support the weight of the skins which are used for the covering.

These skins are of the largest square flipper seals, those too heavy for any other purpose. The skins are used with the hair left on; they are stretched, freed from fat and fleshy particles, trimmed at the edges, and sewn together to form the length of

(a)

(b)

Figure 3. Chippewa lodges: (a) lodge with mat sides and birch-bark roof; (b) elm-bark lodge.

18

the tent. With two of these long strips meeting at the rear of the structure and tied to the poles, an ample covering is achieved. A separate skin forms the door and may be thrown aside when a person enters or goes out. A fireplace in the central portion heats the lodge in cold weather and also provides the cooking area. This lodge is often moved from place to place when the food supply of the locality is exhausted.

Pile Dwellings

Where tribes lived along margins of the sea or on the banks of bayous or tidewater rivers—in short, on any land subject to inundation—it was necessary to raise the floors of the dwellings above the reach of tide and flood. In such cases, mounds of earth or shell were erected, and into these, poles were planted. To these poles, floor timbers could be attached at suitable levels.

Among the Kwakiutl of Johnstone Strait, there were, in the early days, dwellings raised as much as 30 feet from the ground. The house was reached by a long tree with notches cut into it for steps inclined from the platform to the ground.

The Seminoles, even when not in danger of flood waters, build pile dwellings. These are permanent structures, since the Seminoles are not nomads. The houses are built in settlements, with gardens and fields surrounding them.

The palmetto tree supplies practically all the material needed for the structure. Upright logs, without any treatment, support the rafters of the roof; these in turn sustain the palmetto thatching. A platform of split palmetto logs, flat sides up, is laid about 3 feet from the ground, lashed to beams which extend the length of the building. This platform is in reality a raised floor, furnishing a dry sitting or lying down place, when, as sometimes happens, the region is under water.

The thatching of palmetto leaves is a work of art. It is done on both the inside and the outside of the structure and is so carefully laid that it is weathertight. On the outside, the leaves are held down by heavy logs bound together in pairs and laid astride the ridge.

The house is open on all sides, and without rooms. It is, in effect, only a covered platform, but it is entirely adequate to the needs of the family.

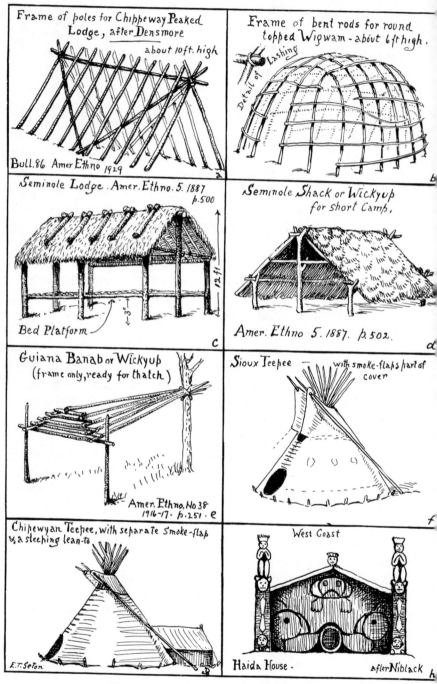

Frame of poles for Chippeway Peaked Lodge, after Densmore
about 10ft. high
Bull. 86 Amer Ethno 1929

Frame of bent rods for round topped Wigwam - about 6 ft high.
Detail of lashing

Seminole Lodge. Amer. Ethno. 5. 1887. p.500
Bed Platform
12 ft
3"

Seminole Shack or Wickyup for short Camp.
Amer. Ethno 5. 1887. p. 502.

Guiana Banab or Wickyup (frame only, ready for thatch)
Amer. Ethno, No 38 1916-17. p. 251. e

Sioux Teepee — with smoke-flaps part of cover

Chipewyan Teepee, with separate Smoke-flap & a sleeping lean-to
E.T. Seton

West Coast
Haida House.
after Niblack

Figure 4. A few tribal habitations.

20

Grass Houses

Grass houses were used by most of the Caddoan tribes. They were shaped like a beehive and required considerable skill to build but were very attractive, both inside and out.

Into a circle drawn on the ground, a number of crotched posts were set. In these crotches, beams were laid, forming an equal circle as high as the outer walls were to be. Against these beams, poles were set close together so as to lean inward. Willow rods laced these one to another, and the tops were brought together and fastened at the peak. A heavy thatch of grass was laid over this frame and bound down by slender rods. A tuft of grass ornamented each point where the rods joined.

To the apex of the roof were fastened two poles lashed together at right angles to form four projecting lengths pointing each to a point of the compass, from which come the powers to help man. At the very peak was built a spire made of bunches of grass, rising 2 feet or more into the air. This symbolized the zenith, the abode of the universal force which is in all nature. In the center of the floor was a circular excavation which served as the fireplace, always sacred to the Indian. In primitive days, four doorways opened out but, later, except for ceremonial purposes, only two were provided.

Couches consisting of a woven covering of reeds fitted over a framework were placed against the wall.

Wigwams

The words *wigwam* and *tepee* have been used by many writers as interchangeable terms, until many people think that there is no difference between these two structures. As a matter of fact, there is very little similarity.

The tepee was always portable, whereas at least the framework of the wigwam was fixed. The poles of the tepee were straight and rigid; the poles of the wigwam were flexible saplings, planted in the ground at the butt ends and bent over to meet their fellows of the other side. The tepee was originally covered with hides and later, canvas; the usual covering of the wigwam was bark or similar material.

Many tribes used the wigwam form of framework for their

habitations. The circumference varied in shape, and the covering was of various material, but the principle involved in the construction was the same. A description of one of the temporary structures of the Menomini will serve to indicate what wigwams were like.

Five or six saplings were set into the ground on each side of an oblong space. The top of each sapling on one side was bound down over the opposite one to form a rounded roof, roughly resembling the top of a covered wagon. Horizontal saplings bound around the original framework made the structure secure. Over the outside of the skeleton, long strips of pine bark were laid, starting at the ground level, so that the upper pieces overlapped the lower in each series.

Similar lodges for summer occupancy were used by the Omaha, the Winnebago, the Iowa, and the Sak. These lodges were frequently elliptical in shape rather than circular, but otherwise they were like the wigwams of the Menomini.

The Chippewa constructed a dome-shaped wigwam, which they called a *wakinoogan*. It was a permanent, year-round shelter. This is a practical type of lodge for a summer camp.

Bernard S. Mason (Ref. 8) who, during his many years of active camping experience with boys, used every applicable idea originated by the Indians, has described the making of a wakinoogan. On a level spot, stake out a circumference of the size desired. Actually, it should be slightly oblong in shape, a good size being 10 by 12 feet. Eight slender saplings about 3 inches in diameter at the base are needed for the frame. Ram two of these, *A* and *B*, Figure 5(a), into the ground, about 2½ feet apart. This is to be the doorway. Bend them back and ram the other ends into the earth, so that the center is about 7 feet high.

Next, do the same with two other saplings, *C* and *D*, Figure 5(a). Now take a split sapling and lash the end of it at *A*, about 2 inches above the ground. Bend this around the bottom of the frame, lashing it at each post. Lash the other half of the sapling at *B*, and run it in the opposite direction till it meets the first.

Between each of the uprights, put in the other four saplings, bending and lashing as you did the others. Two more rounds, *X* and *Y*, Figure 5(b), for support are lashed horizontally above

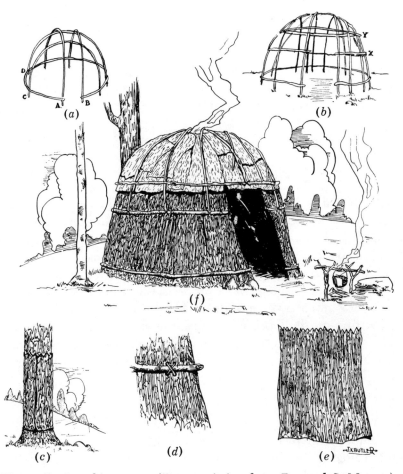

Figure 5. A wakinoogan. (By permission from Bernard S. Mason.)

the previous two. The cross piece (Y) is the top of the doorway. The bark walls are best made of white cedar, which withstands the weather better than the bark of most other trees.

To get this bark without harming the tree is an art in itself. Cut through the bark around the bottom of the tree (Fig. 5[c]) and again about 6 feet up. Peel off the bark slowly and carefully in a sheet (Fig. 5[e]). You will need 12 to 15 of these sheets. Stand these strips on end around the framework and fasten them in

place with split saplings (Fig. 5[f]) directly parallel to those on the inside. Through small holes cut in the bark, lash these saplings to the corresponding ones on the inside (Fig. 5[d]). A second layer of bark above this lashing forms the roof. An opening about 2 feet square is left in the top of the roof to allow the escape of smoke. A piece of birchbark laid over this opening when necessary will keep out the rain, and a similar piece can be used as a closing for the door in bad weather.

Tepees

The tepee was the lodge used universally until the past decade or so by the Plains tribes. It was made of buffalo skins which were shaved and dressed, and, after being cut to shape, sewed together in about three-quarters of a circle, with two triangles like wings attached at the small end, enabling supporting poles to be moved about with the wind to allow escape of smoke. This covering was set up on poles arranged to form what looks like an inverted funnel. Among the Chippewa, the conical frame of the tepee was often covered with birchbark instead of buffalo skins.

Setting up the tepee was always the work of the women, and the skill and dexterity acquired through years of experience made it a fascinating sight to watch the operation wherever a camp was to be pitched.[1]

Jacales

The typical jacal is found among the Seri Indians. The material used is the simplest, and the structure, like the folk themselves, is crude and squalid. Certain features, however, are uniform and conventional.

The jacal is built of upright boughs of ocatilla, roughly stripped of thorns, and horizontal tie sticks of any convenient material. These are lashed together.

The framework is about 10 feet long, 5 feet wide, and perhaps 4½ feet high, with one end open to the full width and height. Over this frame is piled any convenient shrubbery, collected

[1] Full directions for the cutting and making of a tepee and color illustrations of tepee decorations may be found in my *Rhythm of the Redman,* published by The Ronald Press Company, 1930.

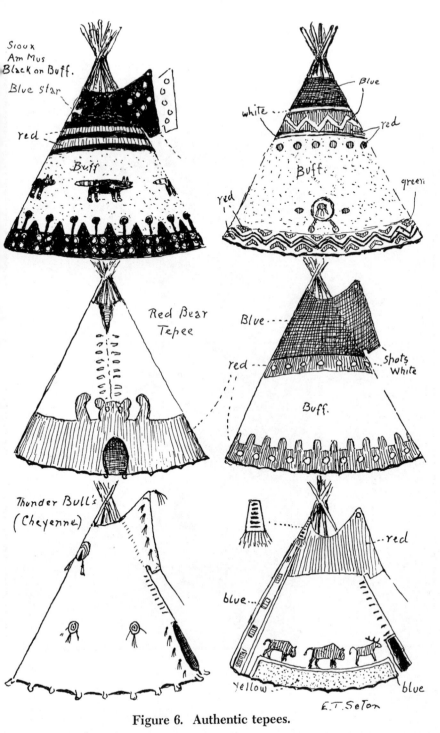

Figure 6. Authentic tepees.

without choice and laid so loosely that it is easily dislodged by even a change of wind.

W. J. McGee (Ref. 7), in his description of these jacales, says graphically:

Ordinarily, the walls are thicker and denser than the roofs, which are supplemented in time of occupancy by haunches of venison, remnantal quarters of cattle and horses, half-eaten turtles, hides and pelts, as well as bird skin robes, thrown on the bows, partly to keep them out of reach of coyotes, and partly to afford shade

Earth Lodges

The earth lodge was a circular dwelling having walls about 8 feet high and a dome-shaped roof with a central opening for the escape of smoke and the admission of light. The work of building an earth lodge was shared by men and women, the marking out of the site and the cutting of the heavy logs being done by the men.

The first stages of building the framework were quite similar to those employed in the construction of the grass houses. If the lodge was to be of a considerable size, it was necessary to plant four to eight large crotched posts midway between the central fireplace and the wall, in order to support the heavy beams which formed the roof. Branches of willow were laid crosswise outside the walls and roof, bound to each slab and pole. Over these willows, a heavy thatch of coarse grass was arranged so as to shed the water. On the grass was placed a thick coating of sod, cut to lap, and laid like shingles. These were then tamped with earth, making the whole impervious to rain.

At one side was built a covered way about 10 feet long and 5 feet wide, at the outer end of which hung two slightly overlapping buffalo hides through which a person might enter. At the interior end of the passage, a similar hanging was used.

The floor of the lodge was carefully worked. The loose earth was removed and the ground tamped. Next, it was flooded with water, then dried grass was spread over it and set on fire. The ground was tamped again, and again the grass was spread and fired. This was repeated until the floor became hard and level. It could then be easily kept clean.

The Eskimo built an earth lodge for summer use; the cover-

ing was earth thrown over the framework to a thickness of 3 or 4 feet.

If used in winter, an underground passage or tunnel led from the outer end of the covered entry way to a point below the floor.

Of all those who build earth lodges, perhaps the Navahos have attained the highest degree of excellence.

The winter hogans are the real homes of the people, and the form and construction of these are dictated by certain rules and a long line of precedents, supported by a conservatism which is characteristic of primitive life.

Cosmos Mindeleff (Ref. 9) has given such a graphic description of the Navaho hogans that we cannot do better than quote his deeply understanding account:

As a rule, . . . each hogan stands by itself, and it is usually hidden away so effectually that the traveler who is not familiar with the customs of the people might journey for days and not see half a dozen of them.

The spot chosen for a dwelling place is either some sheltered nook on a mesa, or a southward slope on the edge of a pinon grove near a good fuel supply, and not too far from water. A house is very seldom built close to a spring—perhaps a survival of the habit which prevailed when the people were a hunting tribe, and kept away from the water holes in order not to disturb the game which frequented them. . . .

The Navaho recognize two distinct classes of hogans—the . . . winter place, and the . . . summer place; in other words, winter huts and summer shelters. Notwithstanding the primitive appearance of the winter huts, resembling mere mounds of earth hollowed out, they are warm and comfortable; and, rude as they seem, their construction is a matter of rule, almost of ritual, while the dedicatory ceremonies which usually precede regular occupancy are elaborate and carefully performed.

Although no attempt at decoration is ever made, either of the inside or the outside of the houses, it is not uncommon to hear the term *beautiful* applied to them.

Strong forked timbers of the proper length and bend, thrust together with their ends properly interlocking to form a cone-like frame, stout poles leaned against the apex to form the sides, the whole well covered with bark, and heaped thickly with earth, forming a roomy warm interior with a level floor—these are sufficient to constitute a . . . "house beautiful."

To the Navaho, the house is beautiful to the extent that it is well constructed and to the degree that it adheres to the ancient model. . . .

A suitable site having been found, search is made for trees fit to make the five principal timbers which constitute the . . . house frame. There is no standard of length, as there is no standard of size for the completed dwelling; but commonly pinon trees 8 to 10 inches in diameter and 10 to

12 feet long are selected. Three of the five timbers must terminate in spreading forks; . . . but this is not necessary for the other two, which are intended for the doorway and are selected for their straightness.

When suitable trees have been found—and sometimes they are a considerable distance from the site selected—they are cut down and trimmed, stripped of bark, and roughly dressed. They are then carried or dragged to the site of the hogan and there laid on the ground with their forked ends together somewhat in the form of a T, extreme care being taken to have the butt of one log point to the south, one to the west, and one to the north. The two straight timbers are then laid down with the small ends close to the forks of the north and south timbers, and with their butt ends pointing to the east. They must be spread apart about the width of the doorway which they will form. . . .

The interior area being thus approximated, all the timbers are removed, and, guided only by the eye, a rough circle is laid out, well within the area previously marked. The ground within this circle is then scraped and dug out until a fairly level floor is obtained, leaving a low bench of earth entirely or partly around the interior. This bench is sometimes as much as a foot and a half high on the high side of a slightly sloping site, but ordinarily it is less than a foot. The object of this excavation is twofold—to make a level floor with a corresponding increase in the height of the structure, and to afford a bench on which the many small articles constituting the domestic paraphernalia can be set aside, and thus avoid littering the floor.

The north and south timbers are the first to be placed, and each is handled by a number of men, usually four or five, who set the butt ends firmly in the ground on opposite sides at the points previously marked, and lower the timbers to a slanting position until the forks lock together. While some of the men hold these timbers in place, others set the west timber on the western side of the circle, placing it in such a position and in such a manner that its fork receives the other two, and the whole structure is bound together at the top.

The forked apex of the frame is 6 to 8 feet above the ground in ordinary hogans; but on the high plateaus and among the pine forests in the mountain districts, hogans of this type, but intended for ceremonial purposes, are sometimes constructed with an interior height of 10 or 11 feet, and inclose an area 25 to 30 feet in diameter. . . .

The two doorway timbers are next placed in position, with their smaller ends resting on the forked apex of the frame, from 1½ to 2 feet apart, and with the butt ends resting on the ground about 3½ feet apart. . . .

When the frame of five timbers is completed, the sides are filled with smaller timbers and limbs of pinon and cedar, the butt ends being set together as closely as possible on the ground, and from 6 to 12 inches outside of the excavated area previously described. The timbers and branches are laid on as flat as possible, with the upper ends leaning on the apex or on each other. The intervening ledge thus formed in the interior is the bench

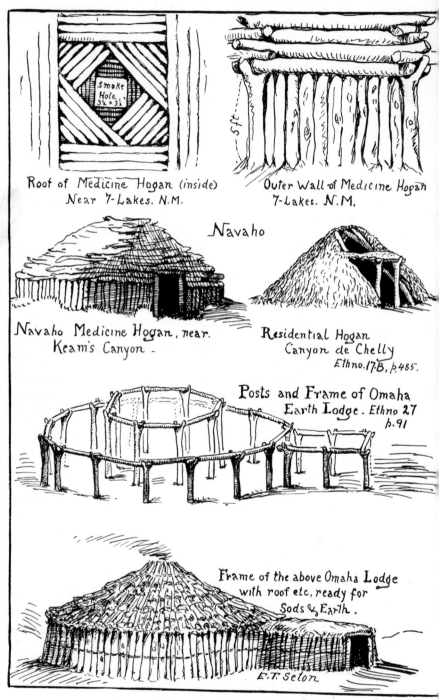

Roof of Medicine Hogan (inside)
Near 7-Lakes. N.M.

Outer Wall of Medicine Hogan
7-Lakes. N.M.

Smoke Hole 3½ x 3½

5 ft.

Navaho

Navaho Medicine Hogan, near.
Keam's Canyon -

Residential Hogan
Canyon de Chelly
Ethno.17.B, p.485.

Posts and Frame of Omaha
Earth Lodge. Ethno 27
p. 91

Frame of the above Omaha Lodge
with roof etc. ready for
Sods & Earth.

E.T. Seton

Figure 8. Earth lodges.

previously mentioned; and aside from its convenience, it adds materially to the strength of the structure.

While the sides are being inclosed by some of the workers, a door-frame is constructed by others. This consists simply of two straight poles with forked tops driven into the ground at the base of and close inside the doorway timbers. . . . When in place, these poles are about 4 feet high, set upright, with a straight stick resting in the forks. . . . Another short stick is placed horizontally across the doorway timbers at a point about 3½ feet below the apex, at the level of and parallel with the cross stick of the doorframe. The space between this cross stick and the apex is left open to form an exit for the smoke. . . .

The doorway always has a flat roof formed of straight limbs or split poles laid closely together, with one end resting on the crosspiece which forms the base of the smoke hole, and the other end on the crosspiece of the door-frame. The whole doorway structure projects from the sloping side of the hogan, much like a dormer window. . . .

The sides of the projecting doorway—that is, the spaces between the roof and the sloping doorway timbers—are filled in with small sticks of the required length. Sometimes the ends of these sticks are bound in place with twigs of yucca, being made fast to the door-frame, but generally they are merely set in or made to rest against the outer roof covering. . . .

The entire structure is next covered with cedar bark; all the interstices are filled with it, and an upper or final layer is spread with some regularity and smoothness. Earth is then thrown on from base to apex to a thickness of about 6 inches, but enough is put on to make the hut perfectly wind and waterproof. This operation finishes the house, and usually there are enough volunteers to complete the work in a day.

Ernest Thompson Seton, in an unpublished manuscript, has written:

There can be little doubt that the Navahos have improved on the hogan architecture within the last 50 years. For comparison with the style described by Dr. Mindeleff, I give details of a good example of a modern hogan, made last summer (1931) at Seven Lakes on the Navaho Reservation.

This was 24 feet in diameter outside, and about 12 feet high in the center.

The material needed for the construction of this hogan is as follows: 14 stout posts (they were of pinon in this case), 7 feet long, 6 inches thick, and each with a forked top; 50 posts, 9 feet long, and 6 inches thick; 50 posts 6 feet long, of lesser size; 50 posts of 5-foot length; 50 of 4-foot, and so on, getting smaller. A pile of cedar bark completes the required material.

The mode of construction would be thus: Mark out a 24-foot circle, with a 3-foot opening to the east. On this circle, dig 14 post holes, 6 feet center to center, except that the two which make the door posts are 3 feet apart. Set in these holes the 14 forked posts. On the forks, set the first row of

horizontal beams, omitting every other space; that is, there will be 7 beams laid on this round.

On the next round, lay a beam in each blank space, but draw it toward the center some 6 inches. Round after round is laid in this way, exactly like rails on an old snake fence, but always drawing in toward the center.

As the dome rises, shorter, lighter poles are used till nothing is left but a square hole 3½ feet across.

A shallow trench, about 12 inches deep, is dug around, between the forked posts, and the sides of the building closed in with 6-foot posts set upright, which are bevelled on the top so as to wedge under the horizontal beams. A few spikes to hold them would have helped, but the Navaho did not use them.

The 6-foot space opposite the door was recessed a foot or more; that is, it was about 1½ feet farther from the center, so as to make an alcove for properties.

Now all the chinks on the roof are stuffed with cedar bark. The floor inside is levelled.

A puddle is made, and the walls plastered with mud. The earth from inside and whatever is handy outside, is now banked up against the walls outside. The roof, well covered with cedar bark, is plastered all over with mud; and the hogan is finished, all but the doorway.

This is made 3 feet wide, and 6 feet high, and closed with a curtain of some heavy material.

Wooden Houses

In many localities, the natives built their houses of wood, the material depending upon the local supply. Most of these are so like the Whiteman's primitive cabins that they need not be described here. One exception to this simplicity is the house of the Northwest Coast where vast forests of yellow cedar are found and utilized by the natives with great skill and decorative sense.

The labor expended in cutting and transporting the huge trunks, in hewing the planks, in carving the house and totem poles, and in erecting the 30- to 40-foot square structures is enormous. The most interesting and artistically valuable part of this type of building, the totem poles, will be taken up in another chapter.

Houses of Stone and Adobe

The higher forms of the art of architecture are not possible without stone or something akin to stone. The permanence of stone buildings enables one generation after another to study

older ideas and develop new ones, thus encouraging a cumulative growth which is necessary for further development.

The Pueblo Indians were and still are to be found in southern Colorado, in central Utah, and especially in New Mexico and Arizona.

In ancient days, the ancestors of the present Pueblos used recesses and shallow caverns, naturally weathered in the faces of the cliffs. As time went on, they built marginal walls for protection and eventually excavated commodious dwellings, some large enough to accommodate whole communities. Where stone was available, it was used in most ingenious ways. The masonry, as still evidenced in many of the ruins, was excellent.

The Pueblo Indians, particularly in Arizona, found themselves in a region where there was a dearth of wood but much easily quarried stone. It was essential that they build what amounted to great strongholds for defense against their ever-present enemies. This encouraged—yea, demanded—united effort.

The stones were eventually hewn and laid in courses. Door and window openings were accurately framed with cut stone and spanned with lintels of stone or wood.

The Hopi houses are excellent examples of this type of building. In some localities, picturesque towers gave the necessary vantage lookouts. And, though many of these edifices were built a thousand years ago, the ruins today give us adequate information on the arts of the past. Chaco Canyon, Canyon de Chelly, and Mesa Verde are remains of this primitive period of architecture.

Among the Pueblo Indians of the Rio Grande Valley in New Mexico, the wonderful abundance of clay soil determined the type of building. The clay is made into adobes (sun-dried bricks) and built up into the walls, much as the stone was used among the Hopi, etc. Today the adobes are molded in a wooden frame. Before the Spaniards came in 1540, the method was more difficult but more interesting. Casteneda (Ref. 16) described it:

> They gather a great pile of twigs of thyme [sagebrush] and sedge grass and set it afire, and when it is half coals and ashes, they throw a quantity of dirt and water on it and mix it all together. They make round balls of this, which they use instead of stones after they are dry, fixing them with the same mixture, which comes to be like a stiff clay.

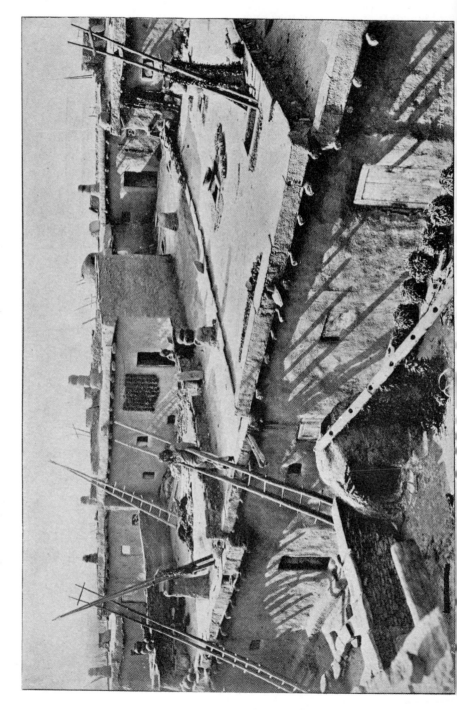

Frederick W. Hodge (Ref. 4) tells us that after the introduction of wheat by the Spaniards, the straw crushed by the hoofs of horses in stamping out the grain on a threshing floor was substituted by the Indians for the charred brush.

A requisite for making adobe is a good supply of water; consequently, the industry is generally conducted on the banks of streams near which pueblos are usually built. When molded, the adobes are set on edge to dry, slanted slightly to shed water. Adobes vary in size, but are usually about 16 inches long, 8 inches wide, and 4 to 6 inches thick.

In setting them in walls, mortar of the same material is used. In the Southwest, where the average precipitation is not great, structures built of adobes last indefinitely with reasonable repair, the greatest amount of disintegration being at the base of the walls during seasons of rain, although prolonged sandstorms also erode the surfaces.

For the sake of appearance, as well as for protection against weathering, adobe masonry is often plastered. The Indian women use their hands as trowels, and the plastered wall presents a pleasing surface, varying in color from gray to a rich reddish brown, according to the color of the earth of which the plaster is made. The interior walls and, on occasion, the borders of the windows and doors are sometimes whitewashed with gypsum.

Another kind of earth masonry in the arid region is that known as *pise*. A house of this type was made by erecting a double framework of poles wattled with reeds or grass to form two parallel surfaces as far apart as the desired thickness of the wall, and into the enclosed space, adobe grout was rammed.

Having prepared the material of which the house is to be built, one would think it was simply a matter of going to work on the construction. Not so! The Pueblo Indians, being sedentary, unhampered by the necessity for continual travel, maintain a more ceremonial approach to life than other tribes. The details may differ from pueblo to pueblo, but the procedure described herewith is characteristic.

When the site for a house has been chosen and the dimensions determined, the builder measures by paces, indicating each corner with a stone or other marker. He then cuts enough trees for the roof, estimating the number he will need placed about 2

feet apart down the length of the room. These are cut about 3 feet longer than the width of the room.

The village chief has meanwhile prepared four small eagle feathers, to the stem of each of which he has tied a short cotton string. The feathers are now sprinkled with sacred meal, and the chief breathes upon them prayers for the welfare of the proposed house and its occupants. These feathers are placed at the four corners of the house, and a large stone is laid over each of these feathers.

At each side of what will be the entrance door, the builder sets some food; then walks around the site from right to left, sprinkling crumbs of food and native tobacco, at the same time singing his house song.

Then the adobes are laid up for the walls to a height of 7 or 8 feet, using mud for mortar between the bricks. Next, the natural round beams called *vigas* are placed flat on the top of the walls, allowing the ends of the beams to project. Smaller poles and split limbs are placed over the vigas at right angles to them, parallel with the side walls. Across these are laid reeds or small willows as close together as possible, then a layer of grass and small twigs or weeds. Now wet earth is spread to a depth of several inches, firmly packed on this foundation. *Canales,* made of wood, are placed as would be our metal rain spouts.

The walls, both inside and out, are plastered with the same mud as was used for the making of the adobes.

Mindeleff tells us that at this point, the builder prepares four feathers similar to those previously consecrated by the chief. These, tied to a short piece of willow, are inserted over one of the central roof beams. These feathers are renewed at a feast celebrated in December, when the sun begins to return northward.

Under a hole left in one corner of the roof, the woman builds a fireplace and a chimney. The fireplace is usually nothing more than a small cavity about a foot square. Over this, a hood is constructed, its lower rim about 3 feet above the floor.

The color of the mud varies from locality to locality, but whatever the basic tone, the effect is one of sheer beauty, soft and graceful in texture and form; nothing can duplicate the warm earth color of the hand-applied mud, though in modern times,

the Whiteman has tried all available substitutes for the native adobe. Why?

These Redmen were living in communities with self-government and tribal development of the arts long before the Whiteman came in 1540. Originally each family probably lived alone or with a very few other families. Their fields were close at hand and, being agriculturists even in the old days, their lives were adequate unto themselves. Later, due mainly to the incursions of more nomadic and warlike Indians, the Pueblo Indians built their houses closer together and in larger groups, until today we find them in communities sometimes of a thousand people.

The villages are often rectangular, the houses being built around a central plaza. The pueblo of Taos, as it stands today,

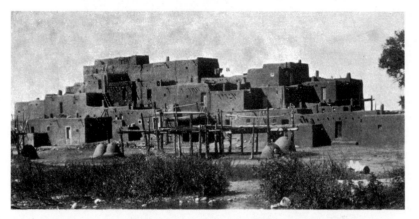

Figure 10. Taos pueblo. (Photograph by Harold Kellogg.)

is an example of the building of the old days, when two large units of dwellings, facing each other, housed several hundred persons, the entire population of the pueblo. Just where in the pueblo a family lived was determined by the clan system which prevails still—the winter people, as one clan is called, on one side of the river, the summer people on the other. The house groups are respectively four and five stories high. In the early days, according to accounts of the Oñate Expedition in 1598, some of the structures were even higher.

Although many concessions to modern ways have now been made, we know that originally the lower stories were without

(a)

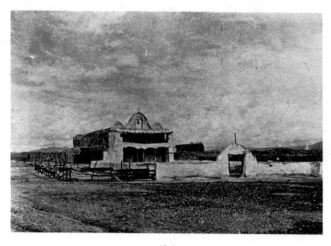

(b)

Figure 11. Mission at Cochiti: (a) as built by Whitemen; (b) as built by Indians.

doors. The dwellings themselves are built in terraced form; each story is set back from the front elevation of the story below and is reached by means of movable ladders which, in times of attack, could be hauled up out of reach of the enemy.

The story of Pueblo architecture would not be complete

without a word about the *kivas*. These are the sacred ceremonial or assembly chambers, still built and used by each village as they were in aboriginal days.

Since the village is divided into two clans according to the social system, there are at least two kivas in each pueblo. These are large rooms, built partly underground, and may be round or square, though the round room is more usual. These chambers belong exclusively to the men, except in a very few instances when they are used by women's religious societies.

The kivas have no doors or windows, though occasionally a few very small openings may be left in the wall. The kivas are entered by means of a ladder on the outside, extending to the inside floor. The inside walls are sometimes decorated with symbolic paintings. A bench of stone or adobe encircles the wall on the interior, and a fireplace occupies the central portion of the floor. Altars appropriate to the various ceremonies are erected as required. A small hole in the floor called the *sipapu* symbolizes the traditional place of origin of the tribe. Through this opening came the first ancestors and also the gods who taught the people their arts and ceremonies.

These pueblos are a beautiful model to follow for the permanent buildings of a camp in areas where stone or clay is readily available and where the climate is dry. But more valuable to our young people is the ritual attitude of these Indians toward their habitations.[2] There is in many of us an inner urge which demands some satisfaction such as is engendered by ritual, thus proving the inherent primitive instinct in the human being.

Modern Adaptations

Ernest Thompson Seton has suggested substitutes for some of the materials used by the Indians. He has written:

The age of boundless resources is gone by. In my younger days, there were millions of canoe-birches, available for any who wished to make a canoe or a wigwam. There were millions of acres of wattap for those who wanted the wildwood cordage. And elm bark and basswood were squandered on every northern landscape.

So far gone by is this period of lavish abundance that now one must be

2 In my *Rhythm of the Redman*, I have given a dedication ceremony for a new home which, when I myself was confronted with the necessity, I evolved from a recorded ritual of the Pueblo Indians.

very circumspect in cutting even willow wands for the wigwam frame, and carefully consult the local forester before digging up the wattap roots of spruce.

Yet each year, more of us feel the urge for a return to the primitive. This means that we must learn to adopt substitutes. What are they?

I hate to write it down. But it is a fact that the natural heir to the birch bark is tar paper—cheap, abundant, portable, rainproof, weatherproof, bugproof, everything but fireproof. We may as well accept and use it. Sheets of tar paper, applied where needed, are as useful as birch bark,—but, oh! so ugly!

We can, however, hide this ugliness with paint, splashed green, olive and yellow, or under a thatch of grass or corn stalks.

If some manufacturer would give us a tar paper that was yellow, or brown, or green, or mottled with all these colors, he could count on securing all the summer camps of the country as his customers.

In place of wattap, the thin strong roots of the spruce (or of the yucca fiber that, in the dry Southwest, replaces wattap, or rawhide thongs that are cordage in the Northwest), we, if wise—but unauthentic— (now get ready for a shock)—we everywhere use haywire. It is strong, abundant, found at every farmhouse, defies weather and rats; every piece of it has been tested by actual trial before it came to the ranch, it is thoroughly satisfactory. We may as well accept it.

Another solution of the binding question is found in an inch augur, which, bored through two timbers, gives one a chance to drive a stout oak pin through and so make a strong and primitive joining.

In place of hand-hewn timbers, what have we? The foresters would forbid our wholesale cutting of such trees; the labor of felling and shaping would be tremendous. They are no longer on the list of possibilities. But we have a good substitute in the slabs which are a by-product of every sawmill, and available in most camping parts of the country. Slabs will take the place of logs for a log house, walls for a hogan, roof shakes for a cabin; and are very inexpensive.

When the slabs are used for a roof, we usually lay them side by side, up and down the slope of the roof, *round side up*. Then, after they have been gone over with a hatchet to remove all sharp points, cover them with heavy tar paper, pressed down and tacked into the trough between each two. This gets rid of the horrible machine-flatness of boards, and makes a picturesque roof that can be splashed with color till it has all the charm of a wildwood creation.

Thatching, other than birch bark, was usually made of sawgrass, palmetto, or reeds. When none of these is at hand, one can make a good thatch of corn stalks, sedge, or bundles of fine brushwood, bound on the rafters and cross poles of the roof.

In the northwest of Canada, I have seen a good roof made as follows: first, a roof of closely laid poles or rods across rafters and securely tied on;

on this, beginning at the bottom, a layer of marsh grass, then, covering the upper half of this, an inch of well-worked mud; then, covering the mud, another layer of grass, the upper or basal half of which is as before embedded in mud. And so on to the top, where are two flattened poles for a ridge finish, one on each side, but held together by angle braces of wood pegged to each. These angle braces are selected of natural forks, tooled and flattened to fit, and finally bound with roots, thongs, or wire to the rafters. Nothing but the grass and roof poles are visible.[3]

Bibliography

1. BOAS, FRANZ. *The Central Eskimo.* (6th Annual Report, Bureau of American Ethnology.) Washington, D.C.: Government Printing Office, 1888.

2. BUTTREE, JULIA M. (MRS. ERNEST THOMPSON SETON). *Rhythm of the Redman.* New York: The Ronald Press Company, 1930.

3. DENSMORE, FRANCES. *Chippewa Customs.* (Bulletin 86, Bureau of American Ethnology.) Washington, D.C.: Government Printing Office, 1929.

4. HODGE, FREDERICK W. *Handbook of American Indians North of Mexico.* Washington, D.C.: Government Printing Office. Part I, 1907; Part II, 1910.

5. HOFFMAN, WALTER JAMES. *The Menomini Indians.* (14th Annual Report, Bureau of American Ethnology.) Washington, D.C.: Government Printing Office, 1896.

6. MACCAULEY, CLAY. *The Seminole Indians of Florida.* (5th Annual Report, Bureau of American Ethnology.) Washington, D.C.: Government Printing Office, 1887.

7. McGEE, W. J. *The Seri Indians.* (Part I, 17th Annual Report, Bureau of American Ethnology.) Washington, D.C.: Government Printing Office, 1898.

8. MASON, BERNARD S. *Camping and Education.* New York: McCall Co., 1930.

9. MINDELEFF, COSMOS. *Navajo Houses.* (Part II, 17th Annual Report, Bureau of American Ethnology.) Washington, D.C.: Government Printing Office, 1898.

10. MINDELEFF, VICTOR. *A Study of Pueblo Architecture.* (8th Annual Report, Bureau of American Ethnology.) Washington, D.C.: Government Printing Office, 1891.

11. MURDOCH, JOHN. *Ethnological Results of the Point Barrow Expedition.* (9th Annual Report, Bureau of American Ethnology.) Washington, D.C.: Government Printing Office, 1892.

12. NELSON, EDWARD WILLIAM. *The Eskimo About Bering Strait.* (Part I, 18th Annual Report, Bureau of American Ethnology.) Washington, D.C.: Government Printing Office, 1899.

13. NIBLACK, ALBERT P. *Coast Indians of Southern Alaska and Northern British Columbia.* Washington, D.C.: U.S. National Museum, 1888.

14. RADIN, PAUL. *The Winnebago Tribe.* (37th Annual Report, Bureau of American Ethnology.) Washington, D.C.: Government Printing Office, 1923.

15. TURNER, LUCIEN M. *Ethnology of the Ungava District.* (11th Annual Report, Bureau of American Ethnology.) Washington, D.C.: Government Printing Office, 1894.

16. WINSHIP, GEORGE PARKER. *The Coronado Expedition, 1540–1542.* (Part I, 14th Annual Report, Bureau of American Ethnology.) Washington, D.C.: Government Printing Office, 1896.

[3] Unpublished manuscript.

Suggested Reading

DELLENBAUGH, FREDERICK S. *North Americans of Yesterday.* New York: G. P. Putnam's Sons, Inc., 1902.

DORSEY, J. OWEN. *Omaha Dwellings, Furniture and Implements.* (13th Annual Report, Bureau of American Ethnology.) Washington, D.C.: Government Printing Office, 1896.

FLETCHER, ALICE C., and LA FLESCHE, FRANCIS. *The Omaha Tribe.* (27th Annual Report, Bureau of American Ethnology.) Washington, D.C.: Government Printing Office, 1911.

TEIT, JAMES A. *The Salishan Tribes of the Western Plateaus.* (45th Annual Report, Bureau of American Ethnology.) Washington, D.C.: Government Printing Office, 1930.

3

Clothing

Just as the habitations of a people depend on the environment, so the clothing is in direct relation to such elements as climate and wild life.

Modesty, from the viewpoint of the Whiteman, has nothing whatever to do with the matter; it is wholly a case of comfort. So we find the Northern tribes clothed in heavy garments, made with a skill born of long experimentation, while the tribes which inhabit the warmer regions went about in a state of nature or nearly so; that is, until the missionaries discouraged the exposure of any part of the body, thereby introducing uncleanliness and disease hitherto unknown among the "naked savages."

We find the Eskimos wearing garments of fur, cleverly tailored with sleeves to the shirts, and legs to the trousers. The skins are cut according to pattern and ingeniously fitted to the body. As we travel southward, the Canadian Indians show less skill in the tailoring of clothing; and when we reach the United States, there is practically no tailoring at all.

Materials

Climate determined very largely the material used for clothing; ceremonial costumes were naturally more elaborate than ordinary dress, but in both cases, where available and practical, tanned hides were used for clothing. Buffalo hide was used for outer robes, as well as for leggings and other small gear. Buffalo

hide, however, was too harsh for general use. Elk and moose hide also were seldom used, since, though soft, they were very thick and difficult to drape. Tanned buckskin was the preferred material.

In some parts of the country, hides were out of the question, so the Indians used fabrics of bark, grasses, feathers, hair, fur, and wool of the mountain sheep.

Weaving in the modern sense was practiced only in the Southwest. Here cotton was used by the Hopi in prehistoric times; and, when wool was later introduced, the process of manufacture with the raw material was a natural development. But even with textile cloth there was very little tailoring.

Sinews of animal tendons and fibers of plants were the usual sewing materials. These were threaded into the fabrics with bone awls. Sewing was practiced by both sexes, each sex usually making its own clothing.

The form of the clothing naturally depended on weather conditions, but, in the early days, it was everywhere very simple if not sparse. The advent of the Whiteman with his trade goods modified the dress of the Indian in both material and form. These variations from the original garments will be taken up in due course.

The footgear of the Indian, since it was a bit more homogeneous throughout the country, is perhaps better known than other parts of his costume. The differences in cut, decoration, etc. are indicative of tribal environmental characters. The Plains and Woodland Indians wore moccasins, but the people along the Pacific Coast went barefoot most of the time. The Southwest Indians wore sandals in the early days, though moccasins are now the rule. The material used in making moccasins was dependent upon the kind of animal in the locality, the character of the trails, and tribal usage.

Except in the Southwest, ornamentation of the moccasin, first with porcupine quillwork and later with beading, was common.

Hats, usually of basketry, were worn by many Pacific Coast tribes. Other forms of headdress varied from the magnificent bonnet of the Plains Indians to the simple, brilliantly colored silk *banda* universal among the Pueblos and their kin.

Mittens were worn in the North where their use was required

for comfort. Belts were worn to encircle the waistline, and also, in most tribes, to carry bags and pouches. Necklaces, earrings, and bracelets were common.

These lesser features of costume will be taken up in detail in the chapters devoted to the dress of the various groups of Indians.

Eskimos

On the upper body, the men wear a frocklike garment of fur, put on over the head and usually provided with a hood reaching to about the middle of the crown of the head. The shape of the hood varies from very pointed to slightly rounded, fits close to the head, and is often edged with wolverine or other long-haired fur, making a vertical halo which is very becoming. The shirt or coat reaches to about mid-thigh. The front lower edge is cut sometimes straight, sometimes with a broad scallop hanging down. The back lower edge in some sections of the country is cut straight; in others it has a narrow tail which hangs down to about the knees. It is often confined by a girdle at the waist.

Beneath the garment, the man wears one or two pairs of tight-fitting knee-breeches. The legs are usually secured below each knee by a drawstring which ties over the tops of the boots. In some locales the trousers reach to the ankles. On the legs are worn a pair of long deerskin stockings with the hair inside. Below these are slippers of tanned sealskin, and outside are a pair of close-fitting boots held in place by a string around the ankle and usually reaching above the knee where they are covered by the breeches.

The men and boys wear their hair combed down straight over the forehead and cut off square across in front but hanging in rather long locks on the sides so as to cover the ears. There is always a small circular tonsure on the crown of the head, and a strip is generally clipped down to the nape of the neck. The men and boys usually wear across the forehead a string of large blue glass beads, sometimes sewed on a strip of deerskin.

The upper part of the woman's dress is similar to that of the man's, except that the lower edge is never cut straight across. In some areas, there is a narrow tail down the front to knee length and down the back long enough to trail on the ground. In other sections, this is modified into a simply rounded edge both front

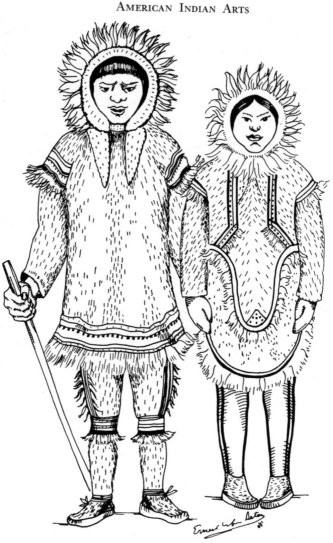

Figure 12. Eskimo man and woman.

and back, reaching to about the knees. The hood of the woman's frock is always bulged into a pocket at the nape of the neck to receive the head of the infant which is often carried in the dropped hood.

On her feet and legs, the woman wears a pair of tight-fitting pantaloons with soles of sealskin but no ankle strings. These pantaloons are fastened with a girdle above the hips.

Both men and women wear gloves or mittens, though the women have a curious fashion of wearing only one mitten and keeping the other arm inside the jacket, withdrawn from the sleeve.

The women bring the hair up from behind into a sort of high topknot, with the addition in some districts of large bows or pigtails on the sides. The hair is parted in the middle from the forehead to the nape of the neck and gathered into a club on each side behind the ear. The club is either simply braided or, without further dressing, twisted and lengthened out with strips of leather, and wound spirally for its full length with a long string of small beads of various colors. A large flat brass button is stuck into the hair above each club. The faces of both men and women are tattooed.

MAKING THE ESKIMO COSTUME

Man's Frock. The body is cut in two pieces, front and back. The hood is continuous with the back in the original Eskimo frock, but it may be added separately for convenience in making. Each sleeve is made in two pieces, front and back, of the same shape. These are sewed together along the upper edge but separated below by a triangular gusset from the armpit nearly to a point at the wrist.

Knee Breeches. There are two pieces in each leg, the inside (*A*) and the outside (*B*). The space between the edges of the two legs is filled by the gusset (*C*). Join the corresponding edges as indicated in Figure 13—*a* to *a*, *b* to *b*, etc.

Boots. Leg and upper are in four pieces, one back (*1*), two sides (*2*), and one front (*3*). Cut the sole as noted in the directions given below for making the pantaloons, and crimp as in that pattern. Join the long seams of the legs, and attach the sole.

Woman's Frock. The woman's frock is cut as is the man's, but is made longer and rounded in front and back. The hood is more easily cut separately and then attached rather than cut in one piece with the frock.

Pantaloons. Each leg is composed of five pieces—front (*1*), outside (*2*), back (*3*), inside (*4*), half waistband (*7*), and gusset (*8*).

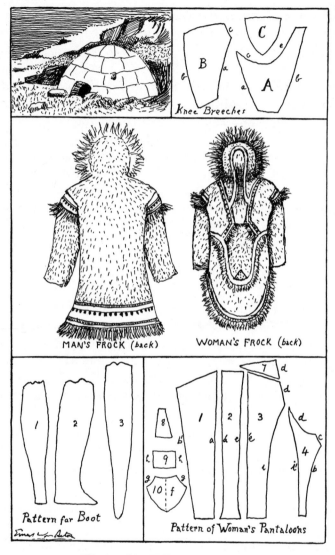

Figure 13. Eskimo garments.

Join the edges *d d d* of the opposite legs, and sew the gusset (*8*) into the space in front with its base joined to the edges *c c* of the two legs. Join *a* to *a'*, then *e* to *e'*, then *i* to *i'*, then *b* to *b'*. Attach the waistband (*7*) to the legs, starting at the middle of the back with the middle of the waistband.

For the sole of each shoe, place the foot on the material, and

outline it. Then cut it about 1½ inches larger all around. Bend it up about 1¼ inches. The toe and heel are gathered into shape by crimping the edge vertically. A space of about 3½ inches is left uncrimped on each side of the foot. Around the top of this sole is attached a narrow band of white sealskin sewn over and over on the edge of the uncrimped space but run through the gathers at the ends so as to draw them up.

The upper is in two pieces—heel (9) and toe (10). The heel piece is folded around the heel of the sole and the toe piece doubled along the line (f). The curved edges g g are joined to the straight edges h h to make the fold fit the outline of the instep. The bottom is then cut off accurately to fit the sole and sewed to the edge of the band. Then the trousers and shoes are sewed together at the ankles.

Chipewyans

In winter, these Indians use skins of deer; in summer, the dress is the same except that they remove the hair from the skins. The pattern of the costume is as simple as could be imagined.

The shoes and leggings are sewed together. The leggings reach up to the waist and are supported by a belt. Under the belt, fore and aft, are drawn the ends of a small piece of leather, passing between the legs and hanging down before and behind. In their shoes, they put the hair of moose or reindeer with additional pieces of leather as socks.

The shirt or coat, when belted around the waist, reaches to the middle of the thigh. Mittens are sewed to the sleeves or are suspended from the shoulders by strings. A ruff is worn round the neck, and a curious cap is made of the skin of the head of a deer. Over the entire costume is worn a robe made of several deer skins sewed together.

The women wear shorter leggings tied below the knee. The coat is wide, hanging down to the ankle and tucked up when desired with a belt which is fastened around the waist.

Makahs

The Makah Indians inhabit all that portion of the extreme northwest part of the State of Washington lying between Flattery

Rocks on the Pacific Coast and the Hoko River near the Strait of Fuca.

The usual dress of the men consisted of a shirt and blanket, but some, especially the old men, were content with a blanket only. During rainy weather, they wore a conical hat woven so tightly of spruce roots as to be waterproof and a bearskin thrown over the shoulders. The men wore their hair long, except on whaling expeditions, when they tied it up in a club knot behind the head. They frequently decorated themselves by winding wreaths of evergreen around the knot or sticking in a sprig of spruce with a feather. At times, they varied the headdress by substituting a wreath of seaweed or a bunch of cedar bark bound around the head like a turban.

The women now wear a shirt or long chemise, reaching from the neck to the feet and some have, in addition, a skirt of calico like a petticoat tied around the waist. Formerly, they wore merely a blanket and a cincture of fringed bark reaching from the waist to the knees, and their hair was either clubbed behind or tied up in a bunch on the crown of the head.

The Makah belle is considered in full dress with a clean chemise, a calico or woolen skirt, a plaid shawl of bright colors thrown over her shoulders, six or seven pounds of glass beads of various colors and sizes on strings about her neck, several yards of beads wound round her ankles, a dozen or more bracelets of brass wire around each wrist, a piece of shell pendent from her nose, and ear ornaments 3 or 4 inches wide and 2 feet long, composed of shells of dentalium, beads, and strips of leather braided together. Her face and the parting of the hair are painted with grease and vermilion. The effect of this combination of colors and materials is quite picturesque.

Chilkats

The Chilkats are a group of Tlingit Indians. They are to be found from Puget Sound in Washington State to Mount St. Elias in southern Alaska. They are usually known as the Coast Indians.

The primitive clothing of these Indians was simple, consisting of an undercoat, a cloak, and sometimes a breechclout. These clothes were made of valuable furs, roughly sewn together. For ceremonial occasions they wore a blanket woven of shredded

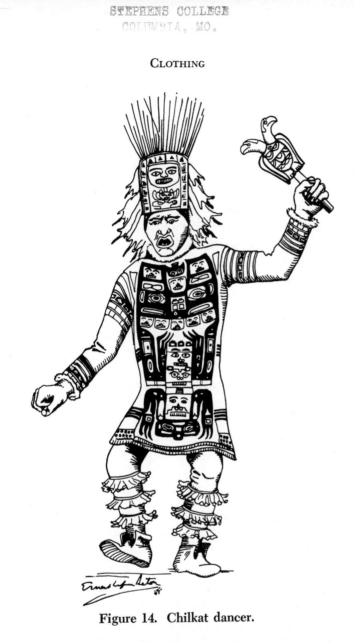

Figure 14. Chilkat dancer.

cedar bark and yarn spun from the wool of the mountain goat.
The blanket is the most marvelous product of the weaver's art.
The Chilkat's blanket was oblong in shape and heavily fringed on
three sides. It was always in a pattern representing totemic ideas
and was done in colors, usually black, blue-green, yellow, white,
and brown. A ceremonial coat or gown was similarly woven.

With the blanket and gown, a conventional headdress was

worn by the chiefs. This consisted of a cylindrical wooden frame about 10 inches high with an elaborately carved front of hard wood, beautifully polished, painted, and inlaid with abalone shell and copper. Hanging behind was a long cloth on which were closely sewn the skins of ermine. Around the upper edge of the headdress was an elaborate fringe of seal whiskers. In ceremonial dances, the space within this fringe and the top of the headdress was filled with the down of eagles and other birds which, in the motions of the dance, fell like snow on a winter's day, adding much to the picturesqueness of the scene.

This costume was completed by leggings of deerhide ornamented with the beaks of puffins, which rattled with the movements of the wearer.

Grass hats are still seen in out-of-the-way places. These are cone-shaped with considerable spread and are particularly adapted for protecting, in rainy weather, the elaborately dressed hair worn on ceremonial occasions.

The women wear an undergarment of fine tanned leather, covering the body from neck to ankle and tied about the waist. The upper garment is much like the man's coat but of tanned skin instead of fur. About the waist is tied a piece of leather like an apron.

Woodland Indians

The Woodlands comprise such a large area of the United States that the aboriginal inhabitants cannot be treated all together. There are several distinct types, each with its own costume. We will take them in groups related as nearly as possible.

MANHATTANS AND THEIR NEIGHBORS

It is difficult to obtain authentic information on the exact costume of these Indians. No remnants of their original dress have survived, and our Colonial ancestors have left very meager accounts of their observations.

As near as we can tell, the Manhattans and their neighbors wore no shirts or coats. Instead, they covered the upper part of the body with robes made of dressed deerskin, wolf, wildcat, or bear fur, or the shimmering feathers of the wild turkey, neatly

attached to a netted fabric. So closely and carefully were these feathers applied that they are said to have shed the rain.

The men also wore loin cloths of dressed leather and leggings and moccasins of the same material. In addition to this costume, the warriors wore necklaces of dyed deer hair, of native copper or shell beads, or of wampum; and they often hung over their chests pendants of stone or gorgets, such as are still to be found occasionally upon the sites of their old camps. They also painted their faces with various pigments, especially red and black, which they obtained from limonite and graphite fragments.

The men shaved their heads, or rather burned off their hair with hot stones. They often left a standing roach of stiff black hair 2 or 3 inches high and as broad, running from the forehead to the nape of the neck; the lock which hung from the crown was usually allowed to grow much longer. This was the famous scalplock, which the warrior cultivated in defiance of the enemy, who might take it if he could. Sometimes, they wore a roach of red dyed deer hair, exactly similar to those worn by the Sauk, Fox, Menomini, and other tribes of the Central West. These Indians did not wear the feathered headdress which was so characteristic of the Sioux and other tribes of the Great Plains and which is now always placed upon the Indians in the conventional picturing of the sale of Manhattan Island.

Old paintings of the Delawares show us that they wore their knives and even their tobacco pouches suspended from their necks. The reason for wearing their knives in this position, old Indians of the Central Western tribes declare, was so they could be more readily seized at a moment's notice.

Besides his deerskin tobacco pouch with its dyed hair, porcupine quill embroidery, and leather fringe, each warrior carried a club carved of wood, with a ball-shaped head set at right angles from the handle, a 6-foot bow, and a quiver containing flint-, bone-, or antler-tipped arrows.

Being a part of the Delaware tribe, these Indians probably followed the ancient custom of tattooing their bodies with designs representing their dreams and warlike exploits.

The women, like the men, were naked to the waist, save for the robe, which was shifted from side to side, according to whence the coldest wind came. They wore knee leggings instead of the

hip-length style of the warriors, and they wrapped about their waists a single square piece of leather, sometimes fringed, which was open at one side. Occasionally, these skirts were made, not of leather, but of cloth woven of Indian hemp, such as was also used to make bags. Like the men, the women protected their feet with soft-soled moccasins.

The women covered their gala costume with wampum beads and quill or hair embroidery, so that some of the old chronicles declare that a dress of this sort was often worth "above 300 guilders."

They often wore their hair in a braid, over which they drew a square cap ornamented with wampum. Presumably, this hair-dress was similar to that used by the Winnebago and Sauk and Fox women of the Middle West.

Algonquins of the Atlantic Coast

The clothing of the men was of softly dressed skins, limited to a breechclout, leggings, moccasins, and sometimes a mantle of skin or feathers thrown over one shoulder. The skin was ornamented, usually with embroidery or wampum. These Indians went bareheaded, with their hair trimmed each according to his fancy. One might shave it on one side and leave it long on the other; another might leave an unshaved strip 2 or 3 inches wide, running from the forehead to the nape of the neck.

In the case of the women, the upper part of the body was unclothed; the lower part was dressed in two leather skirts ornamented with fringe, fastened around the waist with a belt, and reaching nearly to the feet. In winter, they wore leggings and moccasins of soft, dressed leather, often embroidered with wampum. Their hair was arranged in a thick, heavy plait which hung down the back. They wore bands of wampum around the forehead, or sometimes a small cap.

Iroquois

In the main, the clothing was the same as for the other Eastern Woodlands tribes already described; but one distinctive article of dress among the Iroquois men was the feathered cap (Fig. 15). It may be made as follows:

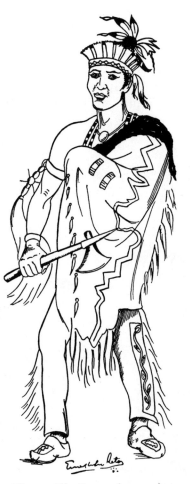

Figure 15. Iroquois warrior.

Cut a band of felt, and fit it around the head like a headband.
Cut three strips long enough to fit (not too tightly) over the head,
and attach these to the headband at equal spaces, so they cross at
the top. Cover the whole frame with velvet or skin, and put a
band of beadwork around the edge. At the top, attach a socket
made as follows: Get a piece of bone (or light wood) about 2 inches
long and ½ inch wide. Cut a wooden pin with a ball at one end.
Widen the hole in the bone at one end till it is easily possible to
push the pin into it, point first, without the ball jamming in the

opening. It must be loosely slung. Plug up the bottom of the hole so the pin cannot fall out. Prepare about twenty short soft feathers with leather loops at the base. Run a lacing through these loops, and attach to the cap in three concentric circles, starting less than halfway down from the top and finishing at the center. Finally, cut off the tip of the quill of an eagle feather and push the quill over the pin. In the wind, it will twirl about in the socket.

CHIPPEWA (OJIBWAY)

The usual costume of the Chippewa men consisted of breech-clout, moccasins, leggings, and, when necessary, a blanket. It

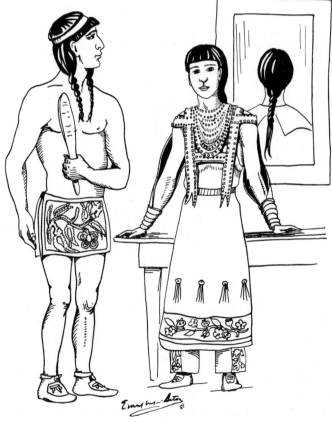

Figure 16. Chippewa couple.

was not until recent years that the shirt was introduced. The leggings were rather tight and did not lap far at the sides. They extended from the ankle almost to the hip and were held in place by a thong tied to the belt. A band was tied below the knee. These bands or garters were made of woven beadwork with a long fringe of yarn which was used for tying the band about the leg.

The old dress of the women was a skirt about mid-calf length, supported over the shoulders by straps. The edges of the skin were tied together and the bottom fringed. The arms were covered to the wrist with detached sleeves sewed as far up as the bend of the elbow, from which point they were open but caught together behind the back of the neck and held on by a throat strap across the front. The back points of the sleeves hung to the waistline.

The moccasin with a puckered seam up the front and a plain seam up the back was characteristic of the Chippewa. Within the past few decades another type has been introduced. This has a tongue-shaped piece of leather or black velvet in the front, to which the sole is gathered, and a cuff around the top. Both the tongue and cuff are decorated.

Making the Puckered Moccasin. Using the pattern in Figure 17, gather *a* and *a'* as far as the points *b* and *b'*. Attach these about ½ inch apart to a narrow strip *A'* which extends from about an inch on the upper side of the foot to about the ankle. Join *c* and *c'*, leaving the little flap *d* hanging loose on the outside. The tie strings are attached at the front of the instep and tied around the ankles into a bow at the back when the moccasin is worn. If short of material, the cuffs may be cut separately along the dotted lines.

Making the Tongued Moccasin. On the material to be used for the sole, draw the outline of your stockinged foot; then, outside of this, draw a pattern line 2 inches from it at all points except at the greatest width where it is only 1½ inches. Cut along this outer line (Fig. 17). The ankle flap has one straight edge long enough nearly to go about the ankle; it narrows to a curved edge which will fit the sole piece from one side of the tongue to the other. If this is to be decorated, it should be done

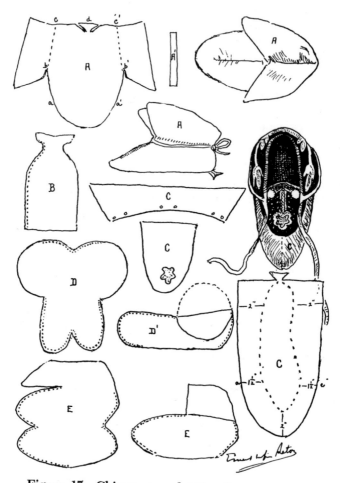

Figure 17. Chippewa and Winnebago moccasins.

before it is attached to the sole. The tongue is the shape shown
in the drawing and is decorated before being sewed to the sole.
Gather the sole from *a* around the toe to *e*. Adjust this to the
size of your own foot. Insert the tongue, running the stitching
about an inch farther than the gathers of the sole. Put the moc-
casin on your foot, and adjust the back seam to fit. When this is
sewed up, sew the little flap up against the seam. Attach the cuff
along the upper edge from the heel seam along each side to the

beginning of the gathers. Run a thong 24 inches long through the cuff or at the junction of the sole and the cuff, making sure that at the heel the stitch is outside.

WINNEBAGO

These Indians live in Wisconsin and are closely related to the Missouri, Oto, and Iowa tribes.

The men wore shirts of cloth or of deerskin reaching from neck to mid-thigh. These shirts were beaded about the collar, over the shoulders, and down the front òver the chest, where the head opening is. The buckskin shirts are usually fringed at the juncture of the sleeves and the body at the shoulders, as well as along the upper seams of the sleeves.

When made of buckskin, the leggings are often skintight and they reach the full length of the leg so as to attach to the belt. They have a broad flap fringed at the edge. If made of cloth the pattern is the same, but the flap is decorated often with ribbon bands running down the outer edge instead of fringe. A flap at the bottom falls over the moccasin. The breechclout is usually of three pieces—a strip of plain, cheap material which goes between the legs and is supported at each end by a belt, and two beaded broadcloth flaps falling over the front and back. Sometimes there is no piece between the legs but merely two ornamented flaps worn like aprons fore and aft. Beaded garters are worn outside the leggings below the knee.

The men's moccasins are cut as in Figure 17A. When folded, they have the shape shown at the right. There are two seams, one in front and one in back, marked by dotted lines. A string attached to the rear fastens the moccasins to the feet.

In former times, the men wore their hair in two long braids, although some seem to have affected the roach. The scalp along the parting of the hair was always painted, the color varying with individuals.

At the present time, earrings are fashioned either of ten-cent pieces strung together or of various ornaments of German silver. Strings of beads also are worn. Bracelets are now generally of German silver, but in former times beaded or quilled buckskin

was used. Armbands are made either of German silver or bead-work. The necklaces consist of long strings of various articles, such as wampum, seeds, and elk teeth. Ordinary belts, as well as cross belts, are now either beaded or woven, but formerly they were always woven of buffalo hair. Tight collars are now made of beadwork.

The bandoliers consist of long sashes with bags attached. Both bag and sash are always gorgeously beaded. The bandoliers are worn in any of three ways—with the bag hanging on the right side, on the left side, or in front. Often two or three bandoliers are worn at the same time.

The typical headdress was a roach or comb-like ornament woven from deer's hair and was generally dyed red. A carved bone somewhat like an elongated isosceles triangle spread out this roach and was attached near the front to another tubular bone in which was inserted an eagle feather. Often this feather was ornamented with dyed horsehair and snake rattles. The whole was fastened on the crown of the head slightly back of the forehead. It was usually pinned to the hair, the scalplock serving to hold it on.

The woman's shirt was very much like that of the man, except that it was longer. In modern times, a short beribboned shirt waist is worn outside the skirt. The leggings consist of a straight piece of buckskin folded around itself so as to leave no free flap such as is on the man's legging. The upper part has a cuff, but there is no flap at the bottom as in the case of the man's.

These are cut much as are the man's but they have a large flap around the ankle. This may be wrapped about the ankle or turned down for warmer weather.

The skirt was a simple piece of broadcloth, the ends of which were handsomely ribbon-worked in appliqué on the outer edge. The garment was wrapped around the body, the ends meeting in front, bringing the ribbon-worked horizontal bands together. The upper part of the garment was folded outward over the woven belt which confined it. A shawl or blanket of broadcloth, hand-somely ribboned, is worn about the shoulders.

In the old days, the hair was probably worn in one braid, which on festive occasions was enclosed in a case. This consisted of two parts—a rectangular piece of beaded broadcloth and long strips of beaded work.

Sioux and Blackfeet

In the Plains areas in the early days, the whole costume of the men consisted of breechclout, moccasins, and sometimes a robe. This was the dress of many groups of Indians in their truly primitive state, but it has, of course, no value for the purposes of pageantry. We will, therefore, give the costume of the Plains Indian, well represented by the Sioux and Blackfeet, in the stage between primitivism and modern degeneracy.

The man's shirt was usually made of two deerskins and reached from the neck to mid-thigh. It had sleeves, full length or as far as the deerskin reached, fringed at the end. The decorations varied in detail according to the use of the shirt, but there were always strips of quill or beadwork over each shoulder reaching down the breast and back, and there was usually another strip down the upper side of each sleeve. The shirt was occasionally decorated with a fringe of human hair, the locks being generally contributed by female relatives.

The leggings were of deerskin and reached from the ankle to the hip. Most were open at the top, front and back, and tied with a thong to the belt. In both shirt and leggings, instead of sewing up the seams, in the old days thongs were often tied through at intervals of 3 or 4 inches. The flaps of the leggings were sometimes fringed and always decorated along the seam with bands of quill or beadwork.

The breechclout was a long straight piece of material, often a soft buckskin strip, a foot wide and 4 or 5 feet long, passed between the legs and hanging over the belt front and back in apron effect.

Originally, the robes were of buffalo hide with the hair left on; later, heavy flannel, often dark blue, was substituted. This was decorated with broad bands of beadwork done on leather, with solid circles of beadwork at intervals along the band. The circles were slightly larger in diameter than the width of the band. Sometimes a man painted his robe in accordance with a dream or pictured upon it a yearly record of his own deeds or the prominent events of the tribe.

The moccasins are of two main types—the one-piece or soft-soled and the two-piece or hard-soled. The one-piece moccasin

was used chiefly among the more northerly tribes of the Plains, and the two-piece was common among the Cree, Assiniboine, the Northern Shoshoni, the Omaha, the Pawnee, the Gros Ventre, and the Santee Sioux.

Many of the Plains tribes wore their hair uncut. Among the northern tribes, the men usually gathered the hair into two braids, which hung in front over the shoulders. The Crows sometimes cropped the forelock and trained it to stand erect; the Blackfeet, Assiniboine, Yankton Sioux, Hidatsa, Mandan, Arikara, and Kiowa trained a forelock to hang down over the nose. The Arapaho say that formerly the men parted their hair on each side; in the middle over the forehead, they left it standing upright. Over the temples it was cut into a zigzag edge. In front of the ears, the hair fell down, either braided or tied.

Headbands with feathers were the usual thing. Each feather was a symbol of an exploit and was marked in an individual fashion to so proclaim it. The position in the band also had significance.

Although the so-called warbonnet was used only on certain ceremonial occasions, it is so typical of the Plains Indians that most people think of it as the only Plains headdress. The bonnet was made of eagle feathers, in most tribes the golden eagle. The feathers had to be tail feathers of the young eagle, that is, less than three years old. The angle of the feathers varied in different tribes, in some being almost erect in a stiff, unflaring circle, rather than in the graceful drooping style of the Sioux. Even among these latter, however, it is likely that in the early days, the bonnets were not nearly so handsome as they became later. There were two forms of the warbonnet, the simple corona of feathers and the tailed bonnet, a gorgeous ornament developed after the advent of the horse.

Song and ceremony accompanied the making of a warbonnet by warriors of the tribe, and a war honor was recounted before each feather was placed in position. A bonnet could not be made without the consent of the warriors, and it stood as a record of tribal valor as well as a distinction granted to a man by his fellow tribesmen.

The dress of the women was like the shirt of the men but long enough to reach below the knee and sometimes to the ankle. It

was made of two whole skins, tail ends at the top, and was without true sleeves. Two whole skins were placed face to face and sewed up the sides from the bottom almost to the two flaps at the top which come to the armpit. Another piece of skin was used

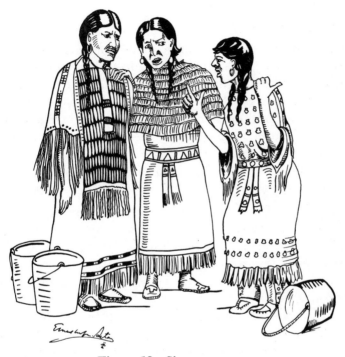

Figure 18. Sioux women.

for the extra capelike yoke, which was sewed in place and fell down loosely over the shoulders and arms. This yoke was usually solidly beaded, often in row after row of brilliant turquoise blue beads with little other pattern. The dress was the same, front and back. The side seams, bottom, and all outer edges were fringed. Other fringes or decoration were added at will. The milk teeth of the elk were the most costly of the ornaments; they were fastened in rows on the woman's dress and often gave the garment a value of several hundred dollars. A belt was sometimes worn, often with long fringes down the front. The leggings reached from the ankle to the knee. The part that fitted around the ankle was usually beaded in a broad band, and there was an-

other band of beading up the outer side. The moccasins were much like those of the men but were attached to the leggings.

Hanging from the belts were often bags, in which the women carried small articles. These bags were beautifully decorated with quill or beadwork, leather fringes, tin cylinders, etc.

MAKING THE COSTUME

The best substitute we have found for buckskin is cotton duvetyn, or suede cloth, which comes in a variety of colors. Any shade from white to light brown will imitate the natural deerhide very well; and even the authentic old hides were often dyed. Outing flannel will do as next best choice, but it does not have the body of duvetyn. Neither of these materials, however, will fringe well. It is better to add the fringes separately. Fringes can be made of chamois skins, which may be bought very inexpensively.

Shirt. The front and back of the shirt may be made alike. There may or may not be shoulder seams, although it fits better if the shoulders are sloped, thus forcing a seam. A short opening at the front of the neck is all that is necessary. The sleeves, long or short, should be sewed to the body before the underarm seams of the shirt are joined. By joining the corresponding letters as indicated in the pattern (Fig. 19), there will be no difficulty. The sleeve (2) need not be sewed up except from *F* to *G*. The flap (3) should be cut twice and attached, one in front and one in back, to the neck, then fringed all the way up or fringed at the bottom and decorated with bead or quillwork above. The seams may be joined with thongs instead of sewing if preferred. If desired, the decoration may be painted on strips of muslin with oil colors or crayons, but the craft of beading is so intriguing that it is well worth the little extra expense if it can be borne.

The fringes are made of scraps of skin, cut up to within ½ inch of the top. This uncut edge is sewed to the garment and covered by the beaded strips. The thinner the fringe is cut, the better it will hang.

Leggings. These (Fig. 19) should be made of the same material as the shirt, though felt makes a good substitute. *AH* is the length from the waistline in front to the ankle, *AI* from the waist-

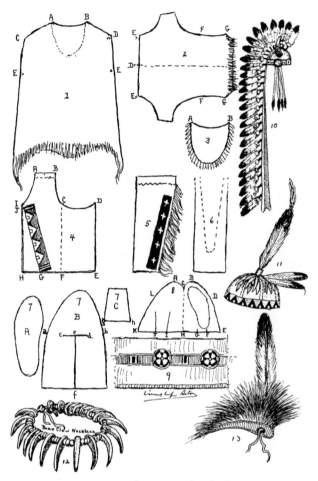

Figure 19. Plains men's clothing.

line in front to the crotch, *BD* from the waistline low around the back and long enough for *D* to meet *I* when folded at *CF*. The width from *H* to *E* must be enough to go around the leg and leave a flap on either side. When the material has been folded at *CF*, sew the two sides together from *J* to *G*. This seam is covered with a decorated strip, and the triangle *JHG* may be fringed. Thongs are added at the top to attach the legging to the belt, or a hem is made at *AB* through which a belt may be drawn. A simpler form of legging is shown in Figure 19.

Breechclout. This is simply a long piece of material, about 12 inches in width and about 2 yards long. The two ends which hang front and back are decorated.

Moccasin. The two-piece moccasin (Fig. 19) is the type which always has a thick, hard sole, often of rawhide. On a piece of rawhide or other thick leather, place your foot with the full weight on it. Draw a line around your foot; cut out ¼ inch larger all around, and reverse for your other foot.

Next, of softer leather, or of felt, cut the upper, *B*. It should be an inch longer than *A*. The width *ab* should be the measured length across your own foot at the widest point. The slit *ef* should be the length of *A* less the distance from the toe of your foot to the point where the tongue of an ordinary shoe is attached. The slit *cd* is about 2 inches.

The tongue, *C,* should be 3 inches wide at *gh,* so that it will underlap the slit *cd* at either side. The tongue is cut long enough to reach to about 2 inches above the ankle.

Decorate the upper *B* before sewing the parts together. Next insert the tongue. Now, starting at the toe and working each way from that point, join the sole and upper. Close the heel seam last of all, doing any adjustment at that point to make the moccasin fit. When all the sewing is finished, lace a thong through the upper, starting about 2 inches up from the sole at the back, and making sure that the thong passes over, not under, the material at this point.

To make the one-piece moccasin (Fig. 19), draw on a piece of paper the exact outline of your foot. Cut this out, allowing ½ inch all around. Place this outline on your material so that there will be about ½ inch from the toe of your paper to the point *B*. Round this point to *C*, making it about 1½ inches from *B* to *C*. Mark a point *D* about ½ inch from the outline of the foot, and a point *E* about 3 inches from the center of the heel and about ½ inch below it. Draw the curve *CBDE*. Draw a straight line *EH* about 6 inches long. *CH* is your center line. Cut out what you have so far drawn, but do not cut from *C* to *H*. *CBDEH* is the sole of your moccasin. Reverse it to make the sole for your other foot.

Fold your material on the line *CH,* and cut out the other half, *CALKH,* which is the upper. Cut the tongue slits *J* and *I* about

6 inches long and radiating from 1½ inches apart at the back to 2 inches at the front. Cut the flap slits *G* and *F* about ½ inch deep and 1½ inches apart. This leaves *FE, IH, HG,* and *KJ* the same length. Fold your material along *CH* and sew *CBDE* to *CALK.* Next attach *E* to *K.* Then sew this *EFKJ* to *GHI,* forming the vertical heel seam. Turn up the flap *GF,* and sew flat on the outside of the heel seam.

Cut another piece 2 inches wide and long enough to go round the top of the moccasin from one side of the tongue to the other. Attach to the upper. Run a thong through this extra piece to tie the moccasin on with.

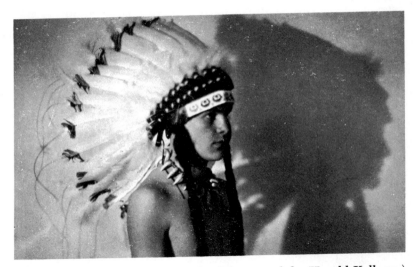

Figure 20. Indian lore made real. (Photograph by Harold Kellogg.)

Warbonnet.[1] Here are directions for the double trailer.

An old felt hat, without brim, fitted to the individual head like a skull cap, is the best foundation. At the back of this, attach a strip of red flannel wide enough almost to reach from ear to ear and long enough just to clear the ground. This red flannel should be bound around the three sides (the fourth is sewed to the cap) with a half-inch fold of yellow cloth.

[1] Full instructions for the making of the single corona bonnet are given in my *Rhythm of the Redman.*

Eagle feathers are, of course, to be preferred. They are, first of all, the authentic thing, and, more important, they are larger than any other kind and make the handsomest bonnet. But they are expensive and scarce, so that we suggest swan feathers as the best substitute. Turkey feathers may be used, but their square ends produce a different effect. They are the cheapest, however, so they have their claim.

Whatever kind of bird they come from, try for tail feathers. These have no curve and stand up best. But if wing feathers must be used, be sure to get half rights and half lefts, and try to get them all from the same bird, as they fit together best. Otherwise, the curve varies, and there is a loss of symmetry.

Enough feathers will be needed to be placed about ¾ inch apart across the front of the foundation to just behind the ears, then about an inch apart down either side of the red flannel to within a foot of the bottom. My own bonnet, an authentic one said to be the most beautiful example in existence, contains eighty-four eagle tail feathers. No fewer than this would do, and if feathers inferior to those of the eagle are used, more are needed.

Near the bottom of each feather, about 2 inches from the end, lash a quantity of down, preferably eagle down. This may be had in natural color or dyed any brilliant shade you wish. Down is now sold commercially in white, black, gray, mottled, royal blue, rose, brilliant red, orange, yellow, light green, dark green, purple, etc. To my way of thinking, nothing is so effective for this lower fluff as white, but it should be put on generously.

If eagle feathers are used, the next operation consists in cutting away perpendicularly half the quill of each feather for about 1½ inches from the bottom. Then, after soaking, bend up the remaining half, thrusting the point into the barrel, thus giving a strong loop. Other feathers are not so strong and have less quill, so that a better method is as follows:

Cut for each feather a thin leather strip about ¼ inch wide and 4 inches long. Wax the quill to prevent slipping; then with a waxed thread lash the two ends of the leather strip to the quill, so that a loop ¼ inch long is left below the quill. Be sure that the leather strip is in the exact plane of the feather, or the feather will not fall well in the finished bonnet. Stitch a piece of red flannel over this lashing, from the top of the loop to the down. Wrap

this flannel cover with white cord, top and bottom, keeping the spacing the same on all feathers.

Next, near the top end of each feather glue a tuft of down. This may well be a shorter tuft than was used at the lower end, since the longer tufts add too much weight to be easily carried by the feathers. These tip tufts may be the same color as the base or in contrast. In any case, at the spot where the tip is attached to the feather, there should be a small circle of white. Marabou is very good for this, but a spot of white paper may be used to save expense. The best material I have found for the gluing of these tufts is chewing gum.

If desired, about a dozen red or yellow horsehairs may also be glued in under the marabou. The yellow is especially good, looking like a flash of light out of each feather with the motions of the wearer.

Lay the feathers away to set while you make the headband. This should be quill or beadwork, but, if used only for stage purposes at a distance from the audience, the design may be painted. The band should be long enough to reach across the front of the felt foundation from ear to ear. Over either end of the band is a beaded concho or target—a circle an inch wider than the band. Directions and patterns for both these forms of beading are given elsewhere in this book (p. 143).

Under these conchos are attached the ear pendants. These were usually whole ermine skins. A good substitute is white rabbit fur tipped with a tuft of black cat or even dipped into black India ink or dye.

On the felt foundation ¼ inch above the beaded browband, cut a series of slits ¼ inch long, perpendicular to the band, and ½ inch apart. Continue this line of slits down the long red flannel strip, making sure that the line is not broken just over the ears where the felt foundation melts into the flannel. The slits do not follow the felt beyond the ear line, because, in this double trailer, the corona is not complete across the back. On the flannel strip, the line of slits draws gradually nearer the middle as it gets lower, until, about a foot from the bottom, the line curves back again up the other side. This allows space for the lowest feathers to drop to the floor level.

If you are using wing feathers, lay them out on the floor or a

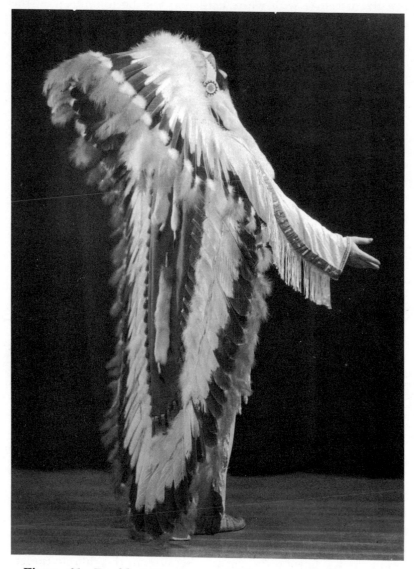

Figure 21. Double-trailer bonnet. (Photograph by Jane Hard-castle.)

long table, matching them until they are smoothly fitted each to the next. Cut a leather lace long enough to reach around all of the slits. Begin at the center front. Run the lace up to its middle point through a slit in the felt, then through the loop of the

feather you have selected for the front or central one, then down through the next hole, and up through the next. Continue until you have used up half the feathers, when you should be down to the bottom of the red flannel. Then start at the middle front again, and continue to the end.

A spacing string to hold the feathers in place is the most important thing. This is run through each feather a little less than halfway up from the quill and is not tied until the form of the bonnet is perfect. The tying can be done only by a second person while the owner has it on his head. Finally, cover the felt foundation with down, and you have a copy, good or bad according to your perseverance, of the most gorgeously beautiful primitive headdress ever devised.

Horned Bonnet. Another headdress worn by the Plains tribes was the buffalo-horn bonnet. It does not take quite so many feathers, and is more easily made (Fig. 19).

The cap and the trailer band are as in the eagle feather warbonnet but without the slits around the edge. Instead, a single line of slits is made from the front to the back along the median line and extending from about 1 inch above the front center down the middle of the trailer. The feathers are prepared as in the other bonnet, except that the base down and the tip tufts are attached on both sides of the feather. About twelve feathers are needed for the cap part, and the number of the others is determined by the height of the wearer.

In place of buffalo horns, cow horns may be used, or horns may be carved out of soft wood. A row of small holes is bored around the base of each horn. With strong waxed thread, sew these to either side of the cap about an inch above the ears, using the bored holes to ease the operation. Now, lace the feathers through the slits, as in the warbonnet. Another lacing is made about 3 inches higher on each feather to facilitate the adjusting of the form.

Next, a string from the tip of one horn attached to the upper lacing string of the topmost feather, then on to the tip of the other horn, will hold the top feathers upright. Finally, cover the foundation cap with short down.

Woman's Dress. The woman's dress is cut much like the man's shirt, but long enough to reach anywhere from below the

knee to the ankle. One form is illustrated in Figure 22. For this dress, the capelike yoke *D* is made separately, then sewed in place.

Another, a simpler dress, is cut all in one piece with a hole large enough to slip the head through. It has not quite so good a shape on the shoulders when there is no seam (Fig. 22).

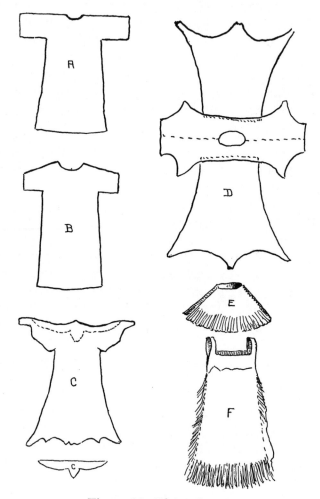

Figure 22. Plains dresses.

It might be cut in two pieces (Fig. 22*A* and *B*), with seams on the shoulders, or a skirt may be sewed to a cloth top, then a separate long round cape made to slip over the head (Fig. 22*E* and

F). The cape should be made in two halves with seams almost to the waistline front and back. The shoulder seams and the round neck should be decorated with beaded bands. In any case, the dress is belted with long ends hanging in front; the bottom is fringed, and the sides may be fringed or not.

Leggings. These are cut long enough to reach from ankle to just under the knee and loose enough to wrap easily around the calf with a little overlap. The decorations are in a broad band around the bottom at the ankle and a narrower band up the side. Attach tie strings along one edge and about an inch from the edge on the opposite side.

Pouches. Medicine bags are a useful accessory and easily made. They should be about 2 feet long and 8 or 10 inches wide when finished. They may be made of leather or felt, with the design in beadwork, quills, or appliqué.

Knife Sheath. The sheath is made of stout leather, laced with thongs. The fringe is placed between the front and back pieces, then all three laced together. The design should, of course, be made before the lacing is done.

Ornaments. Among the Plains tribes, there were a number of ornaments for both men and women which added greatly to the decorative effect of the costume. These included breastplates for the men and necklaces for the women. Breastplates were made originally of the bones of the leg of the deer. In later days, the traders stocked a substitute called hairpipes.

When you have enough beads for the project, cut three leather strips, called dividers, each ½ inch wide and long enough to reach from the upper chest to the waistline. In each strip, punch or burn small holes about ½ inch apart down the entire length.

You need next some strong waxed thread or a long leather lacing. Make a knot 1 inch from the end of the lacing or thread. String it through the top hole of one of your dividers, then through a bead, then through the top hole of another divider, then through another bead, then through the top hole of your third divider. On the outside of this last divider, make a knot in the lacing string, and cut it off an inch from the knot. Repeat the process through all the holes of the dividers.

Attach an ornamental cord, of beads if you like, to one upper

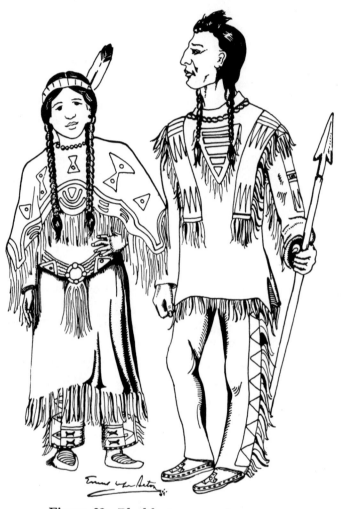

Figure 23. Blackfoot man and woman.

corner of the breastplate, then to the upper center, then to the other upper corner, making two loops which are about 2 inches long each. Then to the top of each of these loops, attach another cord long enough to easily go over the head. At the two lower corners tiestrings are fastened about the body to keep the breast-plate in place.

The women wore necklaces of deer leg bones (Fig. 18). Some-times the necklaces were long enough to reach the lower edge of

the dress, but more frequently ended at about mid-thigh. The method of making these is the same as that for the breastplate, and the pattern is clear from Figure 18.

Arm and leg bands made of small tube beads about ¼ inch square or of wooden beads which come in several sizes and many colors are good accessories. They are made with the dividers and lacing, just as is the breastplate, with five or six beads between each two dividers. These bands are very effective if finished off with a pendent thong strung with beads and tipped with a few fluffy feathers.

Plateau Indians

The Salishan tribes of the Western Plateau comprised the Coeur d'Alene, the Okanagan, and the Flathead groups. They inhabited British Columbia, Idaho, Montana, and extended a little way into Washington. Among these tribes there were several types of man's shirt, varying slightly from group to group, but usually the shirts were short, reaching to the hips or a little below. The sleeves reached to the elbow.

One type was made of a single buckskin, folded across the middle with a piece cut out for the head to pass through. It was sewed up the sides and under the arms or sometimes only at the sides. Some had stitches only here and there under the arms, and others were laced with a great many thongs along both sides and under the arms. The thongs took the place of fringes. But fringes of some kind were essential, both along the seams and the bottom. Occasionally, the fringes were made of ermine skins.

The most common ornamentation was the addition of another piece of skin which hung down in a triangle front and back from the neck. It seems to have been an imitation of a collar and was either embroidered or pinked and embroidered with red dots.

Scalp shirts, ornamented with fringes of hair, were also in common use. Sometimes the bodies of these were painted in two or three colors, arranged in fields. For instance, the upper part of the shirt, including the sleeves, might be red and the lower part yellow. Yellow, red, brown, blue, green, and black were used.

Leggings reached to the thigh and were fastened to the belt with tie strings. They were fringed along the outer seams and

frequently had bands of beadwork or quillwork bordering the fringes. Sometimes, instead of fringes, especially after cloth was substituted for skins, a double flap along the outside seams was decorated.

The breechclouts were simply a long, narrow piece passed between the legs and hung over the belt in front and behind. In the Flathead group, long aprons were worn in front, besides the breechclouts.

In cold weather, the men usually wore round, rather high caps of fur. The tail of the animal hung down behind. Headbands of various kinds were worn and headdresses of feathers for special occasions.

Long strips of skin were wrapped around or braided into the hair. Pendants of twisted fur were also attached to the hair. Ribbons of embroidered skin were often used for wrapping around the hair or binding it. In later days, silk ribbons, colored braid, and strips of red and blue cloth took the place of these.

At the present time, skin vests entirely covered with beadwork are common.

The woman's dress was simply cut of deerskins, usually with three rows of inserted fringe or thongs around the skirt below the waist. There was a yoke, often beaded or quilled in lines following its contour. Fringes edged the sides, bottom, and ends of the sleeves. The skirts usually reached to the ankles; the sleeves to the elbow. Belts were commonly worn, richly quilled or beaded. Paint pouches were frequently attached to the belt.

All women wore leather leggings. They reached to the knee and were fringed along the outer seams. Some were closed and had to be pulled up over the foot; they were fastened below the knee with garters or drawstrings. Others were open on the outside of the leg and were fastened with tiestrings. Many were beautifully beaded, especially on the lower part.

The usual head covering was a basket cap, fez-shaped and ornamented at the crown with a small fringe of loose strings, or sometimes loops, of skin, on which were strung beads and shells.

Skin caps were used by some women. They were more or less conical or pointed at the top. Some were ornamented with fringes, and many had a fringe or tassel at the crown. Beads and shells were sometimes strung on the tassel.

Hair ribbons of short pieces of skin were used, embroidered on one side with quill or beadwork. They were provided with strings for tying round the braids of hair.

California Tribes

While there are naturally many variations among the numerous tribes of California, we shall use the Hupa as the type.

The old men usually went naked. The young men folded a

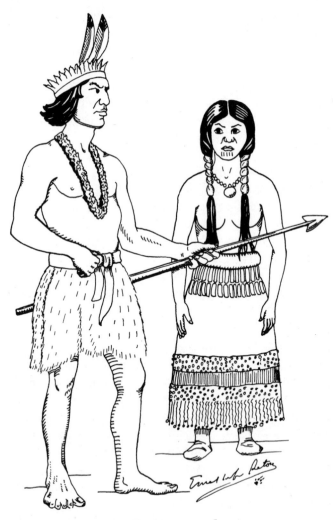

Figure 24. Hupa man and woman.

deerskin about the hips or a skirt of small animals sewed together. It encircled the waist and hung approximately to the knees. Leggings, if worn, reached from ankle to knee and were made of painted deerskin. The seam was down the front. The upper edge was fringed and turned over so the fringe hung downward.

Moccasins were worn very rarely. When going up into the mountains to hunt, this tribe wore a rude snowshoe, a hoop with a few crossties of grapevine.

They often wore a cape made of two deerskins sewed together without any fit to the body or squaring of the skins. The hair was tied into two clubs, one hanging down on each side of the head, or rarely into one club which hung down behind. In dances, bands of deerskin ornamented with woodpeckers' crests were worn about the head. Sometimes feathers were stuck in the hair.

A quiver filled with arrows was a part of full dress. This was usually made of handsome skin. A skin pouch or sack of netting was worn as a pocket for small articles.

The woman's skirt was made of deerskin, and reached from the waist to the knees with a long thick fringe below. There was also a short fringe at the waist. It opened in the front and underneath was worn an apron made of long strands of pine-nut shells and braided leaves attached to a belt.

Another form was a buckskin apron about a foot wide, its length slit into fringes which were wrapped with a braid of lustrous leaves or strung with pine-nuts. From the rear of the waist, a much broader apron or skirt was brought around to meet the front piece. This rear apron was also fringed but contained a considerable area of unfringed skin.

They wore neat, round, snugly fitting caps of basketry. These were modeled with a nearly flat top, but after some months' wear the cap became peaked. The front came low enough to protect the forehead from the carrying strap by which burdens and baby baskets were borne. As a protection against the cold, a robe of deerskin or wildcat fur was worn with the hair next to the body. In rainy weather, it was turned about, hair side out.

The ordinary footgear was a one-piece, front-seamed moccasin without decoration. It was not worn regularly but was chiefly for travel.

Rich women ornamented their dress heavily. Haliotis and

clam shells jangled musically from the ends of the fringes, and occasionally a row of obsidian prisms tinkled with every step. Small dentalium and olivella shells, pine-nut shells, and small black fruits were strung for necklaces. From their ears hung pendants of abalone shell attached to twine. All adult women had their faces tattooed.

The hair was gathered in two masses which hung in front of the shoulders and were held together by a thong or, on gala occasions, by a strip of mink fur set with small woodpecker crests.

Secotans

This was an Algonquin tribe which occupied parts of North Carolina and Virginia. They dressed in loose mantles of deerskin and wore summer aprons of deerskin about the loins. The men wore the aprons only in front, but the women wore theirs front and back.

The men cut their hair close on the sides of the head, leaving a crest from the forehead back to the nape of the neck. It was then tied in a knot behind the ears. The women's hair was comparatively short, thin, and soft; it was clipped in front and held in place by a fillet about the brow.

They were tattooed to a limited extent.

They hung pendants of shell in their ears and long strings of beads made from seashells or cold-beaten copper around the neck and wrist.

Seminoles

The man's shirt is a loose garment usually slipped over the head with a short opening at the neck in front. It hangs to the knees and has loose sleeves gathered full at the shoulders to fit the armhole and gathered at the wrist into a narrow cuff. Sometimes it is made with a yoke front and back, with considerable fullness attached for the rest of the shirt. The material of the shirt is gaily colored calico, often striped. About the neck is always a loosely knotted kerchief of contrasting color. Sometimes several of these are worn at the same time, often with small accessories, tied into the corners. Usually a belt of leather or buckskin encircles the waist; from it are hung one or more bags or pouches and often a hunting knife about 10 inches in length.

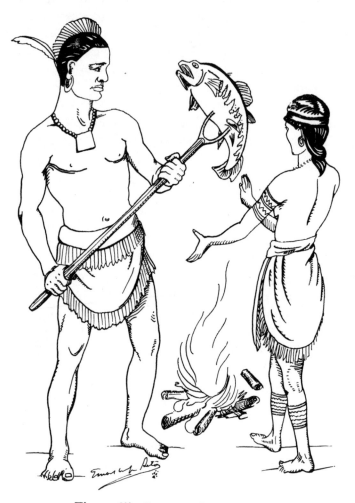

Figure 25. Secotans from Virginia.

For outdoor wear, a turban is the ordinary headgear. It is
made of one or more shawls, often in Scotch plaids and of wool.
These shawls are folded diagonally over and over until only
about 3 inches wide. Then, successively, they are wrapped tightly
around the head, leaving the top of the head bare. Somewhere in
the folds and without the aid of pins or other fastening, the final
end is tucked.

The men shave the head close, except for a strip about an inch

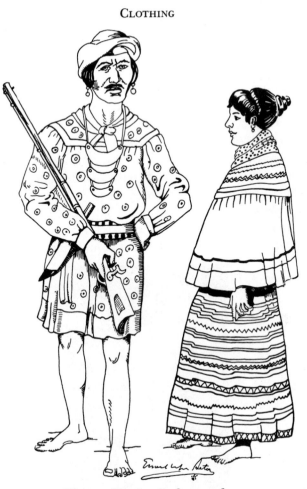

Figure 26. Seminole couple.

wide running over the front of the scalp from temple to temple
and another strip of about the same width crossing the crown of
the head to the nape of the neck. At each temple, a heavy tuft is
allowed to hang to the bottom of the lobe of the ear. The long
hair and strip on top of the head is usually gathered and braided
into two plaits.

Mustaches are commonly worn.

The woman's blouse is composed of a circular yoke slipped
over the head and hanging about to the shoulders and rather low
at the neck. The cloth of which it is made usually is dark blue
or other dark color. To this is attached a wide, gathered flounce

of a lighter color reaching to the waistline front and back. This is bordered with several rows of brightly colored material about ½ inch wide; yellow, red, and brown predominating. Beneath this is sometimes worn a sleeved waist, of which only the sleeves show from beneath the flounce. These are gathered into a tight band about the wrist.

The material of the skirt is similar to that of the man's costume. The skirt is made of a brilliantly striped calico or of many narrow stripes of various colors sewed together horizontally. Often diamonds and squares of color are worked into these, making an elaborate pattern of the whole. The skirt is made very full and so long that it often touches the ground. Additional width is often added by further ruffles about the lower part.

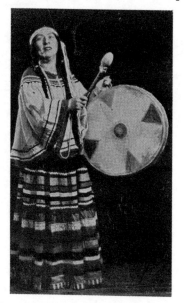

Figure 27. Author in Seminole costume. (Photograph by Jane Hardcastle.)

The women wear as many strings of beads as they possibly can accommodate. These strings reach up to the ears and weigh many pounds, making it difficult for the women to move their heads. MacCauley (Ref. 9) reported that one woman wore no less than 200 strings. Six quarts of beads are required to make these strings, and all the strings are worn at the same time.

From a line crossing the head from ear to ear, the hair is gathered up behind and bound into an elongated cone about 3 inches up from the back of the neck. This cone is often wrapped at the end with a piece of brightly colored ribbon. The front hair hangs down over the forehead and along the cheeks in front of the ears in a thick bang.

The women, like the men, usually go barefoot.

Pueblos

Pueblo, the Spanish word for town or village, is a term designating all the Indians who live along the Rio Grande in permanent stone or adobe houses as well as the villages themselves.

The everyday wear of the Pueblo men is loose calico trousers, slit at the ankle for about 10 inches, calico shirts worn outside the trousers and usually belted with a silver concho belt. A bright silk kerchief encircles the head, holding the carefully coiffed hair neat and smooth, and always around the neck are strings of ground and drilled shell and strings of turquoise beads. Ear and neck pendants of the same materials are commonly worn, as are beautifully executed mosaic pendants. For ceremonial days, the calico trousers remain, but the shirt is made of velveteen in the manner of the Navaho.

In the summer, the Pueblo women wear a calico dress cut on the very same lines as was the dress of the natives when Coronado first came into the country. In winter or for ceremonial purposes, the cut is the same, but the dress is made of a black handwoven material of diagonal weave. It is merely two lengths sewed down the sides and worn over the right shoulder and under the left arm. A broad, woven belt of red, green, and black wool in geometric pattern is wrapped many times about the waist.

A calico slip with long sleeves and high neck is worn, and over the slip are many petticoats. In most pueblos, the women have several inches of decorative lace showing at the hem line.

In some of the villages, the women wear a square of silk, bordered and edged with lace, hanging down their back from their shoulders. In some places, as Zuñi, a brilliantly flowered wool shawl is worn.

The Pueblo woman wears white buckskin moccasins, and loose

strips of buckskin fastened to the top of the moccasins are wrapped around and around their legs up to the knees.

Certain of the pueblos demand a white apron; in some instances simple, in other instances elaborately embroidered. Wherever the Pueblo woman is seen, she is gorgeously hung with silver and turquoise.

For everyday wear the hairdress is the same for men and women—a square-cut bang, and the rest of the hair pulled back into a chongo at the back of the neck.

Hopis

The Hopis are a Pueblo tribe living in northeastern Arizona.

Long ago when skins were plentiful, the Hopi men almost certainly wore shirts of tanned deerskin, as did most other tribes. The form is shown in Figure 29a. However, as soon as weaving was introduced, the body garment of the man became a length of dark blue or black woolen cloth with an opening made in the middle for the head to go through. Thus the garment closely resembled the Mexican poncho (Fig. 29b). Soon this garment acquired short, loose sleeves and was sewed partly down each side, leaving openings under the armpits and at the bottom of the sides (Fig. 29c and d).

As a breechclout, the Hopi Indians wore a kilt, a width of cloth 20 by 39½ inches reaching from the waist to the knees, wrapped around the waist, overlapping on the right side, and held up by a belt (Fig. 29e).

The leggings were formerly a square of tanned deerskin folded around the calf of the leg and tied with a thong or woven garter (Fig. 29f and g). Another type, more ornamental, had tying string and fringes (Fig. 29j and k). Still another folded on the leg and tied with the garter (Fig. 29h and i). Knit leggings are sometimes worn by old men and women.

In aboriginal days, the Hopi wore sandals. The moccasins which are now in general use were probably copied from the Rio Grande tribes; at least, they have several features in common. The sole is made of rawhide and bent up all around the edge. The diagram (Fig. 29l, m, n, and o) shows its construction. In modern times, the Hopi often use Navaho silver buttons instead of the tie strings.

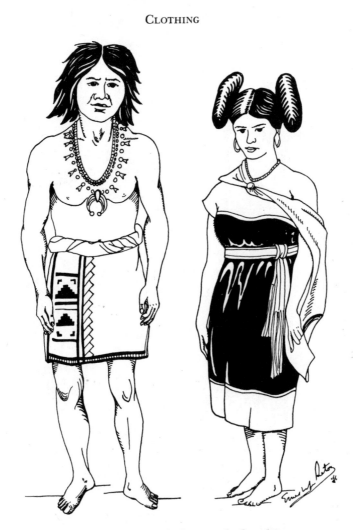

Figure 28. Hopi father and daughter.

The hair is tied in a knot at the back of the head with a narrow woven tape. It is cut into a bang across the eyebrows, and the sides are cut straight back on the lower line of the ear.

The Hopi wear necklaces of beads made from worked shell and stone. The beads are perforated disks and are strung uniformly into a strand or are sometimes spaced at intervals with roughly oval pieces of shell or turquoise. Several of these strands are bunched and bound together for a short space, forming a necklace which is put on over the head. The beads have religious

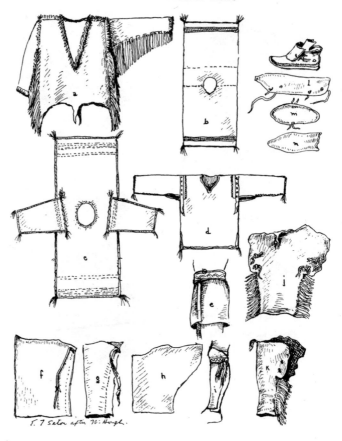

Figure 29. Hopi man's costume.

significance. They are not made by the Hopi but are usually obtained in trade from the Pueblos.

The woman's dress is usually of black or dark blue hand-woven material of a particular diagonal weave, woven wide enough to reach from the shoulder to the middle of the lower leg. A broad band, always blue, is woven in across top and bottom; then the material is doubled and sewed up the open side. The upper edges are then sewed together for a short distance where the dress will come over the right shoulder. The dress is now ready to be drawn on over the head, and when it is in place, the left arm and shoulder are free (Fig. 30e and f). A wide, long belt, usually woven by the woman, is wound many times around the waist and

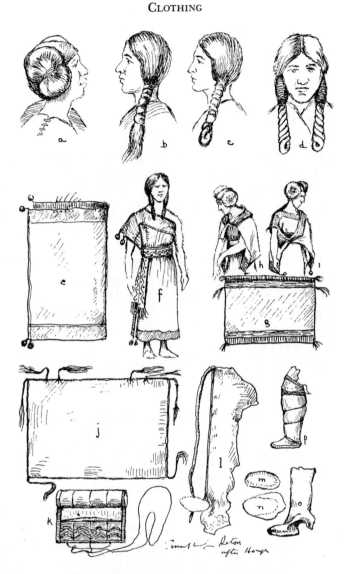

Figure 30. Hopi woman's costume.

the end tucked under, the long fringe hanging down on the left side (Fig. 30*f*).

In full dress, the married woman wears a blouse with sleeves. In modern times, this is made of calico.

The women wear a blanket which is merely a rectangle 36 by 48 inches. It is worn over the shoulders like a shawl; the material

is white cotton and wool in an excellent weave, bordered with red and blue. It is worn over the left shoulder and tied under the right arm at the hip.

The wedding blanket is made of white cotton, 48 by 58 inches, in a heavy weave which looks much like canvas. The corners are often reinforced with yellow yarn. There are tie strings attached as in Figure 30*j*. The blanket is rolled in a reed mat (Fig. 30*k*). During the year following the marriage ceremony, the blanket is heavily embroidered on the upper and lower borders with worsteds in symbolic patterns in black, green, and red yarn, and heavy tassels are fastened to the corners. At the upper corners, white tassels are used; at the lower corners, black and red tassels, larger than the white tassels, are used. The embroidered band on the upper margin of the blanket is narrower and simpler in design than the band on the lower margin, whose pattern represents rainclouds, rain, squash flowers, and butterflies.

Moccasins are worn by the women only occasionally; at other times the feet are bare. The sole of the moccasin is turned higher around the edges than is the man's. To the edge of this upturned sole is sewed a whole, white, tanned deerskin, which is wrapped in folds around the calf of the leg and ties at the knee (Fig. 30*l, m, n, o, p*).

The married women part their hair in the middle and gather it into two parts, one over each ear. Each lock is then wound over the first finger, and the end is drawn through as the finger is withdrawn (Fig. 30*b*). The end of the lock is then looped up and caught in the winding (Fig. 30*c*). There is then formed a loose knob which is wound over and over with hair cord, making a thicker barrel close to the top (Fig. 30*d*).

Unwedded girls of marriageable age dress their hair in whorls symbolic of squash blossoms, implying fertility. The method is peculiar to the Hopi: The hair is carefully brushed with a bundle of grass stems and then parted in the middle, and divided into two locks, each wound over a flexible wooden U-shaped bow of a size determined by the length of the hair. The mass of hair on the bow is pressed together at the middle and wound with hair cord, which is passed at each turn also around the lock of hair next to the head in figure-eight winding. When the winding is

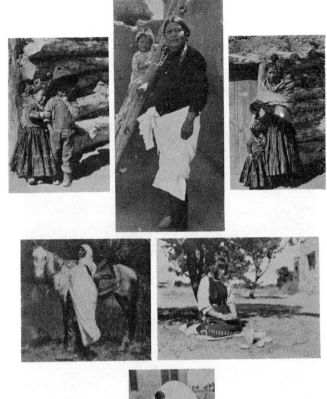

Figure 31. Scenes in the Southwest. (Photograph by Clyde Fisher.)

completed, the bow is removed and the hair is adjusted into a circular shape.

Taos

At the north end of the Rio Grande pueblos are the Taos. Since they are close to some of the Plains tribes, especially the Utes, the members of this tribe have intermarried and have borrowed customs and language, unlike the other Pueblos. In ap-

pearance, also, the Taos resemble the Plains people, being taller and slimmer than the Pueblos.

The men wear beaded moccasins and deerskin trousers with a wide flap, which is frequently fringed down the sides. They never are without the white cotton blanket or sheet which they drape gracefully about their middles or, in hot or cold weather, over their heads, giving them much the appearance of Bedouins.

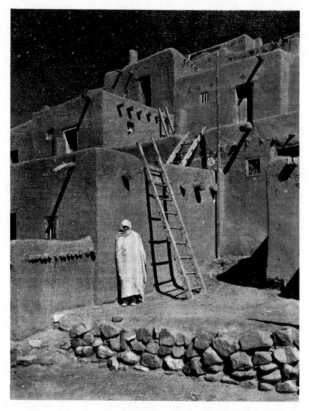

Figure 32. A Taos Indian at home. (Photograph by Clyde Fisher.)

Their hairdress is most distinctive. They wear their hair interwoven with ribbon or tape, in two long plaits over the shoulders.

The women's dress is much like the dress of the Pueblo women but usually has short sleeves and open throat. Over this dress they wear a black shawl; they complete their costume with high boots of white buckskin reaching to the knees.

The ceremonial dress of all the Pueblos is intriguing. The embroidered designs are sacred and have survived throughout all the centuries of the Whiteman's influence. In these days, they are often made with commercial yarns, but the symbols themselves are unaltered. These designs are highly conventionalized and dynamically abstract—for example, mountains geometrically terraced or clouds measurably graduated into smooth triangular images.

The dance kilts are of white hand-woven material embroidered with a broad band of black wool with two vertical stripes of green at intervals. These bands are almost completely covered with the embroidery. The design itself is made by the white cotton base showing through, diagonally crossing the black and green. The stitches of the black and green yarn are vertical, and the design of white creates an impression of movement with its slantwise tilt. The unstitched line is the decoration.

Embroidered medallions of special symbolism in sharp red or green are frequently set into these borders. The mantas (blanket-shawls or off-shoulder dresses) are similarly embroidered in designs of rain, clouds, and mountains.

Navahos

The Navahos are an important tribe occupying a large reservation in northeastern Arizona, northwestern New Mexico, and southeastern Utah.

The modern Navaho costume is extremely colorful. The shirt or jacket is of brilliantly colored velveteen—green, purple, crimson, or blue. It is close-fitting, has full-length sleeves, and hangs over the trousers to the hip line. It is decorated with silver buttons of native manufacture and it is held at the waist by a belt.

Both men and women wear belts made of as many conchos or disks as the wearer can accommodate. These are, in the best form, from 2 to 4 inches in diameter, either round or slightly flattened, convex, and beautifully designed. They are all hand-wrought. The oldest ones had a strip of leather strung through them, each disk having two upright slits cut near the center. Those of later manufacture have short straps of metal attached at the back through which the strap is laced. They are fastened at the front with a buckle, larger and even more elaborate than the conchos.

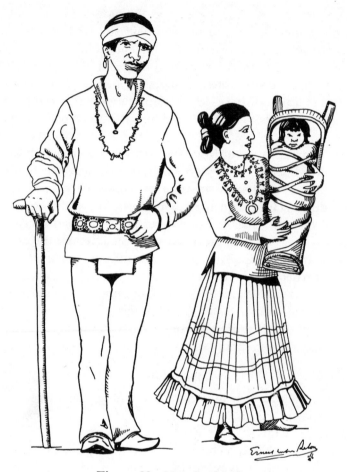

Figure 33. Navaho family.

The trousers look much like the modern Whiteman's but are sometimes made in two separate legs with a breechclout completing the gap. They are often of striped or other print calico, and occasionally they have triangular gussets inserted at the bottom of the outside seam of each leg.

The moccasins are made usually of terra-cotta–colored buckskin with a rawhide sole turned up all around the edge; they are fastened with silver buttons where they overlap on the outside of the ankle.

The hair is done up in a club at the back, wrapped with white

woolen string. A head-kerchief of brilliant silk, called a banda, is bound about the forehead. Magenta is a favorite color.

All the worldly wealth of the Navaho is on his person in the form of turquoise and silver necklaces, belts, rings, earrings, etc. A favorite form of necklace is composed of round hollow beads of silver, at least ½ inch in diameter, with a pendant in front shaped somewhat like a horseshoe. The silver wrist guard is also popular. Originally, this was to protect the wrist from the rebound of the bow; the ornament is still worn, even though little archery is now practiced.

The woman's blouse is almost the same as the man's shirt except that it is fitted more closely to the figure. It is made of brightly colored velveteen and is fastened about the waist by a belt similar to that of the man's. The skirt is usually of cotton material, gathered very full. It may be anywhere from 12 to 18 yards around the bottom. Flounces further add to the width and are decorated with contrasting colored bands of cotton or ribbon.

The moccasins are like those of the man, and the hair is dressed much as is that of the man, except that it is clubbed at the back both above and below the wrapping of white woolen string. The women do not wear the banda.

Arapahos

The dress of the men consists of a shirt, leggings reaching from the ankles to the hips, breechclout, moccasins, and a blanket of buffalo hide. The skin blankets are either painted or embroidered. At one time, porcupine quills were used for the decoration; later the quills were replaced by glass beads.

The women wear an open-sleeved dress which reaches to the lower calf, moccasins to which are attached leggings which extend up to the knee, and a blanket. Small boys often wear nothing or only a shirt.

One form of Arapaho headdress consists of a small hoop wound with yellow quills. Two owl feathers are attached to it and it is worn on the side of the head.

The navel strings of Arapaho girls are preserved and sewed into small pouches stuffed with grass. These pouches are usually diamond-shaped and covered on both sides with beads. The child wears this amulet until it is worn out.

Young men sometimes wear a head protection which is like the brim of a hat without a crown. A piece of rawhide is cut a foot or so long and nearly as wide. Near the back end of this, a circle about 6 inches in diameter is cut out. The round edge left is slit into a number of points. When this part of the rawhide is pressed upon the top of the head, the points yield and stand up, forming a circle around the head. The whole is painted in characteristic parfleche designs.

Bibliography

1. BOAS, FRANZ. *The Central Eskimo.* (6th Annual Report, Bureau of American Ethnology.) Washington, D.C.: Government Printing Office, 1888.

2. DELLENBAUGH, FREDERICK S. *North Americans of Yesterday.* New York: G. P. Putnam's Sons, Inc., 1902.

3. DENSMORE, FRANCES. *Chippewa Customs.* (Bulletin 86, Bureau of American Ethnology.) Washington, D.C.: Government Printing Office, 1929.

4. FLETCHER, ALICE C., and LA FLESCHE, FRANCIS. *The Omaha Tribe.* (27th Annual Report, Bureau of American Ethnology.) Washington, D.C.: Government Printing Office, 1911.

5. GODDARD, PLINY E. *Life and Culture of the Hupa.* Berkeley, Calif.: Univ. of California Press, 1903.

6. HOFFMAN, WALTER JAMES. *The Menomini Indians.* (14th Annual Report, Bureau of American Ethnology.) Washington, D.C.: Government Printing Office, 1896.

7. HOUGH, WALTER. "Hopi Indian Collection," *U.S. National Museum Proceedings,* Vol. 54.

8. KROEBER, ALFRED L. "The Arapaho," *Bulletin of American Museum of Natural History,* Vol. XVIII (1902), pp. 1–150.

9. MacCAULEY, CLAY. *The Seminole Indians.* (5th Annual Report, Bureau of American Ethnology.) Washington, D.C.: Government Printing Office, 1887.

10. MURDOCH, JOHN. *Ethnological Results of the Point Barrow Expedition.* (9th Annual Report, Bureau of American Ethnology.) Washington, D.C.: Government Printing Office, 1892.

11. NIBLACK, ALBERT P. *Coast Indians of Southern Alaska and Northern British Columbia.* Report U.S. National Museum, 1890.

12. SETON, ERNEST THOMPSON. *Birch Bark Roll of Woodcraft.* Revised by Julia M. Buttree. New York: A. S. Barnes & Co., Inc., 1931.

13. SETON, JULIA M. *Indian Costume Book.* Santa Fe, N.M.: Seton Village Press, 1938.

14. SKINNER, ALANSON. "Notes Concerning New Collections," *Anthropological Papers,* American Museum of Natural History, Vol. IV, Pt. II.

15. ———. *Indians of Manhattan Island and Vicinity.* American Museum of Natural History Guide Leaflet Series No. 41.

16. SWANTON, JOHN R. *Aboriginal Culture of the Southeast.* (42d Annual Report, Bureau of American Ethnology.) Washington, D.C.: Government Printing Office, 1928.

17. TEIT, JAMES A. *Salishan Tribes of the Western Plateau.* (45th Annual Report, Bureau of American Ethnology.) Washington, D.C.: Government Printing Office, 1930.

18. TURNER, LUCIEN M. *Ethnology of the Ungava District.* (11th Annual Report, Bureau of American Ethnology.) Washington, D.C.: Government Printing Office, 1894.

19. WISSLER, CLARK. *Indian Costumes of the United States.* American Museum of Natural History Guide Leaflet Series No. 63, 1926.

Suggested Reading

ROEDIGER, VIRGINIA MORE. *Ceremonial Costumes of the Pueblo Indians.* Berkeley, Calif.: Univ. of California Press, 1941.

4

Weaving

The textile art is one of the most ancient known, dating back to the very beginning of culture. The earliest fabrics were undoubtedly made of vegetal growths, such as twigs, leaves, roots, and grasses; later, threads from all the natural sources were freely used. Still later, artificial products were employed.

Weaving is so ancient that its origin is unknown. In North America, it had passed far beyond crude beginnings long before the Whiteman appeared upon the scene. In the ruins of Casa Grande, Arizona, which there is good reason to believe are older than most of the present pueblos, or cliff dwellings, textiles of native cotton and other vegetable fibers were found.

The materials to be made into fiber varied with the locality. Among the Southern and Southwestern tribes, cotton was the favorite; but in other places, hemp, hair of animals, and feathers were used. The Kwakiutls of the Northwest Coast made blankets of the wool of the mountain goat, of dog's hair, or of a combination of these. Along Puget Sound, the natives used a mixture of the wool of the mountain sheep and the hair of a particular kind of dog. Probably the mountain sheep and mountain goat were similarly used by the Pueblos before the Spanish came with their domesticated sheep.

According to Dellenbaugh (Ref. 2), the Paiutes made a garment of rabbit skin, which was very warm. The skins were twisted and attached one to another, end to end, making a sort of fur

rope, and this rope was tied in parallel lines, forming a kind of large cloak which was most serviceable in winter.

Flax or a plant closely allied to it grew wild all over Arizona and New Mexico and was used for garments. The bark of the sagebrush was used to make cord and mats, and yucca also furnished a supply of valuable fiber.

It is believed that the Osage Indians in the middle and upper Mississippi country used the hair of the buffalo and other animals in their weaving. In short, the art of weaving seems to have been universal among the Indians from earliest times.

In the very early days, much of the weaving was done entirely by hand, without the assistance of any kind of loom. Baskets, bags, mats, and belts were made by hand, some of them among the most beautiful examples of the art. Later, this method was abandoned in large part but has recently been taken up again, thus resurrecting and developing a phase which might well have use in the world of commerce.

As we have pointed out, the art was practically universal among the Indians; but there are three major exponents of weaving—the Chilkat in the Northwest, the Hopi in the Southwest, and the Navaho, who originally borrowed their art from the Hopi and Pueblo but have since made of it an integral part of their lives, expressive of their own character. These three groups of weavers we shall discuss after we have reviewed briefly what some other tribes have done.

Use of Plants in Weaving

Our best source of information on plants used in weaving comes from Matilda Coxe Stevenson (Ref. 13), who made her investigations chiefly among the Zuñi. The Zuñi claim that beautiful white dance kilts, women's belts, and other articles were woven from the fiber of the milkweed. A primitive spindle is still in use by the rain priests for spinning native cotton and milkweed for ceremonial purposes. As in the old days, this spindle is a slender stick a bit heavier than a lead pencil and the length of four fingers crosswise, plus the distance from the tip of the thumb to the top of the middle finger when the fingers are extended. This spindle has no whorl.

It is certain that the Pueblos of the Rio Grande Valley as well

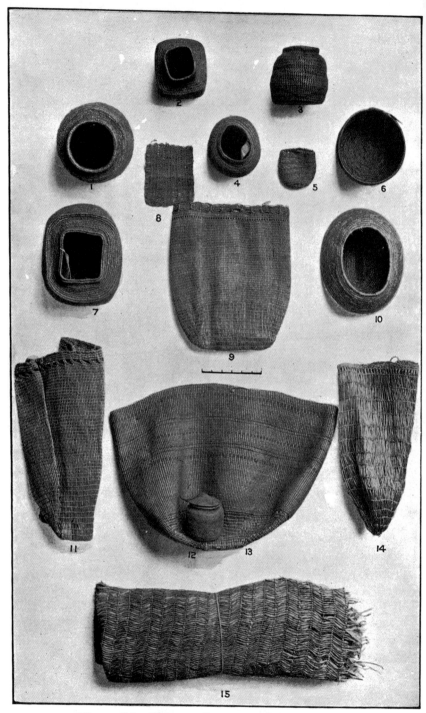

Figure 34. Objects of grass and spruce root.

98

as the Hopi of Arizona and others cultivated cotton long before the coming of the Whiteman. Cotton, however, is not indigenous to New Mexico and Arizona and must have been brought from Mexico either by Indians moving from the south northward or through trade. The only Pueblo Indians cultivating cotton to any considerable extent at the present time are the Hopi of Arizona. Even these people, however, no longer depend entirely on the native cotton for weaving ceremonial garments but purchase the cotton twine of commerce. For certain ceremonial purposes, however, they must have native cotton.

Fibers from the new leaves of the yucca were used largely in weaving fabrics before the introduction of sheep by the Spaniards. These leaves must be boiled and, when cooled, peeled and then chewed, after which the fibers are separated. This procedure is still followed. A cord is made by rolling the fibers on the right knee with the right hand, then doubling and twisting them into a two-strand cord. These cords are used principally to tie prayer-plume offerings together, and for other ceremonial purposes. The split leaves are also used to plait into mats, to fashion the pads used on the head to support water jars, to make baskets of all kinds—in short, to take the place of cords or rope for many purposes.

Weaving Among the West Eskimos

I have had no personal contact with the West Eskimo natives, but their weaving is worthy of record and appreciation.

E. W. Nelson (Ref. 9), when working among the Eskimo about Bering Strait, reports:

At Chukwuk, on the lower Yukon, I saw a woman making one of these mats, and watched the process she employed. A set of 3 or 4 straws were twisted and the ends turned in, forming a strand, a number of which were arranged side by side with their ends fastened along a stick, forming one end of the mat and hanging down for the warp.

Another strand was then used as a woof. By a deft twist of the fingers, it was carried from one side to the other, passing above and below the strands of the warp; then the woof strand was passed around the outer strand of the warp and turned to repeat the operation. The strands were made continuous by adding straws as necessary, and with each motion the strands were twisted a little so as to keep them firmly together. By this simple method a variety of patterns are produced. . . .

In making grass bags, they are started from a point at the bottom, where the strands of the warp, consisting of two or more grass stems, are fastened together and extend vertically downward. The woof is formed by a double strand of grass which is twisted about itself with the strands of the warp inclosed in the turns; both are continually twisted as the weaving progresses. In coarsely made bags, the strands of the woof are spaced from an inch to two inches apart, and those of the warp at intervals of from a quarter to half an inch. These bags have a conical bottom, which slopes from the center to the sides. At the mouth, the ends of the warp are braided to form a continuous edge.

Bags of the Nez Percés

The Nez Percés make bags by a technique of plain twined weaving which is one of the oldest methods known and is found almost all over the world. In America, in the graves of the Mound Builders, there have been found pottery bowls with the impression of a fabric which was twine-woven; and twined bags are found in caves of the Basket Makers. Modern tribes have also made—in fact, still are making—bags and wallets by this method. The decoration is really a form of false embroidery.

At first, the Indians used Indian hemp for these bags and made the false embroidery from bear or squaw grass dyed in soft colors. Nowadays, the false embroidery is made of the husks of some variety of corn; hence, all are commonly called cornhusk bags. In some of the more recent bags, ordinary cotton twine has taken the place of the native Indian hemp.

Anne Wyman (Ref. 14) has given a fine description of the making of cornhusk bags, which might be copied by modern weavers to commercial advantage. She tells us that the threads which are to form the warp are suspended from some convenient object. Then the weaver begins to fill in the weft, the threads of which are woven in pairs. As one thread passes over a strand of warp, the other goes under it; then before the next strand of warp is reached, the two strands of weft thread are crossed one over the other.

The false embroidery is woven in with the weft. A thread of the embroidery material is twisted over the weft as it crosses the warp strand in such a way that it shows on the inside of the bag only. Any join of thread is thus hidden. The false embroidery overlays the basic twining with the threads of the em-

broidery lying in the opposite direction and at a slightly greater angle. The bag is finished off at the top by turning down the warp threads and binding them with the weft, or by running a drawstring of rope or thong through a band of deerskin or colored cloth. The decoration takes the form of simple geometrical patterns in color against the natural colored background of the cornhusk.

The Thompson River Salish make wallets similar to the Nez Percés bags but have the false embroidery stitches showing inside as well as out.

Weaving Among the Chippewa

Frances Densmore (Ref. 3) is the best source for the customs of this tribe. She describes in great detail the weaving of mats for both the floor and the sides of wigwams.

Floor mats were made of either bulrushes or cedar. The rushes were carefully dried in little bundles and then boiled, some in decoctions of certain plants in order to obtain a variation of color.

The weaving had to be done while the rushes were slightly damp. It was done on a very simple frame which hung horizontally at a height equal to the length of the desired mat, allowing the rushes which formed the warp to hang down free. Basswood twine passed between these rushes completed the weaving.

The cedar mats were made on a similar frame, but the woof, instead of being basswood twine, consisted of cedar strips the same width as those of the warp.

The mats used for the sides of the wigwams were made from cattail reeds and were woven on the same frames as the floor mats. But the reeds were strung together with strands of basswood fiber which had been boiled to make it tough. This fiber was threaded into a bone needle, which was passed horizontally through the reeds at intervals of 8 or 10 inches.

The Chippewa also wove screens for drying berries. These screens were made on a frame like that already described. The twine was knotted between each two reeds, thus producing spaces through which the air could circulate.

These people also wove bags of bark, roots, and later yarn. These bags were woven across a short stick, suspended at the

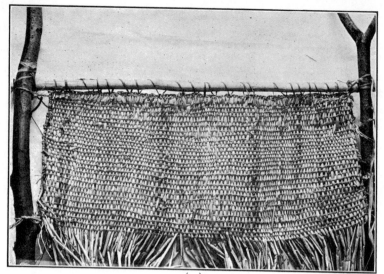

(a)

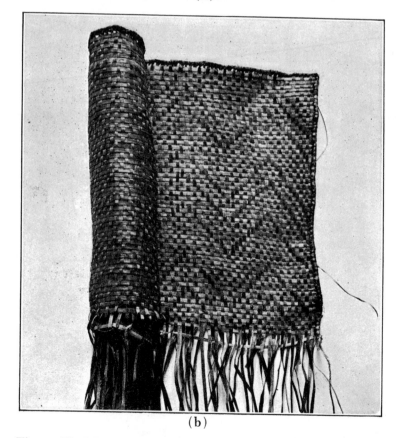

(b)

Figure 35. Mats: (a) unfinished reed mat on frame; (b) unfinished mat made of strips of cedar bark.

ends; the work was completed as it was drawn down and shaped into a square or oblong bag. When the bag was finished, the stick was removed, and the corners sewed down.

As time went on, commercial materials came into more common use. Every Chippewa woman carefully conserved the cloth obtained from the Government or from the trader; and from strips of old cloth, she wove bands which were sewed into rugs for the floor of her dwelling. These rugs are sometimes seen at the present day. Some are round or oval, but the most typical are oblong with the bands extending the length of the rug.

The loom on which these rugs are woven is of cedar, 13 by 13 inches in size, with bars 1 inch wide separated by spaces. Each bar has a hole midway down its length. Strips of cloth were passed through the holes and through the spaces between the bars. The strips were fastened at one end to an iron bedstead, while the other ends were fastened to the belt of the worker, who maintained the right tension for weaving by adjusting her own distance from the bed. As the work progressed, she let out the strips that were tied to the bed and slipped the finished work through her belt, tying it in place. The loom was placed an easy arm-length from the worker's body and about the same distance from the bedstead.

The process is like weaving rag carpets, except that no shuttle is used. A strip of cloth 3 or 4 yards long is wound in the form of a little roll and used as the woof, other strips being added as necessary. The worker holds the roll of woof in her right hand, passes it between the warp threads, elevates the weaving frame, and returns the roll of woof with her left hand, the change in position of the frame producing a change in the relative position of the woof. The pattern is determined by the arrangement of colors in the warp, only one color being used in the woof. A great variety is seen in the patterns. The usual width is about 1½ inches, but much wider braids are frequently made. Similar braids were made entirely of yarn and tied above the bands on cradle boards.

Belts were made using yarn as the warp and carpet warp as the woof, this being a comparatively modern form. A narrow belt made of soft basswood bark was worn by hunters, the knife

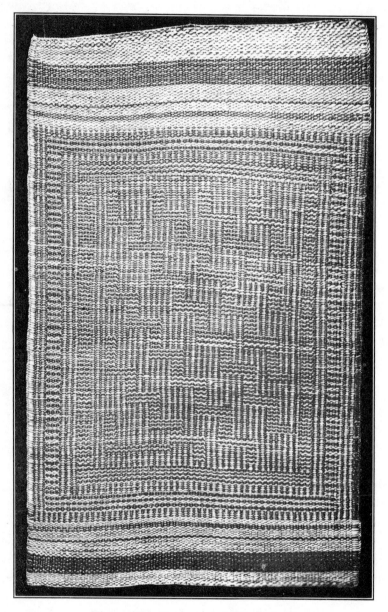

Figure 36. Rush mat (old design).

sheath being attached to this belt. No loom was required for this purpose, the threads being crossed diagonally.

Belts made of yarn are the most common among the Chippewa and are usually about 9 inches wide and 2 yards or more in length. These belts are made on a simple loom consisting of two poles or stakes driven firmly into the ground. Miss Densmore (Ref. 3) has given accurate directions for this weaving, or rather netting, in her book—such clear instruction that anything the present author might say would be superfluous.

WEAVING BLANKETS OF RABBIT SKIN

Two ways of weaving these blankets were used by the Chippewa in northern and northeastern Minnesota and in Canada. One method was to cut the rabbit skin round and round in a narrow strip so that one hide made a continuous strip. Green hides were used, and the strips twisted in drying so that they resembled soft cords. The weaving was done on a warp of cotton twine with a space of about ½ inch between the rows of skin. The blanket was firmly woven as the skin was tied around each thread of the warp. When the other method was used, the skins were tanned dry without removing the hair. These were then cut just as the green hides were cut, after which they were woven like the netting on snowshoes. Either method results in a blanket which looks alike on both sides and is very thick.

The Chilkat Robe

The Chilkat robe is the most marvelous product of the weaver's art. It is a ceremonial dance robe of roughly rectangular shape, slightly curved at the lower edge, and heavily fringed on this edge and on the two adjoining sides. The whole is embellished with a totemic animal design in blue-green, yellow, dark brown, and cream.

There is no other textile or finished product like the Chilkat robe. It is made of shredded cedar bark and the wool of the wild goat. The thread is spun by rolling the fiber on the thigh with the palm of the hand. The pattern of the robe is painted on a board by the men. They then drive two forked stakes into the ground as far apart as the width of the blanket and lay a stout

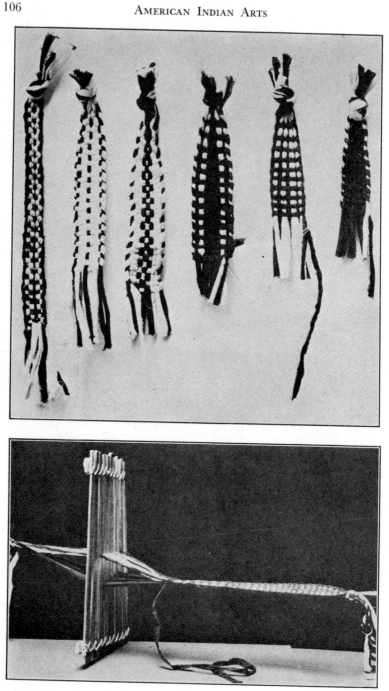

Figure 37. Woven braid and heddle with unfinished work.

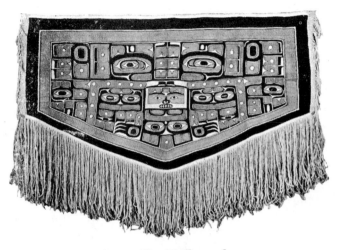

Figure 38. Chilkat robe.

bar or pole across for a warp beam. From this is suspended a
thong or stout cord stretched from side to side, which holds the
warp of goats' hair and cedar bark. The woman, sitting in front,
weaves her intricate patterns with her fingers alone, using neither
shuttle, heddle, batten, nor other device. Each small section of
the design is woven separately and framed with a line of twined
weave.

I have known of no Whiteman with enough skill and per-
sistence to copy one of these robes in weaving. And I sincerely
hope there never will be one who will do it, since it is a ceremonial
procedure and belongs to those psychologically fitted for the art.

Weaving Among the Pueblos and Hopi

There is no longer any doubt among students of weaving
that the Pueblos were well versed in the art long before the Nava-
hos came on the scene. In all probability the Pueblos used the
vertical loom of today, as well as the waist loom for sashes and
small articles of the kind. Among the Pueblos, the men were
the weavers. They still are today in the Hopi villages where
weaving yet persists.

The Hopi blankets are simple in pattern, usually with stripes
of white, black, and sometimes a bit of red. To weave the
cotton they cultivated, the Hopi once used a loom fitted with

several cord-heddles that resulted in a twill weave. This weave is still found in the woman's blanket-dress, which is now woven of wool.

Compared with the Navaho, the Hopi show greater skill in their weaves but are much more conservative—or less glaring—in their use of color and design. The Hopi ceremonial garments, especially the wedding shawls, are exceedingly beautiful and are practically unchanged since ancient days. These are made by the bridegrooms for their wives. A solid band of black and green is woven across the top and bottom of a white background. On these bands, a design formed of the unworked line stands out, allowing the background to show through. These embroidered borders are made with medallions, symbolizing rain, plants, and butterflies.

Weaving Among the Navaho

There is much dispute over the history of Navaho weaving. Some hold that the Navaho had at least an elementary knowledge of the craft when they came down from the North. To be sure, their relatives in the North did some weaving, but it was so crude that it hardly seems worth considering. The other group of students claim that the Navaho learned the art from the

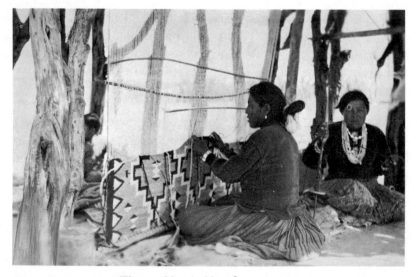

Figure 39. A Navaho weaver.

Pueblos, a claim that seems far more likely. Certainly the Pueblos were weaving centuries before the Whiteman came on the scene, and the Navaho adopted the craft from the Pueblos whom they forced into slavery. At that time, of course, all the weaving was done with cotton. It was not until Coronado came in 1540 that wool was introduced.

The Navaho were much better fitted for tending flocks of sheep than were the Pueblos. The Navaho were nomads, and the women readily fell into the way of herding. In the 300 years between the time Coronado returned to Mexico City, leaving a few flocks behind, and the time the Navaho were taken into captivity about 1860, they had increased their sheep to well over a million.

Up to 1900, most of the weaving was used for the Navahos' clothing, saddle blankets, etc. Then the traders saw an opportunity and sought a market for the Navaho weaving. The early products were the lighter blankets; but soon demand developed for the Navaho rug, which is made of heavier wool, is more closely woven, and is sold all over the world as the best expression of the weaving of an individual race, proud, versatile, progressive, independent, and spiritual.

SETTING UP THE LOOM

The description of setting up the loom, given by Dr. Washington Matthews (Ref. 8), has never been equaled, so it is reproduced here. The instructions can be followed exactly—indeed, have been many times at Seton Village—with the certainty that the results will be entirely satisfactory. (Fig. 40.)

Two posts, *a a*, are set firmly in the ground; to these are lashed two cross-pieces or braces, *b c*, the whole forming the frame of the loom. Sometimes two slender trees, growing at a convenient distance from one another, are made to answer for the posts. *d* is a horizontal pole, which I call the supplementary yarn-beam, attached to the upper brace, *b*, by means of a rope, *e e*, spirally applied. *f* is the upper beam of the loom. As it is analogous to the yarn-beams of our looms, I will call it by this name, although once only have I seen the warp wound around it. It lies parallel to the pole *d*, about 2 or 3 inches below it, and is attached to the latter by a number of loops, *g g*. A spiral cord wound around the yarn-beam holds the upper border cord, *h h*, which, in turn, secures the upper end of the warp, *i i*. The lower beam of the loom is shown at *k*. I will call this the cloth-

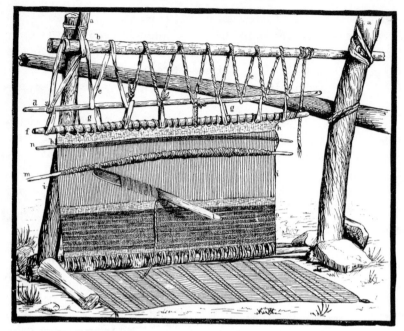

Figure 40. Navaho blanket loom.

beam, although the finished web is never wound around it; it is tied firmly
to the lower brace, *c,* of the frame, and to it is secured the lower border
cord of the blanket. The original distance between the two beams is the
length of the blanket. Lying between the threads of the warp is a broad,
thin, oaken stick, *l,* which I will call the batten. A set of healds attached
to a heald-rod, *m,* are shown above the batten. These healds are made of
cord or yarn; they include alternate threads of the warp, and serve when
drawn forward to open the lower shed. The upper shed is kept patent by
a stout rod, *n* (having no healds attached), which I name the shedrod. Their
substitute for the reed of our looms is a wooden fork, which will be desig-
nated as the reed-fork.

For convenience of description, I am obliged to use the word "shuttle,"
although, strictly speaking, the Navaho has no shuttle. If the figure to be
woven is a long stripe, or one where the weft must be passed through 6
inches or more of the shed at one time, the yarn is wound on a slender
twig or splinter, or shoved through at the end of such a piece of wood;
but where the pattern is intricate, and the weft passes at each turn through
only a few inches of the shed, the yarn is wound into small skeins or balls
and shoved through with the finger.

The warp is thus constructed: A frame of four sticks is made, not unlike
the frame of the loom, but lying on or near the ground instead of standing
erect. The two sticks forming the sides of the frame are rough saplings or

rails; the two forming the top and bottom are smooth rounded poles—
often the poles which afterward serve as the beams of the loom; these are
placed parallel to one another, their distance apart depending on the length
of the projected blanket.

On these poles, the warp is laid in a continuous string. It is first firmly
tied to one of the poles, which I will call No. 1; then it is passed over the
other pole, No. 2, brought back under No. 2 and over No. 1, forward again
under No. 1 and over No. 2, and so on to the end. Thus, the first, third,
fifth, etc., turns of the cord cross in the middle of the second, fourth, sixth,
etc., forming a series of elongated figures 8 . . . and making, in the very
beginning of the process, the two sheds, which are kept distinct through-
out the whole work. When sufficient string has been laid, the end is tied
to pole No. 2, and a rod is placed in each shed to keep it open, the rods
being afterwards tied together at the ends to prevent them from falling out.

This done, the weaver takes three strings (which are afterwards twilled
into one, as will appear) and ties them together at one end. She now sits
outside of one of the poles, looking toward the center of the frame, and
proceeds thus: (1) she secures the triple cord to the pole immediately to
the left of the warp; (2) then she takes one of the threads (or strands as
they now become), and passes it under the first turn of the warp; (3) next
she takes a second strand, and twilling it once or oftener with the other
strands, includes with it the second band of the warp; (4) this done, she
takes the third strand and, twilling it as before, passes it under the third
bend of the warp, and thus she goes on until the entire warp in one place
is secured between the strands of the cord; (5) then she pulls the string to
its fullest extent, and in doing so separates the threads of the warp from
one another; (6) a similar three-stranded cord is applied to the other end
of the warp, along the outside of the other pole.

At this stage of the work, these stout cords lie along the outer surfaces
of the poles, parallel with the axes of the latter, but when the warp is taken
off the poles and applied to the beams of the loom by the spiral thread,
as above described, . . . and all is ready for weaving, the cords appear on
the inner sides of the beams, i.e., one at the lower side of the yarn-beam,
the other at the upper side of the cloth-beam, and when the blanket is fin-
ished they form the stout end margins of the web. In the coarser grade of
blankets, the cords are removed, and the ends of the warp tied in pairs
and made to form a fringe.

When the warp is transferred to the loom, the rod which was placed in
the upper shed remains there, or another rod, straighter and smoother, is
substituted for it; but with the lower shed, healds are applied to the an-
terior threads, and the rod is withdrawn.

The mode of applying the healds is simple: (1) the weaver sits facing
the loom in the position for weaving; (2) she lays at the right (her right)
side of the loom a ball of string which she knows contains more than suf-
ficient material to make the healds; (3) she takes the end of this string and

passes it to the left through the shed, leaving the ball in its original position; (4) she ties a loop at the end of the string large enough to admit the heald-rod (5) she holds horizontally in her left hand a straightish slender rod, which is to become the heald-rod, its right extremity touching the left edge of the warp; (6) she puts her finger through the space between the first and third threads and draws out a fold of the heald-string; (7) she twists this once around, so as to form a loop, and pushes the point of the heald-rod on to the right through this loop; (8) she puts her finger into the next space and forms another loop; (9) and so on she continues to advance her rod and form her loops from left to right until each of the anterior (alternate) warp threads of the lower shed is included in a loop of the heald; (10) when the last loop is made, she ties the string firmly to the rod near its right end.

When the weaving is nearly done and it becomes necessary to remove the healds, the rod is drawn out of the loops, a slight pull is made at the thread, the loops fall in an instant, and the straightened string is drawn out of the shed.

DESIGN

The Indian sense of design is innate and, when uncontaminated by foreign influence, most beautiful and reaches the highest level of artistic portrayal. In these days, some atrocious examples of Navaho blankets or rugs are on sale for the tourists, but with these we have little concern. The Indian knows as well as we do that they are not what the artist calls good products; but, as is the case with many of our own people, he will manufacture what the purchaser wishes to buy.

The earliest Navaho blankets were of undyed wool. At first, they were entirely white, then striped with rusty black, and later with a mixture of white and black which made a gray.

About 1800, the bayeta cloth or baize was brought in by trade. The brilliant cochineal red of this cloth started a taste for color in the Indians. The traders ravelled the cloth which was then respun and rewoven by the Navaho. But it was expensive, and at first was used only in narrow stripes, alternately with the natural colors for wider spaces.

Little by little, the simple stripes developed into a sort of checkerboard design, with the blocks still running crosswise in the blanket but rising in a terraced pattern.

It was not until about 1820 that symbolic patterns were introduced. Sun, clouds, rain, mountains, tracks, day, night, and

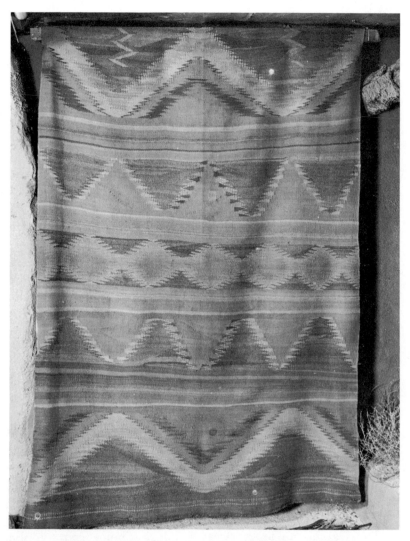

Figure 41. Excellent example of Navaho weaving.

hundreds of other ideas were portrayed with significance. In these days, the patterns on the ordinary rugs are necessarily combinations of symbols with which the weaver is familiar. But the symbols have almost entirely lost their meaning and have become purely decorative, planned according to the whim of the weaver, the colors she wishes to use, and the time she wishes to spend on

the product. Nevertheless, if the rug or blanket is a genuine
Navaho product, it will be beautifully evolved out of the marvel-
ous sense of rhythm and color which is inherent in the American
native Indian.

A ceremonial blanket is an accurate copy of a Navaho sand-
painting. Such copy may be made only with the consent of the
medicine man, and this consent is so seldom given that a real
ceremonial blanket is the rarest form of weaving. If, by some
chance, one is able to obtain what is called a ceremonial blanket,
it is almost certain that some element of the ritual is omitted.
The tabu is very strict indeed.

However, it is possible to occasionally find what is the closest
approach to such a blanket. A simple rug with a balanced de-
sign of corn, or bows and arrows, or birds is permitted to be made.

Figure 42 shows an excellent example of the so-called Chief's
blanket, one that has been in the Seton Museum for many years.
As in the case of all Chief's blankets, the design is one of broad
horizontal stripes. At the center of the blanket is a special motif
which is repeated in half at the edges, and again in quarters at
the corners.

THE NAVAHO RUG

For over half a century now, Navaho weaving has been sub-
jected to every kind of bad influence from the Whiteman. Com-
mercialism has been a pressure of the worst kind. The weavers
soon found that the ever-increasing tourist was not interested in
quality but in low cost, and they learned that they could sell for
a few dollars a blanket that could be made in a day or two. Why,
then, put months, even years, into products which, when finished,
would not sell to these visitors?

The Navaho no longer weaves only for home consumption.
There is nothing the Navaho enjoys more than driving a good
bargain. If a weaver can get as good a price for a quickly and
carelessly woven blanket as she can for one over which she has
spent weeks of labor, she, like her White neighbor, forgets quality
in the face of the almighty dollar and makes rugs as fast as she
can weave.

The worst setback to the Navaho weaver was not the depres-

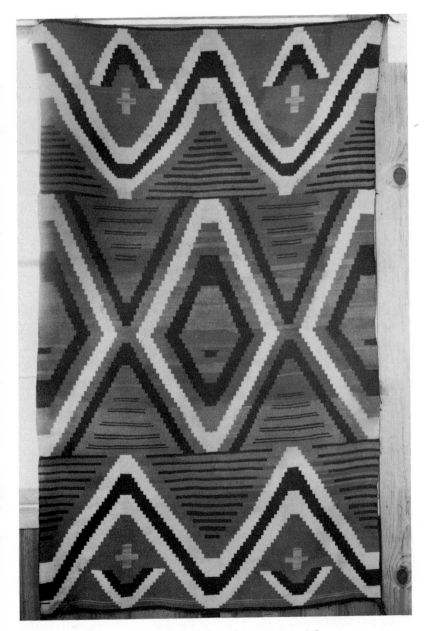

Figure 42. Chief's blanket from Seton Museum.

sion, but the boom period. An influx of tourists poured into the Southwest. They were looking for novelty. The Indian supplied the demand. They made rug designs of motor cars, airplanes, tomato cans, Western Union telegraph blanks, swastikas— anything under the sun that came into their heads or hands.

The unfortunate part was that the tourists were pleased and paid as good a price for this trash as for a good rug. Naturally, the Indian wove fast and furiously and badly. Why not? It brought her money for canned goods, calico, and maybe money to buy a car.

The White trader introduced cotton string to substitute for the warp which the Navaho women had previously made through days and days of patient spinning. The introduction of aniline dyes was a blow from which the Navahos are only now beginning to recover. They had been accustomed, as we have said, to a very few colors, extracted from roots, barks, and leaves of trees or other plants. There had also been a very small variety of colors from native clays. When the vivid aniline dye came to the weaving Navaho, she went into an orgy of blatant, clashing tones. The results were often horrible.

But even worse than this happened. Her artistic instincts told her that the soft weaving texture of the old-time blanket was not appropriate to the harsh factory colors, so she changed her weaving technique to produce a stiffer quality of material. No longer was the Navaho making blankets; she was producing "rugs." But the weaving was so poor, the colors so harsh, the designs so atrocious that eventually the traders themselves realized that it was bad business to put such products on the market.

Aided by the Indian Bureau, local museums, and individuals with vision, an undertaking of far-reaching influence began. After conferences, first in the Navaho country, then in Santa Fe, a group of weavers was brought to the collections made by the State Historical Museum and the Laboratory of Anthropology. Here the awe-struck women, too young to have ever seen a first-class blanket, were instructed in wool scouring, carding, spinning, dyeing, and proper weaving and design.

As a result of this project, while there are still rugs which the tourist can buy for a few dollars, there are many blankets of excellent workmanship. Apparently, the innate good taste and the

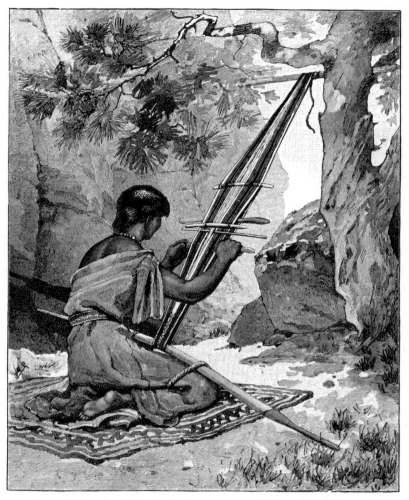

Figure 43. Navaho woman weaving a belt.

feeling for the right artistic expression was not killed off—it has been lying dormant, perhaps frustrated, during these years until released finally by an awakened public demand.

Although the present-day traders, now frequently men of high ideals and far-seeing wisdom, have almost won their fight against cotton warp, a blanket with this inferior warp is occasionally woven. Instead of spinning her own warp yarn, the weaver is still using ordinary cotton twine or yarn, and in this way saves herself a great deal of work.

In an ordinary four-by-six blanket, there are 1,400 feet of warp yarn, and the substitution of the ready-made material saves many days of tedious labor. To the casual observer, the cotton warp is not evident and in no way affects the appearance of the blanket, but it does affect the wearing qualities, for cotton warp is weak and cannot stand the strain of rough usage.

The dealer's word can usually be relied upon, but if the buyer wishes to examine the warp, it is not difficult. If the blanket is not too tightly woven, the weft threads can be spread apart with the fingernails, and the warp threads brought into view, or short sections of the warp threads may be seen at the ends of the blanket where they loop around the last weft threads. Note the appearance of these threads. If they are very smooth and even and not very tightly twisted, and if each thread is made up of several smaller threads twisted together and looks like ordinary twine string, the blanket has a cotton warp.

But if the warp threads are somewhat rough and uneven, very tightly twisted, and are not made up of several small threads, they are of wool. They are usually gray or white in color, and their handmade character is evident.

Bibliography

1. AMSDEN, CHARLES AVERY. *Navaho Weaving.* Santa Ana, Calif.: Fine Arts Press, 1934.

2. DELLENBAUGH, FREDERICK S. *North Americans of Yesterday.* New York: G. P. Putnam Sons, Inc., 1902.

3. DENSMORE, FRANCES. *Chippewa Customs.* (Bulletin 86, Bureau of American Ethnology.) Washington, D.C.: Government Printing Office, 1929.

4. FEWKES, JESSE WALTER. *Casa Grande, Arizona.* (28th Annual Report, Bureau of American Ethnology.) Washington, D.C.: Government Printing Office, 1912.

5. HOLMES, WILLIAM H. *Textile Art in Relation to Form and Ornament.* (6th Annual Report, Bureau of American Ethnology.) Washington, D.C.: Government Printing Office, 1888.

6. JAMES, GEORGE WHARTON. *Indian Blankets and Their Makers.* Chicago: A. C. McClurg & Co., 1927.

7. KISSEL, MARY LOIS. "Indian Weaving," *Introduction to American Indian Art* (Collected and published by the Exposition of Indian Tribal Arts, New York), Part II, 1931.

8. MATTHEWS, WASHINGTON. *Navaho Weavers.* (3d Annual Report, Bureau of American Ethnology.) Washington, D.C.: Government Printing Office, 1884.

9. NELSON, EDWARD WILLIAM. *Eskimo About Bering Strait.* (18th Annual Report, Bureau of American Ethnology.) Washington, D.C.: Government Printing Office, 1899.

10. RUSSELL, FRANK. *The Pima Indians.* (26th Annual Report, Bureau of American Ethnology.) Washington, D.C.: Government Printing Office, 1908.

11. SETON, JULIA M. *The Indian Costume Book.* Santa Fe, N.M.: Seton Village Press, 1938.

12. SLOAN, JOHN, and LA FARGE, OLIVER. "Weaving," *Introduction to American Indian Art* (Collected and published by the Exposition of Indian Tribal Arts, New York), 1931, pp. 15–21.

13. STEVENSON, MATILDA COXE. *The Zuñi Indians.* (23d Annual Report, Bureau of American Ethnology.) Washington, D.C.: Government Printing Office, 1904.

14. WYMAN, ANNE. "Nez Percé Bags," *The Masterkey*, May, 1935, pp. 92 and 94.

Suggested Reading

BLOOM, LANSING BARTLETT. "Early Weaving in New Mexico," *New Mexico Historical Review*, Vol. 2 (July, 1927), pp. 228–38.

CLARK, ANN NOLAN. "Art of the Loom," *New Mexico Magazine*, Vol. 16 (November, 1938), pp. 9–11, 35–36.

DICKEY, ROLAND FRANCIS. *New Mexico Village Arts.* Albuquerque, N.M.: Univ. of New Mexico Press, 1949.

DOUGLAS, FREDERIC HUNTINGTON. *Southwestern Weaving Materials,* Leaflet 116, Denver Art Museum, Dept. of Indian Art, 1953; *Acoma Pueblo Weaving and Embroidery,* Leaflet 89, Denver Art Museum, Dept. of Indian Art, 1939; *Weaving at Zuñi Pueblo,* Leaflets 96 and 97, Denver Art Museum, Dept. of Indian Art, 1940; *Weaving in the Tewa Pueblos,* Leaflet 90, Denver Art Museum, Dept. of Indian Art, 1939.

HUNTER, JOHN D. *Memoirs of a Captivity Among the Indians of North America.* London: Longman, Hurst, Rees, Orme, Brown, and Green, 1823.

McNITT, FRANK. "Two Gray Hills, America's Costliest Rugs," *New Mexico Magazine,* Vol. 37 (April, 1959), pp. 26, 52, 53.

MERA, HARRY PERCIVAL. *Navajo Textile Arts.* Santa Fe, N.M.: Laboratory of Anthropology, 1947.

REICHARD, GLADYS AMANDA. *Navajo Shepherd and Weaver.* Locust Valley, N.Y.: J. J. Augustin, Inc., 1936.

SPIER, LESLIE. "Zuñi Weaving Technique," *American Anthropologist*, n.s., Vol. 26 (January–March, 1924), pp. 64–85.

TOULOUSE, JOSEPH HARRISON, JR. "Navajo Slave Blanket," *Desert Magazine,* Vol. 22 (February, 1959), pp. 22–24.

UNDERHILL, RUTH MURRAY. *Pueblo Crafts.* Phoenix: U.S. Indian Service, Dept. of the Interior, Education Division, 1944.

5

Leather

The untreated dry skins of animals are inflexible and soon rot. Primitive man early learned how to prevent this decay by treating hides in various ways—with smoke, oils, and the brains of animals themselves. This treatment is called tanning. Leather is the term applied to animal skins chemically modified by tanning and otherwise, so as to arrest that proneness to decomposition and to increase their strength, toughness, and pliability.

There yet exist remains of tanned leather made in Egypt not later than 900 B.C. In modern times, the methods and principles of leather-making have come to be well understood, but the processes employed now are not radically different from those used by earlier man.

The skins of all animals may be made into leather; but, in practice, the raw materials of the manufacturer consist of the skins of certain animals which are reared and slaughtered primarily for other purposes, and of which the supply is sufficiently large to form the basis of a great industry. Large skins, such as those of oxen and horses, are in trade termed hides; those of calves, sheep, goats, and other smaller creatures are called skins.

Skins of animals were the Indian's most valued and useful property and later his principal trading asset. Every kind of skin was used in some tribe or another, but those most used were the buffalo, elk, deer, antelope, beaver, ermine, certain large birds in ceremonial costumes, the jackrabbit and, among the Eskimo, the seal, the walrus, the salmon, and the wolf-fish.

Large hides with the fur on were used for bedding and robes.
Elk and deer skins were used for clothing, the left-over scraps
serving for the uppers of moccasins, for fringes, and for small bags
and pouches. In these pouches were kept various things, such
as dry pulverized paint which the Indians used to adorn their
persons as well as for decorating utensils, the porcupine quills
which the Plains Indians used in embroidery, and the awls and
sinew used in the sewing of many of their garments. Figure 44
shows a few of these bags. These were generally partly covered

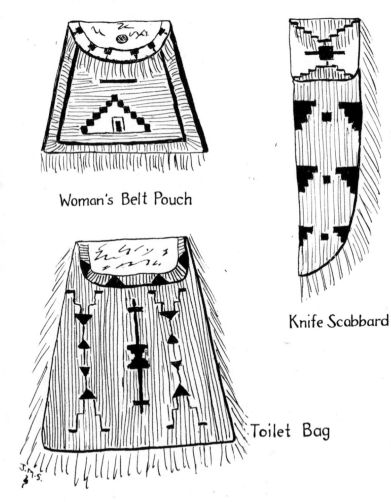

Woman's Belt Pouch

Knife Scabbard

Toilet Bag

Figure 44. Leather bags.

with beadwork and often further decorated by the attachment of tin cylinders or buttons.

The skins used for shields were prepared so as to be hard and resistant; parfleche skins used largely for saddle bags were stiff but thinner; and skins for clothing were usually pure white, soft, and smooth.

Methods of Dressing Skins

There are three methods by which leather is prepared: first, and by far the most important, with tanbarks and other vegetable substance containing tannin; second, by shamoying or impregnating with oil; and third, by tawing with alum, bichromate of potash, and other mineral salts.

The skins used for leather contain a fibrous gelatinous substance called collagen, which, in being boiled, forms the ordinary gelatin of commerce, and an interfibrous compound called coriin, which is insoluble in water but which, together with collagen, unites with tannin to form the insoluble and unalterable compound tannogelatin, the chemical basis of tanned leather.

Dressed skins vary greatly in texture and in finish, depending on the treatment given.

TANNING

The word *tan* is the old word meaning *oak* or *fir*, the tanning tree; hence, also the word *tannin*, the principal substance used in the process.

Tannin, tannic acid or digallic acid, is an astringent, vegetable substance found in gall-nuts and hence called gallo-tannic acid. The name tannin has, however, been applied to a number of different astringent compounds existing in the bark or leaves of most trees. These compounds, though not intimately related to each other, yet agree in giving blue or green-black compounds with salts of iron and in producing leather by their action on animal skins.

The methods for dressing skins were very much the same everywhere in the United States, the difference being chiefly in the chemicals used and in the amount of labor given to the task. Among the Plains tribes, the ancient method is still used with

only slight modifications. The process consists of six principal stages: fleshing, scraping, braining, stripping, graining, and working. When the skins are dressed for robes, the hair is not removed.

James Mooney (Ref. 3) tells us that the fleshing process begins as soon as possible after the hide is stripped from the carcass, while the skin is still soft and moist. The hide is staked out upon the ground, fleshy side up. Two women, working together, scrape off the flesh and fat by means of a sort of gouge with a serrated edge, made from the leg bone of some large animal, more recently made of wood or metal. Each side is scraped in turn, the final scraping being the more delicate operation.

Then comes the braining process, in which the skin is thoroughly anointed with a mixture of cooked brains and liver, grease, and pounded yucca, all mixed together and applied with a sponge of yucca fiber. A little salt is frequently added. The liver is hashed, or sometimes chewed, to render it fine enough for cooking.

Next a bundle of dried grass is laid in the center of the hide and saturated with hot water; then the corners of the hide are brought together over it in the shape of a bag, and the skin tightly twisted into a solid ball and hung up to soak overnight.

Now comes the stripping, intended to squeeze out the surplus moisture and the dressing mixture. The dampened hide is first opened out and twisted into a rope in order to expel as much moisture as can be thus dislodged. Then it is stretched tightly, at an angle of about 45 degrees, in a frame consisting of a crosspiece supported by two stout forked poles, the lower end of the skin being staked to the ground.

The stripping is done by two women, each one using a broad blade about 6 inches long set in a bone handle. These tools are drawn steadily from top to bottom, causing a thin stream of water to ooze out before the blade. As one woman nears the bottom, her partner follows along the same track before the moisture can work back under the blade. In this way, the work goes on over the whole surface of the skin, which is then left suspended in the frame to dry and bleach until it is ready for graining.

Graining is done with a globular piece of bone as large as can

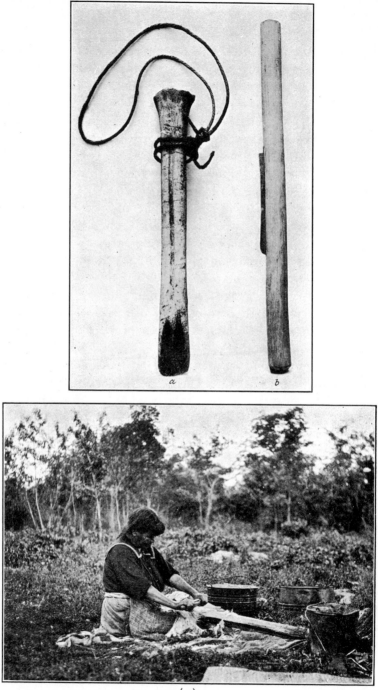

Figure 45. Dressing skins: (a) flesher; (b) scraper; (c) woman removing hair from skin.

be conveniently held in the hand. With this piece of bone, the whole surface of the skin is rubbed as with sandpaper to reduce the hide to uniform thickness and smoothness and to remove any hanging fibers. After this, the breaks and holes are repaired with an awl and sinew thread.

Then comes the process of working and softening to render the skin pliable. It is done by drawing the skin for some time in seesaw fashion across a rope of twisted sinew stretched between two trees a few feet apart. Sometimes it is first drawn around the trunk of a tree for a short time, two women again working together, one at each end of the skin. Then it is cleaned with a wash of white chalk clay in water, put on thick with a bunch of root fiber or dried grass for a brush and brushed off when dry.

It is doubtful if skin dyeing was commonly practiced in primitive times, although every tribe had some method of skin painting. The Omahas, however, procured a dark blue or black dye by combining the bark of the white maple with pulverized and roasted yellow ocher. The Plains tribes used the juice from the leaf of the prickly pear as a mordant to fix the painted design; and they obliterated it, when so desired, by rubbing it with a piece of roasted liver.

Since the process described above is impractical for present-day living, here is a tried and proven method which will be useful.

The first stage in the preparation of the hide for the actual tanning operation is to cleanse it thoroughly and bring it back to the soft pliable condition which it had as a part of the living animal. To do this, the hide is soaked for several days in a solution of salt and water—6 pounds of salt to 20 gallons of water, unless the skin is bloody, in which case more salt is required.

When the skin is soft and clean, take it out of the salt water solution, and wash it thoroughly with soap and water. Rinse carefully, making sure that there is no salt or soap left on the skin.

This cleansing process may be done by burying it in warm mud until the hair begins to slip. In summer weather, three to six days are required; but we have had a skin buried for six weeks without success when it was so cold that it froze every night.

A quicker method is as follows: Make a stock solution of 5 pounds of quicklime to 5 gallons of water. Use about half of this stock to 20 gallons of water to make a solution in which the skin

is to soak. Leave it in this bath for about twelve hours or until the hair or wool is loose. Do not put your bare hands into the lime solution, or even handle the lime-soaked skin much. Remove it with a stick, and wash it with soap and water. Neutralize it in a bath of sal soda (washing soda) and water; or, if delicate skins are being treated, household ammonia and water. When the hair is ready to slip, the skin is much thicker than it had been, densely white, and soft as silk.

The hair is now easily removed by laying the skin across a fleshing beam and running the back of a drawknife or other blunt blade over the skin against the hair and away from the body of the worker.

After the hair is removed, turn the skin over. All the surplus meat and fat must now be scraped off without cutting into the hide during the process. When the scraping is finished, the flesh side of the skin should be nearly as smooth and clean as the grain side, from which the hair was removed. The skin is now bluish-white in color, and clammy but not greasy to the touch.

We are now ready for the actual tanning process. The notable characteristic of all hides and skins is not so much their chemical composition as their physical structure. They are made up of a vast number of minute fibers, intricately interlaced. This structure gives the hide its wonderful flexibility and strength, while leaving it sufficiently porous so it can breathe, permitting air and moisture to pass in and out through it. The problem of the tanner is to retain this marvelous fibrous texture of the hide with its strength and flexibility and power to breathe, and yet to make the tanned hide so permanent that the leather will not rot or dissolve or materially alter under normal conditions of use. The tanner has found several ways of doing this.

OIL TAN OR SHAMOYING

Shamoying consists in impregnating and saturating skins with oil. The name *shamoying* is derived from the fact that the process was originally applied for the preparation of the skins of the Alpine chamois. The oil is worked slowly into the interstices of the skin and there becomes oxidized, forming a combination with the gelatinous constituents and yielding a peculiarly soft and spongy texture.

For oil tanning, the materials may be neatsfoot oil, yolks of eggs, tallow or other animal fat, or brains. These are mixed with a thick jelly or solution of white soap made by boiling fine soap shavings in water, using five parts of soapy water to four parts of oil. Thin this mixture out with water until it is quite thin and runs freely—about the consistency of milk.

The Indians did this tanning with the liver and brains of a calf. At Seton Village we have used this method successfully. Boil the liver for an hour, then mash it up with the raw brains. If the liver is hard to come by, the brains alone will do. They may be prepared by soaking in cold water with a little salt for twelve hours. One set of brains will do two hides.

This mash is now rubbed thoroughly into the flesh side of the hide, which is then doubled, rolled up, and put in a cool place for a couple of days. It is then opened out, washed clean, and hung till nearly dry. Then, over the sharp angle of a hardwood stake, it is worked till it is soft and leathery.

Mineral Tan or Tawing

Tawing consists in dressing skins with certain mineral salts and is useful principally for glove leathers and the so-called kid-leather employed for the uppers of ladies' shoes. Here are the details of one method of tawing.

Bring to a boil 3½ pounds of aluminum alum in 5 gallons of water. Add 3½ pounds of salt and stir thoroughly. This makes the stock solution. Add one-third of this stock to 30 gallons of water, and soak the hides in it for three days, stirring two or three times a day. Add another third of the stock and soak three days more. At the end of the sixth day, add the last third of the stock, and soak three days more.

Now take the hides out of the alum solution, and rinse out all the alum possible. Work the hide a little over an edged beam, then rub the oil emulsion as described in the previous section on the underside of the skin, and place it in the sun, outer side up. Let it dry, then pull it, and rub in more of the oil emulsion.

Again let it dry, pull, and rub in more oil until the leather turns white and soft on pulling. This process is called oxidizing the leather.

VEGETABLE TAN

Oak and hemlock bark are sources of tannic acid much used in the industry. Next to these, the principal tanning material used in this country is chestnut bark, found in great profusion in our southern forests. There are, however, many other types of tanning material.

In the Southwest, the plant called by the natives Kaniegra (*cania aigra,* or sour cane) is a fine tanning and dyeing source. As a dye, it gives a brilliant yellow-orange. With all our vast area of chestnut, oak, and hemlock, we must nevertheless import great quantities of tanning material, the most important of which is quebracho. This remarkable tree grows in Argentina and Paraguay. Its name is derived from the Spanish words *quebrar,* to break, and *hacha,* axe; it has earned this name, axe-breaker, on account of its flinty hardness. It is generally used with oak or hemlock, rarely alone. Valonia, which is the acorn cup of the Turkish oak, grows in practically all tropical island districts. This material, mixed with other barks and extracts, is widely used in the tanning of sole leather. Galls on the oak tree's leaves are caused by insects which lay eggs on the leaf or bud and so produce an abnormal growth. This gall nut, when dried, contains a high percentage of tannic acid. Sicilian sumac is considered the best of this variety of tanning material, although good grades of sumac are found in some South American countries and in Virginia. The leaves are collected and dried, then ground to a powder, in which form it is shipped. Sumac is used to produce light-colored, soft leathers.

Gambier is derived from a climbing shrub found in the Dutch East Indies and is also grown in China to some extent. Only the leaves of the plant are used. These are chopped and boiled; the heavy extract is then drawn off in almost a pasty condition, allowed to cool, and cut into cubes, in which form it is shipped. Gambier produces a soft leather and is much used in the production of glove leathers. Myrobalans are obtained from the unripe, prunelike fruit of a tree growing in India. Myrobalans, which contain a high percentage of tannic acid, are invariably used with other extracts as a tanning material in making sole leather or leather for machinery beltings. Divi-divi is obtained from the

dried pods of a tree which grows in Central America. This extract, used in conjunction with extracts from other sources, is considered very desirable in the making of sole leather. Wattlebark is from various species of acacia; its principal points of shipment being in South Africa. Its use is increasing on account of its high percentage of tannic acid. Palmetto roots also yield valuable tannic acid used in making sole leathers.

It is not advisable to make less than a 5-gallon batch of vegetable tanning solution. Weigh the vegetables while dry, and cut them into small pieces before boiling. Use 5 pounds of vegetables to 5 gallons of water. Simmer the solution down to about 1 gallon; then cut the vegetables again into smaller pieces. If possible, reduce them to a pulp, adding 4 gallons of water to give the required 5. Boil again for about an hour, till about 1 gallon of water has boiled away. Add half of it to 30 gallons of water.

After the skin has soaked in this, it is ready for the oiling process to soften it.

Some Tips on Tanning

The softening, dehairing, and defleshing of buckskin are the same as for any other skin. Then place the skin in a solution of equal parts of soap and oil or soap and brains.

Take the skin out, oxidize it, and work it. The process of placing it in soap and oil, oxidizing it, and working it is repeated several times until the skin is soft.

In tanning furs when the skin is ready to be taken out of the salt solution, wash it, being sure that there is no dirt left. Deflesh it, and place it in tanning solution. Or, better still, make a paste as follows: Take two cups of the alum stock solution, add white flour, corn meal, or rye flour to make a paste, and add three tablespoonfuls of neatsfoot oil. Rub this paste on the skin. The alum does the tanning, the flour is the carrier, and the oil is the lubricant. This type of tanning is used on fur in the spring when animals are shedding their fur. The alum helps to hold the hair to the skin.

To put a high luster on leather, use beeswax or any other wax. Apply with a woolen cloth or a fairly hot iron. The more you rub, the higher the finish will be. Use paraffin for pliable

leather. Be sure the leather is free from water while waxing, or it will draw up.

Rawhide or Parfleche

Tanned leather such as we have been discussing must be distinguished from rawhide or parfleche. To prepare this, the skin was fleshed, dehaired, and stretched till it dried stiff. Green rawhide, which shrinks greatly in drying, was used in many ways, notably for casing handles and heads of stone clubs, for mending broken articles, for making drumheads and lacing them. Sometimes rings of rawhide from the tails of animals were shrunk on club handles or pipestems, like bands of iron. In the West, soles of moccasins were made of this material. Cut in strips of different sizes, rawhide was used for harness, thongs, whiplashes, wattling, cages, fencing, etc. Narrow strips, called *babiche* by the French, were employed for fishing and harpoon lines, nets, and lacing for snowshoes, rackets, ball sticks, and gaming wheels.

Whole buffalo or cow skins were used as covers for the bullboats by the Sioux and other tribes of the Upper Missouri; deer skins and seal and sea lion skins, joined by sewing, covered the canoes, kayaks, and uniaks of the tribes of the far North.

Undecorated rawhide was used as a vessel in which to boil meat. A hole was dug in the ground, and rawhide pressed down into it, its edges weighted down with stones. The sacklike rawhide was then filled with water, which was made to boil by means of heated stones.

Plates also were made of rawhide, and a flat piece of rawhide was used to pound dried meat on. Buckets, dippers, cups, rattles, shields, and cradles were made of rawhide by various tribes, and helmet masks were made of the same material by the Pueblos.

The trunks and cases are perhaps the most interesting forms. The largest of these were often 2 feet by 3 feet in size and were used for storing clothes, food, and other items. They were usually made in pairs, and one was hung on each side of a bed, or, in traveling, one on each side of the horse. Each of these cases consisted of a single, approximately rectangular piece of rawhide, generally half a buffalo hide. This was trimmed to proper size while still pliable, and the two long sides were folded inward to meet in the middle. The opening where the two long edges

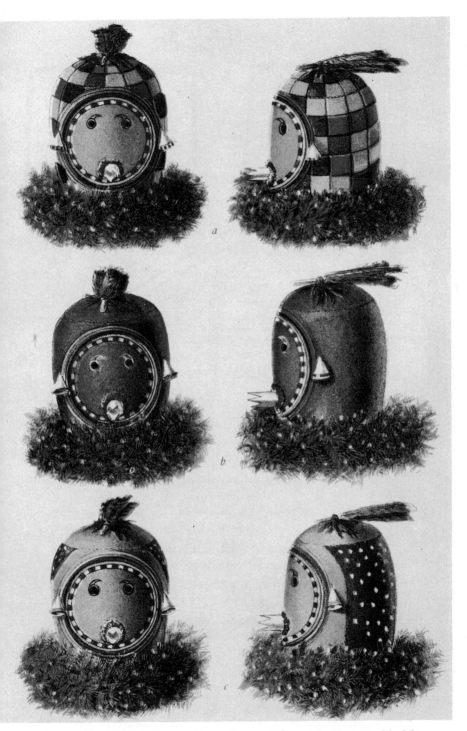

Figure 46. Masks of rawhide. (From Edgar L. Hewett, N. M. State Historical Society, 1930.)

Figure 47. Parfleche designs.

came together was closed by turning over the two short ends of the folded hide so that they also met in the middle, where they were tied together with thongs passed through holes punched along the edges.

Rawhide is stiff and keeps its folded shape, but it is elastic enough to allow the bag to be pressed very flat when empty and widely distended when filled. The side where the ends met in the middle was painted with a design; the back was often simpler than that on the front. The designs were always geometric, and there was a definite symbolism to the pattern, though the inter-

Figure 48. Arapaho sunshade.

pretation of the symbolism varied from tribe to tribe and even within the same tribe. The colors for these patterns were a dark blue, red, yellow, and sometimes green on the creamy white background of the rawhide.

Bags or pouches were also made of one piece of rawhide. There was a fold along what constituted the lower edge of the bag; the edges along the two sides were sewed together. The top was covered by a triangular flap, which was part of the back and was drawn down over the front of the bag.

Small parfleche cases called medicine cases or feather cases were made to hold shamanistic or ceremonial objects. They were roughly cylindrical in shape but tapered slightly toward the bottom and were a foot or more in total length. For some reason, these were always brown in color rather than the creamy white

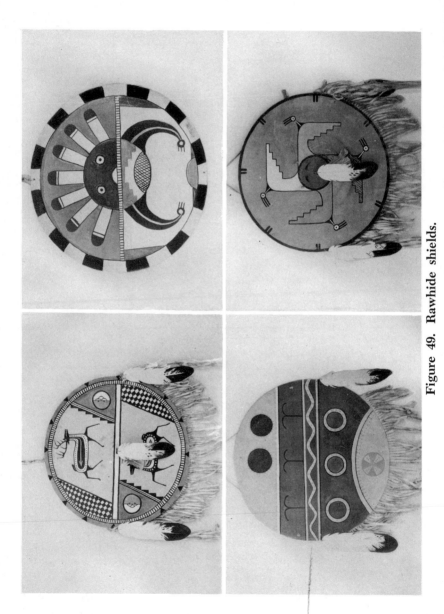

Figure 49. Rawhide shields.

of the ordinary parfleche bags. Arrow cases were approximately the same shape but necessarily longer.

All in all, parfleche was one of the most useful of materials in a great many tribes, and it is still highly prized for its versatility.

Bibliography

1. BOAS, FRANZ. *The Central Eskimo.* (6th Annual Report, Bureau of American Ethnology.) Washington, D.C.: Government Printing Office, 1888.

2. KROEBER, ALFRED L. "The Arapaho," *Bulletin of American Museum of Natural History,* Vol. XVIII, 1902.

3. MOONEY, JAMES. "Skin and Skin Dressing," *Handbook of American Indians.* Washington, D.C.: Government Printing Office, 1910. Part II, pp. 591–94.

4. MURDOCH, JOHN. *Ethnological Results of the Point Barrow Expedition.* (9th Annual Report, Bureau of American Ethnology.) Washington, D.C.: Government Printing Office, 1892.

5. NELSON, EDWARD WILLIAM. *The Eskimo About Bering Strait.* (18th Annual Report, Bureau of American Ethnology.) Washington, D.C.: Government Printing Office, 1899.

6. TURNER, LUCIEN M. *Ethnology of the Ungava District.* (11th Annual Report, Bureau of American Ethnology.) Washington, D.C.: Government Printing Office, 1894.

Suggested Reading

KING, ARDEN R. *Aboriginal Skin Dressing in Western North America.* Berkeley, Calif.: Kroeber Anthropological Society, Spring, 1956. Pp. 97–98.

SPIER, LESLIE. *Plains Indian Parfleche Designs.* Seattle: Univ. of Washington Press, Publications in Anthropology, December, 1931. Vol. 4, No. 3, pp. 293–322.

6

Beading

The American Indian has made many contributions to the esthetic life of our race. Baskets, blankets, and pottery are among the crafts in which he excelled, but beading is particularly his own, at least in its original forms. The most famous beadwork in the world is that of our Indians; no other people produce anything like it. Most tribes bead to some degree nowadays, but in its beginnings, beading was the art of the Great Lakes and Western Plains Indians.

Before the coming of the Whiteman, the Indians made beads out of shell, stone, deer hoofs and toes, teeth of various animals, bones, nuts, and seeds. Minerals of bright color or shiny surfaces were also used. Much skill and patience were developed in cutting, grinding, and rolling such substances into shape. It was necessary to perforate each of these, and the beads thus made were strung as necklaces or tied as pendants to the hair, the ears, the arms, the neck, and waist. They were also hung to skin or basketry receptacles, and sometimes inlaid in wood or soft stone.

Applied Design

Aside from mere stringing or tying of beads, there are so many forms and varieties of beading that the decorative possibilities of the craft are almost inexhaustible. Probably the earliest type of beading practiced by the Indians, with what we now call seed beads, was sewing the beads onto a piece of buckskin with a sinew thread. For this, no needle was required. Holes were punched

into the skin with a bone awl, four or five beads were strung on the sinew, and the stiffened end of this thread passed through the hole. The process is much facilitated these days by the use of needles. If the material to be beaded is leather or buckskin, the work is done on the flesh side, and the stitches do not go through to the other side; thus giving a perfectly smooth surface to be worn next to the body. In a moccasin this is particularly important. The method of beading depends largely on the design selected.

The Chippewa method of using beads consists of sewing beads on cloth or leather. In the early days, they were sewed directly onto the cloth of the garment; in more modern times, they are frequently sewed to black velvet which in turn is sewed to the garment. Originally, deer sinew was used as thread, and the result was work which was strong and durable. But cotton or silk thread is available now and, used with care, is fairly satisfactory.

The decoration on Chippewa garments is usually floral patterns, full of curves. Therefore, the outline must be followed first. Originally, this was all the beading that was done, and old examples of women's dresses show this form used on the front piece.

When beads became more abundant, a second line of beads was sewed inside the first, making a double outline. Still later, the whole pattern was filled in, row after row, until the entire space was solidly filled with beads.

Now the Chippewa frequently use a background consisting of solid rows of white beads sewed on cotton cloth. This method of beading is as follows: If velvet is to be used, it is sewed to a piece of calico to give it firmness. Each color of beads is now strung separately on thread, then wound on a roll of cloth. A string of beads of the desired color is then laid along the outline of the pattern and fastened in place by overlaid stitches at intervals of two or three beads, depending on the fineness of the pattern (Fig. 51).

Another method I personally have found satisfactory for this type of beading is as follows: A thread is fastened firmly to the side of the material (usually leather) to be beaded, thus protecting the body from any roughness caused by knots. Beads, the number varying according to the curve to be followed, are strung on

Figure 50. Beaded bags: (a) old design; (b) and (c) partially completed beadwork on black velvet.

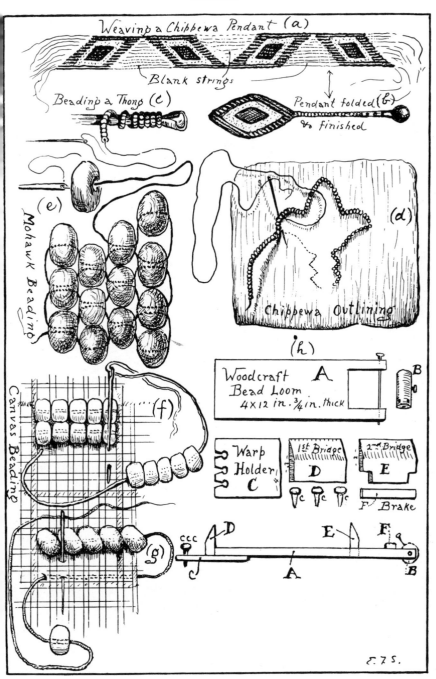

Figure 51. Indian beading methods.

the needle; then a tiny backstitch is taken into the leather but not through it. (This is known as the lazy stitch.) This process is repeated until the pattern is completed.

If a large area is to be solidly covered with beading, the method is much the same except that there is no outline to follow. However, even in this, there are two different effects possible. If a ridged appearance is desired, the same number of beads are strung on the thread at each stitch. If a flat surface is wanted, the number of beads at each stitch is varied; that is, if on one line five beads are strung at a time, use six or four on the next line. Both methods were used by the Indians.

BEADED MOCCASINS

The beading of moccasins was an important part of the everyday life of the Plains Indians.

There is invariably a band of beading on the upper where it joins the sole. Sometimes this is barely half an inch wide, sometimes much more; in fact, in many cases, the entire upper is solidly beaded. But, whatever the degree of ornamentation, the method is the same. It is a ridged applied form.

A thread is anchored to the moccasin, six or eight beads are strung, usually on a sinew, and the thread is secured to the moccasin again at a point which will exactly accommodate the string of beads in a vertical line. This process is repeated immediately alongside the first line and continued all around. If the beaded band is to be 2 inches wide, twelve to sixteen beads are strung at a time, anchored flat, and then a catch-stitch is put in at the middle of the line. Often, beading and quillwork are combined on one moccasin.

In the illustrations of the beading of moccasins (Fig. 52), we have tried to tell of which tribe each is. There are certain characteristics of the local groups; but in these days, they borrow and exchange so much that it is almost impossible to tell the origin of a given pair.

BEADED ACCESSORIES

In some of the tribes, notably the Menomini, neighbors of the Chippewa, a garter was a usual accompaniment to the man's

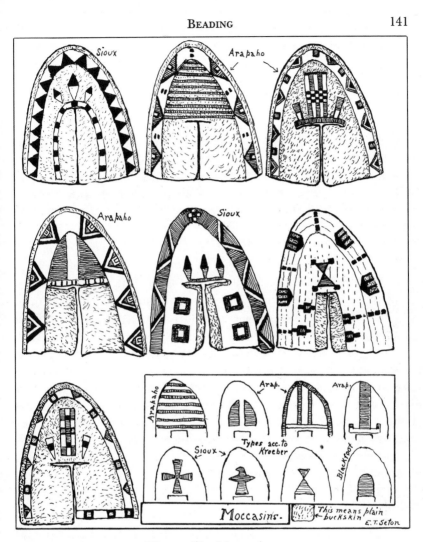

Figure 52. Moccasins.

costume. Worn immediately below each knee, it varied in width from 2 to 4 inches and in length from 18 to 20 inches. At each end was attached a strand of colored yarn 2 feet long which passed around the leg and tied in front in a bowknot. The garters were always made by the women, who also contrived the designs. Usually the pattern was diamond shaped, sometimes in solid colors but more often filled in by sharply contrasting shades.

Down the sides of the pants and around the lower edge of the leg, the men often attached bands of flannel or buckskin, hand-

somely beaded. Beaded armlets and bracelets were sometimes worn also. Extremely showy bags of cloth, solidly beaded, were worn by the men. They hung at the side from a broad band which passed over the opposite shoulder.

BEADED THONGS

Beaded hangers of various kinds were popular among the Indians of most tribes. They were a very decorative touch added to the rosettes of a warbonnet or as loose ends with which to trim a dress. The method of beading was much the same as in the floral patterns.

To make beaded thongs, cut a thong to the required length; this will form the core. The needle, threaded with sinew or other strong thread, is anchored about an inch from one end, leaving enough unbeaded material to sew the finished product to the bonnet or dress. Wrap the core firmly with several rounds of the thread. Now string a dozen beads on the thread. Wrap these around the core as many times as they will go, keeping the beads close together, and stitch through the core. Go through the last two or three beads again and repeat the stringing, wrapping, and stitching until the beading is the required length. It is helpful if the thread is the same color as the beads and if the thong is strained between two points. This method of beading might be used for the handles of war clubs, quirts, etc., going round and round the core to be covered.

BEADED TARGETS

There are two methods by which a solid circular disk, or target, may be beaded. One is by concentric rows of beads, done according to either of the methods described above for sewing beads to any design. The other method has been variously called Ute and Mohawk beading. A very small circle of beads is sewed firmly in the center; there should, however, be space enough between each two beads to allow another bead to be slipped in on the next row. A bead is now strung on the thread, and the needle passed through a bead of the original circle. Another bead is strung, and the needle passed through the next bead of the original row, and so on, the thread taking a zigzag path with each

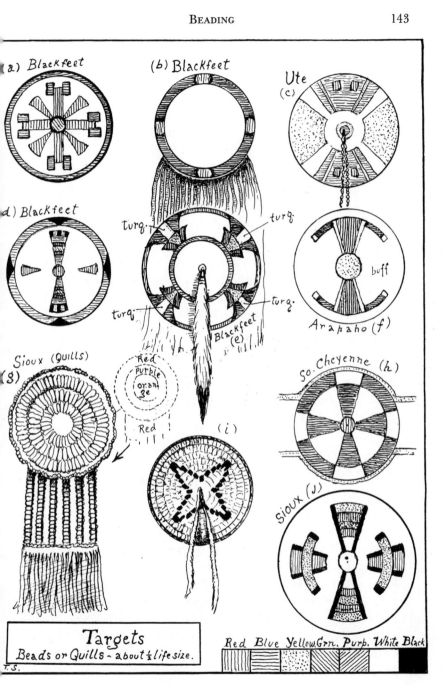

Figure 53. Targets.

successive bead (Fig. 51). Once in a while, it is necessary to anchor the thread through the backing or the rosette will be loose except at the very center.

The fault with this method of beading a target is that, on each successive row, the beads are a little farther apart, and the background shows through. The first method is preferable for a solid disk.

BEADED PENDANTS

Two methods of construction for bead pendants are popular, especially among the Chippewa. The simpler one is merely to take a ball of some soft material covered with white cloth, and sew strings of beads to this in rows, round and round. The other method is a bit more complicated, but, by the same token, more interesting. The method is illustrated in Figure 51. It is done by the woven-bead technique, which is discussed in detail later. Diamonds of any desired size are woven on a loom, leaving strands in triangular form between them. When the desired length is made, it is removed from the loom, and the threads drawn together, forming a little bead bag. This is stuffed with cotton and sewed along the edges where necessary. It makes a pendant which can be attached to any part needing decoration.

CANVAS BEADING

There is a very simple method of beading a band. The way is not Indian but gives the same effect with less danger of inaccuracy. This method is appliquéing beads to cross-stitch canvas. The canvas can be bought at any art embroidery shop and is the same material used for embroidering cross-stitch in silks or wools. It is a firm-threaded canvas in which pairs of threads are spaced apart a distance about the size of our seed beads. At intervals of half an inch in each direction, the threads are colored blue, so that the entire surface is blocked off into half-inch squares.

The effect of the solid beaded ridged pieces, as described for the moccasins, can be exactly duplicated in this manner: Anchor your sewing thread to the corner of one of these blue outlines. Thread as many beads on your needle as will exactly reach to the opposite corner on the same line of the block. Sew *into* that

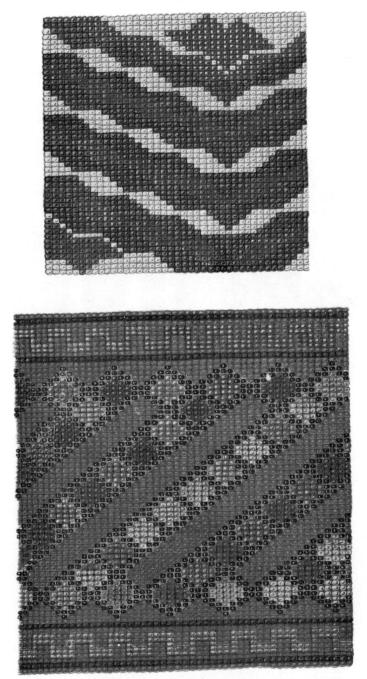

Figure 54. Dancing garters.

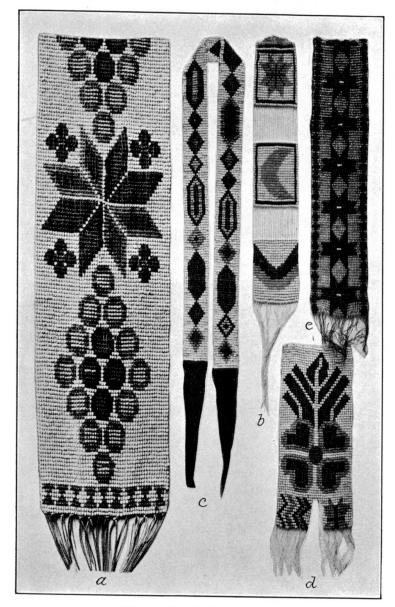

Figure 55. Bead patterns.

corner hole and *out* of the one directly below it, treating each pair of threads of the canvas as one. Again thread the same number of beads on the needle, sew into the opposite hole and out of the one below it. A design may be made by varying the colors of the beads (Fig. 51).

Where a ridged effect is not desired, an all-over design may be obtained by sewing one bead at a time on this canvas, carefully watching the colors. Anchor the thread at one hole, pick up a bead, sew into the hole diagonally downward to the right and out of the hole directly to the left of it. Pick up another bead and continue as before. The stitch used is the first diagonal stitch of cross-stitch embroidery (Fig. 51). The effect is much like that of diagonally woven beads, as each bead is sewed on slantingly.

This canvas beading can, of course, be used when only one side of the completed product is to be seen. Strips for pantaloon legs, garters, armlets, and headbands are possible when they are backed with material after the beading is finished.

Woven or Loom Beadwork

The woven form of beading, done on a loom, is perhaps the most popular form now. In the very early days, before the loom was invented, two layers of birchbark were used, one over the other. Between these two layers, a number of threads were stretched, side by side, the number determined by the width desired for the finished band. These were the warp. Then, by means of a needle and thread, a string of beads, really the woof, was fastened in place at right angles to the warp threads, so that the beads were held horizontally beneath the warp threads. The beads were then pressed upward so that one bead was between each two threads. The threaded needle was then passed through the beads above the warp and then back again through the bead, below the warp. This held the beads securely in place. The whole was kept taut by fastening one end to a stick held beneath the woman's knee or to a cord tied around her waist. The other end was attached to a post or a tree at a little distance.

A loom may now be bought for a nominal sum; or one may easily be made at home in an evening, according to the directions given below (Ref. 4).

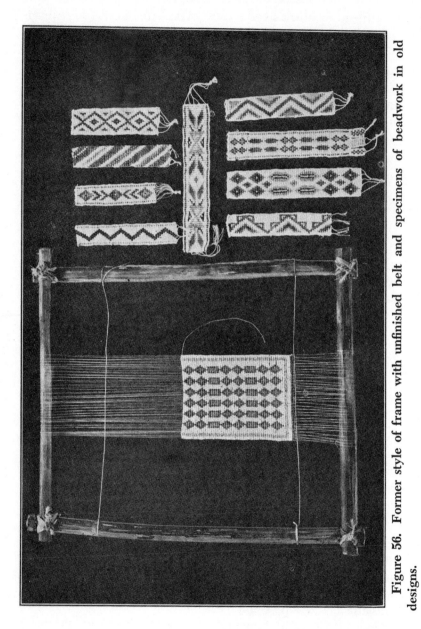

Figure 56. Former style of frame with unfinished belt and specimens of beadwork in old designs.

If the beaded band is to be a short one (not over 8 or 9 inches), the loom may be made of a cigar box with the cover removed and the two long sides cut down to about half the original height. Cut slots into the top of the two short sides, the distance apart depending on the size of the beads to be used. Drive a nail into the bottom of the box at one short side, and peck a hole into the center of the other short side. Cut a wooden peg to fit the hole.

Cut one more thread than the number of beads to be used in the width of the band, and about 12 inches longer than the finished band is to be. Tie all these strings together at one end, and secure the bunch on the nail which you drove in at one end of the box. Pass the threads into the slots which you cut into the top of the short side of the box, one thread in each slot. When all are in, gather them together, roll them into a rope, slip the end through the hole in the side of the box, and fasten there with the wooden peg.

If the finished band is to be 15 or 16 inches long, the loom may be threaded differerently, and the hole at one short side eliminated. Fasten to the nail one end of a thread from a spool. Draw the thread into the far slot, across the top of the loom, into the near slot, around under the box, up into the slot again; and so on until the required width is obtained. Do not break the thread from the spool until the loom is wholly threaded. As the beading progresses, move the whole band of threads until it is long enough, then cut across the threads, releasing the band.

If the finished band is to be longer than twice the length of the loom, another device must be employed. In this case, a cigar box is not desirable, though still possible with reinforcement. The best plan, I take it, is to make one's loom out of solid pine boards. Herewith I offer a plan that is quite satisfactory. I made this loom in one hour—could do it in less time if all the material were ready at hand. [Fig. 57.]

The baseboard (A) is of ¾ inch stuff; i.e., dressed inch. The roller (G) is 3 inches of a broom handle, with a small hole bored right through the long way, and 4 small holes at right angles to this to receive nails that hold it fixed after the beadwork is rolled. The slot (E) is nailed on the two arms so that the nails may rest against it as a lock. The roller has a short strong nail in the middle to secure the bundle of warp strings.

The first bridge (C) has saw cuts at intervals determined by the size bead to be used. This bridge is nailed on to the end of the baseboard. The second bridge needs no grooves or saw cuts; it is nailed between the arms on the other end of the base.

The warp holder is of ½ inch stuff. It has three slots, into each of which one-third of the warp ends are firmly held by plugging with one of the wooden plugs (F). This holder is nailed on the under side of the base after the first bridge is in.

Now cut your threads as before—one more than the number of beads in the width of the desired band, and about 12 inches longer than the desired length. Tie them together at one end, and fasten this bunch to the

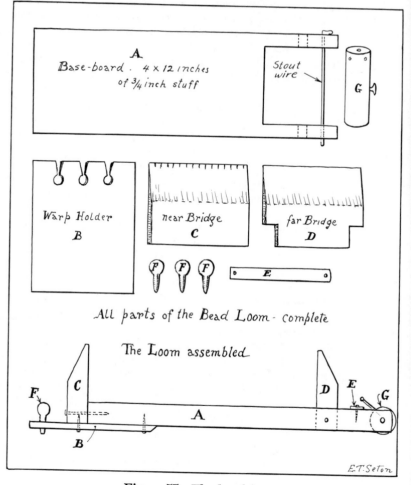

Figure 57. The bead loom.

large-headed nail in your spool. Slip a thin wire nail into whichever hole on the sides of your spool will hold the spool, without allowing it to turn.

Thread the loom as before, using the slots in the two bridges; then gather them together in one bunch (or two or three if there are many), slip the bunch through the open side of the holes in the base (C), and fasten with a wooden peg.

As the beading progresses, and becomes too long for the loom, wind the finished part up on the spool, and proceed to the end.

The method of beading on a loom is very simple, and results are quick when once the mechanics are mastered.

Attach the beading thread to the left-hand warp thread about an inch

in front of the top bridge. Put on as many beads as are required for the width of the band (one less than the number of threads), pass the beading thread *under* the warp threads, pushing one bead up between each two threads. Now double back the beading thread *over* the right-hand warp thread, and pass the needle back through the row of beads, making very sure that it always goes *over* the warp threads. Then string the beads for the next row, and proceed as before.

When the beading thread is almost exhausted, go back through as many beads as you can get through, and cut off the end close to the work. Re-thread the needle, pass through the last row of beads again from right to left, and you are ready to start again.

The band may be finished off with a square edge straight across, or with a tapered point, or with a fringe of beads.

There is another form of loom beading much practiced by the Menomini. Dr. Walter James Hoffman (Ref. 2) describes the method thus:

The pattern is begun at the lower end, several inches from the frame. A fine needle is threaded, the other end of the fiber being secured to one of the lateral threads of the warp. Then the needle is passed through a bead of the desired tint of the ground color of the garter, and the thread passed under one vertical or warp cord. Another bead is then taken up, after which the needle is pushed along over the next cord. Then, another bead being threaded, the needle is again passed along under the next following cord, and so on alternately above and beneath the warp cords until the other side is reached, when the outer cord is merely inclosed by one turn. The same process is followed in the return to the side from which the beginning was made, except that the threads alternate, the woof being now above instead of below the warp cords.

This is much slower than the previous method, is harder on the eyes, and has the same appearance except that the work is not so firm. I do not advocate it for youngsters.

When the design is completed, the warp cords are gathered by bunches of twos or threes, and tied in knots, so as to prevent the dislodgment of the woof fibers and the consequent destruction of the entire fabric. To these ends are afterward attached strands of woolen yarn to lengthen the garter, so as to reach around the leg and admit of tying in a bowknot.

As a rule, the ends of the pieces of beadwork are at right angles to the direction of the warp, but in many small examples, such as collars or necklaces, the ends terminate diagonally, an effect produced by the successive rows containing one or two beads less

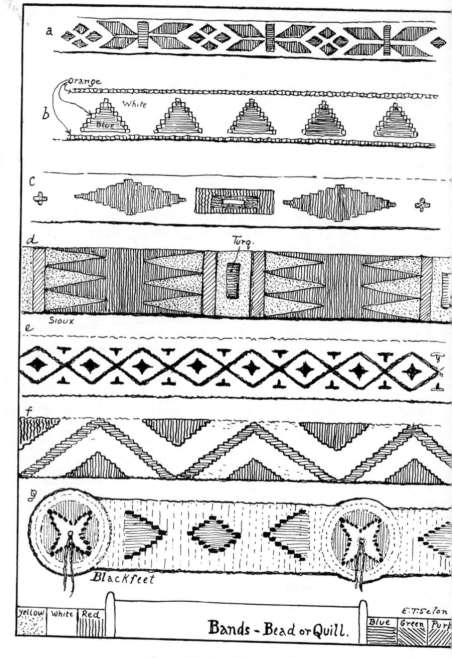

Figure 58.　Bead or quill bands.

than the preceding row, the diagonal side being on one side of the article only, and not divided so as to turn toward a central apex by simultaneously leaving off one or more beads on both sides.

The lateral edges of the garter may be smooth or beaded— that is, the threads may either simply inclose the outside vertical thread and return to take up the next upper row of beads, or they may pass through one bead and then return on the next line.

The object of the lateral beads, which project edgewise, is to protect the outside cords from wear.

The Seminole and other southern tribes use an interesting form of beading. First, a belt or garter is woven of commercial yarn. Both warp and weft are diagonal. On this background, beads are strung at intervals in predetermined designs with colored yarn showing through.

Another very striking effect is obtained by the use of diagonal weaving, using horsehair for both warp and weft. The entire surface is then beaded. The stiffness of the horsehair holds the threads apart and allows the light to shine through, creating a most interesting effect.

Tube Beads

The tube bead, which is much like the old wampum, works up into many artistic forms. These beads are practically square, measure about a quarter inch each way, and are pierced with a much larger hole than seed beads—so large, indeed, that they may be strung on thongs instead of threads. They are particularly useful in the making of armbands, garters, and so on.

To string tube beads on thongs, first, make four or five leather strips about ½ inch wide and as long as the width of the finished band is to be. These strips are pierced with a hole at each spot where a row of beads will pass through, that is, about ¼ inch apart. Now, pass your thong through the uppermost hole in one leather strip, string five or six beads on the thong, then thread the thong through the uppermost hole in the next leather strip. Take up another five or six beads, and continue until the required length is obtained. Fasten the thong into the first leather strip to hold

the circle. Then proceed to the remaining rows in the same manner. The band may also be made in a long strip, and tied in place on the body when worn.

These arm and leg bands are very effective if finished off with a pendent thong strung with beads and tipped with a few fluffy feathers. Breastplates may be made in the same way, or very good ones may be made of long ivory paper beads.

Paper Beads

The making of paper beads is an activity which is popular with many people, especially the young. It is a really useful pursuit, and there is practically no cost for the material. These beads may be made of colored magazine covers or scraps or samples of wall paper; and even printed newspapers make most attractively designed beads, which no longer resemble print but produce a beautiful mottled effect. For most beads, the paper is cut into long isosceles triangles. The length of the bead is determined by the length of the short side of the triangle; the finished bead will be exactly as long as the short side. The thickness of the bead is determined by the length of the two long sides; the longer these sides are, the thicker the bead.

For breastplates (the Indians' original were made of bone), the best material is a slightly creamy paper without any pattern, such as the cheapest wrapping paper, or a cheap quality of ivory wall paper. To make a breastplate, cut a form 4 inches on one side, tapering to 2 inches—24 inches away. Starting with the 4-inch side squarely toward you, begin to roll the paper onto a steel knitting needle or other rod of about that thickness, slightly greased to prevent the bead from sticking to the knitting needle later on.

When the whole strip is thus rolled up, paste the final end firmly in place. As many beads should be put on the knitting needle as it will hold. Then dip the whole string, needle and all, into colorless shellac, being careful that the bare needle is not exposed to the shellac, or there will be difficulty in removing the beads. When the shellac is dry, take the beads off the needle, and they are ready for use. For the breastplate, leather strips should be used as for the arm bands in order to hold the strings in place.

I have seen these separating strips made of felt or even cotton cloth, but they have not body enough to hold the breastplate in shape.

Designs

Beading is a project of almost inexhaustible possibilities. There are so many beautiful beaded products that it is impossible to give directions for all of them in this chapter. Here, however, are instructions for certain of the articles pictured.

In the directions which follow, colors are keyed as follows: w is white; b is blue, meaning a turquoise, not the dark blue; r is red; o is orange; and y is yellow.

BEADED BAND (See Fig. 58a.)
19 Beads Wide

(1)	5w	1r	3w	1b	3w	1r	5w
(2)	4w	3r	5w	3r	4w		
(3)	3w	5r	3w	5r	3w		
(4)	4w	3r	5w	3r	4w		
(5)	5w	1r	3w	1b	3w	1r	5w
(6)	8w	3b	8w				
(7)	1w	1r	5w	5b	5w	1r	1w
(8)	1w	2r	5w	3b	5w	2r	1w
(9)	1w	3r	5w	1b	5w	3r	1w
(10)	1w	4r	9w	4r	1w		
(11)	1w	5r	7w	5r	1w		
(12)	1w	6r	5w	6r	1w		
(13)	1w	7r	3w	7r	1w		
(14)	1w	8r	1w	8r	1w		
(15)	2w	7r	1w	7r	2w		
(16)	3w	6r	1w	6r	3w		
(17)	4w	5r	1w	5r	4w		
(18)	5w	4r	1w	4r	5w		
(19)	6w	3r	1w	3r	6w		
(20)	7w	2r	1w	2r	7w		

(21)	2w 15b 2w
(22)	As (21)
(23)	As (21)
(24)	As (20)
(25)	As (19)
(26)	As (18)
(27)	As (17)
(28)	As (16)
(29)	As (15)
(30)	As (14)
(31)	As (13)
(32)	As (12)
(33)	As (11)
(34)	As (10)
(35)	As (9)
(36)	As (8)
(37)	As (7)
(38)	As (6)
(39)	as (1), and continue therefrom.

BEADED BAND (See Fig. 58b.)
19 Beads Wide

(1)	1o	17w	1o			
(2)	As (1)					
(3)	As (1)					
(4)	As (1)					
(5)	As (1)					
(6)	As (1)					
(7)	As (1)					
(8)	As (1)					
(9)	1o	14w	2o	1w	1o	
(10)	1o	12w	2o	2b	1w	1o
(11)	1o	10w	2o	4b	1w	1o

(12)	1o	8w	2o	6b	1w	1o
(13)	1o	6w	2o	8b	1w	1o
(14)	1o	4w	2o	10b	1w	1o
(15)	1o	2w	2o	12b	1w	1o
(16)	As (14)					
(17)	As (13)					
(18)	As (12)					
(19)	As (11)					
(20)	As (10)					
(21)	As (9)					
Repeat from (1)						

BEADED BAND (See Fig. 58c.)
13 Beads Wide

(1)	6w	1b	6w		(25)	As	(14)		
(2)	5w	3b	5w		(26)	As	(13)		
(3)	6w	1b	6w		(27)	As	(12)		
(4)	13w				(28)	As	(11)		
(5)	13w				(29)	As	(10)		
(6)	13w				(30)	As	(9)		
(7)	13w				(31)	As	(8)		
(8)	13w				(32)	As	(7)		
(9)	6w	1r	6w		(33)	3w	7r	3w	
(10)	As	(9)			(34)	As	(33)		
(11)	5w	3r	5w		(35)	As	(33)		
(12)	As	(11)			(36)	3w	2r	3b	2r 3w
(13)	4w	5r	4w		(37)	As	(36)		
(14)	As	(13)			(38)	As	(36)		
(15)	3w	7r	3w		(39)	3w	2r	1b	1w 1b 2r 3w
(16)	As	(15)			(40)	As	(39)		
(17)	2w	9r	2w		(41)	As	(39)		
(18)	As	(17)			(42)	As	(38)		
(19)	1w	11r	1w		(43)	As	(37)		
(20)	As	(19)			(44)	As	(36), and continue back		
(21)	As	(18)					from here through line (4);		
(22)	As	(17)					then start with (1) again and		
(23)	As	(16)					continue therefrom.		
(24)	As	(15)							

TARGET (See Fig. 53h)

Cut a circle of buckskin (or if preferred, felt) 2¼ inches in diameter. Anchor the needle to the center of the circle. Thread 16 red seed beads. Sew these in a close spiral; these will make a circle about ½ an inch in diameter. Each of the following rows must be secured to the background between every 6 or 8 beads.

(1)	2b	3w	2b	3w	2b	3w	2b	3w
(2)	3b	5w	3b	5w	3b	5w	3b	5w
(3)	4b	6w	4b	6w	4b	6w	4b	6w
(4)	5b	8w	5b	8w	5b	8w	5b	8w
(5)	6b	10w	6b	10w	6b	10w	6b	10w
(6)	7b	12w	7b	12w	7b	12w	7b	12w
(7)	8b	14w	8b	14w	8b	14w	8b	14w
(8)	9b	16w	9b	16w	9b	16w	9b	16w
(9)	10w	18b	10w	18b	10w	18b	10w	18b
(10)	12w	20b	12w	20b	12w	20b	12w	20b
(11)	14w	22b	14w	22b	14w	22b	14w	22b

MOCCASIN (See Fig. 52, *upper left.*)

For the beading close to the sole of the moccasin, the design is as follows, whether done as two ridges or as one line of beads secured in the middle. Doing it in the two ridges of 6 beads each is more authentic, but doing it in one ridge of 12 beads is quicker.

(1)	12r			(7)	As	(5)
(2)	4w	8r		(8)	As	(4)
(3)	6w	6r		(9)	As	(3)
(4)	8w	4r		(10)	As	(2)
(5)	9w	3r		(11)	As	(1), then con-
(6)	10w	2r				tinue from (2).

The beading around the top:

(1)	6w		(6)	As	(1)
(2)	As	(1)	(7)	6r	
(3)	As	(1)	(8)	As	(7)
(4)	As	(1)	(9)	As	(7)
(5)	As	(1)		Repeat from (1)	

The central design on the vamp, starting at the top:

(1)	2w		(11)	11w
(2)	3w		(12)	13w
(3)	As	(2)	(13)	15w
(4)	As	(2)	(14)	12r
(5)	4w		(15)	10r
(6)	5w		(16)	8r
(7)	6w		(17)	5r
(8)	8w		(18)	3r
(9)	9w		(19)	1r
(10)	10w			

The small design at the side of vamp:

(1)	2w		(7)	9w
(2)	3w		(8)	7r
(3)	4w		(9)	5r
(4)	5w		(10)	3r
(5)	6w		(11)	1r
(6)	7w			

Books of beading designs can be bought for very little, and cross-stitch patterns work perfectly for beading. Frequently, however, a personal design is desired, and of course, there is no way to get this except to make it yourself.

Graph paper is a necessity for drawing beading designs. But remember that a bead is not a square; it is almost, but not quite, twice as long as it is wide. There is a special beading graph paper made, which is marked in correct proportions. If you use the graph paper marked off in perfect squares, you must mark each bead as being two squares long and one square wide.

Bibliography

1. DENSMORE, FRANCES. *Chippewa Customs.* (Bulletin 86, Bureau of American Ethnology.) Washington, D.C.: Government Printing Office, 1929.

2. HOFFMAN, WALTER JAMES. *The Menomini Indians.* (14th Annual Report, Bureau of American Ethnology.) Washington, D.C.: Government Printing Office, 1896.

3. LYFORD, CARRIE A. *Quill and Beadwork of the Western Sioux.* Washington, D.C.: U.S. Office of Indian Affairs, Education Division, 1940.

4. SETON, ERNEST THOMPSON. *Birch Bark Roll of Woodcraft.* Julia M. Buttree, ed. New York: A. S. Barnes & Co., Inc., 1931.

5. SETON, JULIA M. *Indian Costume Book*. Santa Fe, N.M.: Seton Village Press, 1938.

6. WISSLER, CLARK. *Indian Beadwork,* Guide Leaflet No. 50, N.Y., May, 1927.

Suggested Reading

HUNT, WALTER BERNARD, and BURSHEARS, J. F. *American Indian Beadwork*. Milwaukee: Bruce Publishing Co., 1951.

ORCHARD, WILLIAM C. "Beads and Beadwork of the American Indians," *Contributions,* Vol. XI, New York Museum of the American Indian, Heye Foundation, 1929.

SPECK, FRANK G., and ORCHARD, WILLIAM C. *The Penn Wampum Belts,* Leaflet No. 4, New York Museum of the American Indian, Heye Foundation, 1925.

7

Quillwork

Porcupine quillwork was an American Indian art, one which was practiced nowhere else in the world. Long before the advent of the Whiteman with his glass beads, quillwork decoration was common on the American continent from Maine to Virginia and west to the Rocky Mountains north of the Arkansas River. On the Northwest Coast, it was used by the tribes which had come in contact with the Athapascans. In California and the Southern Plains, where the porcupine was not found, the art was at first unknown. But quills seem to have been an article of barter, so that later we find the Kiowa, Comanche, Apache, and Wichita using this embroidery also. Each tribe, or at least each group of tribes, had its own designs and its own method of applying the decoration; hence, examples of the art may be quite accurately dated and assigned to their place of origin. From the Western Sioux came some of the most beautiful examples of quill embroidery which seem to follow the rule held in painting as well as other arts—since it was done by the women, the designs had to be geometrical.

The art of quillwork was tedious and required much technical skill as well as unlimited patience, so that it reached its highest development among those tribes which had an abundant food supply and whose men were the principal providers. Only in these tribes had the women the leisure time for the craft.

The quill embroidery was done on dressed skin or birchbark,

and was used to decorate tobacco and tinder bags, work bags, knife cases, cradles, bands of burden straps, moccasins, shirts, leggings, arm and leg bands, robes, and sometimes the trappings of horses. It was the task of the men to hunt the porcupines and gather the raw material. In some tribes they also prepared the dyes. Some of the designs, too, undoubtedly originated with the men, while others were invented by the women.

Preparation

The sorting of the quills was the first process. Quills differ in length, thickness, and stiffness. The largest and coarsest quills come from the tail; the next largest from the back; the thin, delicate ones from the neck; and the finest from the belly. The different grades were kept in separate containers, usually the bladders of elk or buffalo or sometimes parfleche pouches.

The quills were next colored with a choice assortment of dyes or pigments obtained from berries, roots, bark, flowers, and some minerals. The quills were steeped in decoctions of these until a uniform color was obtained.

Among the Sioux, where quillwork was used most extensively, red was obtained by boiling the quills with buffalo berry or squaw berry. Yellow came from the wild sunflower or cone flower with pieces of decayed oak bark or with the roots of cattail. Black was generally derived from the wild grape, or, when a brownish shade was desired, from hickory or black walnuts. White was the natural color of the quill. No variegated quills were made and rarely more than one shade of a color.

My own experience with the dyeing of quills may be of help to others. Frances Densmore (Ref. 1) reported that quills were the easiest of all materials to dye. When I started to work with quills, I used one of the standard commercial dyes and had no difficulty in obtaining four or five brilliant colors. Soon after, I had a letter from a student complaining that she had tried every old method of dyeing quills without success. In my own vainglory, I tried again—and this time had the same trouble she had. Apparently the grease of the quill rejected the dye, and no matter how long I boiled them, they came out the same clear cream color they were in their native state. I washed them well in gasoline, think-ing I could extract the grease; but again, in spite of boiling, the

dye would not soak in. I tried strong soap—with the same lack of success. Next, I soaked a handful of quills in lye. Within about five minutes, they came out looking like miniature boiled spaghetti and at the first touch they pulled into small segments. They were horribly slimy.

I grew desperate and started a campaign of inquiry. The Dye Company sent a recipe which may or may not have been good. I never tried it, because by the same mail came a reply from an old Sioux woman who, through her son, wrote me to put one-fourth cup of sugar into the dye solution before setting up the quills to boil.

This I did—and the dye took with perfect success.

Using the Quills

From an examination of the examples still available, there were four general methods of using the quills—sewing, weaving, wrapping, and lacing through perforations in leather, birchbark, or other background material.

For all the methods except lacing (and sometimes for this), the quills were flattened. To do this, the Indian woman kept a bunch of quills at a time in her mouth to make them pliable, as they needed both warmth and moisture to bring about that condition. The black end, or tip, was then held by the thumb and forefinger of the right hand, the nails being used to flatten the quills, repeating the pressure till the quills became smooth and flat. In the old days, the sewing was done with a thin strip of sinew for thread. This was kept moist, except one end which was twisted to a sharp point and allowed to dry to be used as a needle. Perforations were made in the skin or bark with an awl formed of bone or with a thorn. Later, steel awls became available, but the sinew was still the only "needle" used.

Most of the old designs were made up of wide or narrow lines, each composed of a series of upright stitches lying close together. The width of the lines varied from $\frac{1}{16}$ inch to $\frac{1}{4}$ inch. A hole was made, let us say, at one end of the top line of a band. The flattened quill was pushed up through the material, leaving on the back of the material a short length which was bent and pressed close to the skin or bark to serve as a fastening. Another hole was made on the bottom line and the point of the quill inserted from

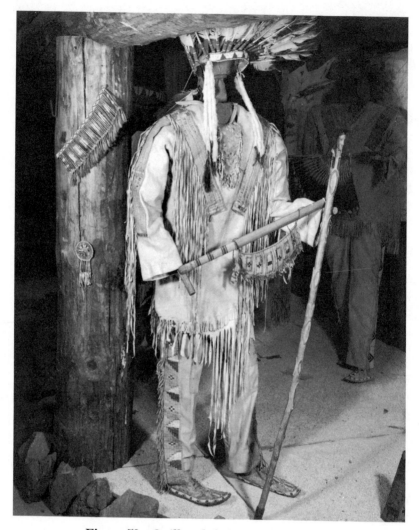

Figure 59. Quillwork from Seton Museum.

front to back, thus making a stitch. Another method, more common than this, did not allow the stitches or quills to show on the back of the material. The perforations did not go through from front to back but went just beneath the surface. The quills were sewed down with the sinew; two lengths were worked simultaneously, one for the upper line of the quill band and one for the lower.

There were several ways of splicing the quills, and much of the beauty of the work depended on the skill in joining.

Alice C. Fletcher (Ref. 2) has described one Omaha method of sewing, which is easy and produces a beautiful braided effect.

A stitch was taken, but not through the skin, and the sinew was passed through and pulled tight. Then another stitch was taken in the same way, but the sinew was not pulled tight. A little loop was left, and through this loop the blunt ends of the quills were put. If, for example, four quills were to be used, they were placed one on the other through the loop, which was then tightened. A quarter of an inch from the first stitch of sinew, a similar stitch was taken, and in the loop, four quills were fastened in the same way. Then the first quill was bent toward the second loop and the first quill of the second loop was bent toward the first loop, and the braiding went on, back and forth, until all four quills were in place, the last quill being doubled under, and the sinew used in a stitch to hold it in place. In this way, little by little the pattern progressed.

The banded fringe usually attached to the border of tobacco bags was made from strips of dressed skin cut to the desired width, around which flattened quills were closely and evenly bound, care being taken to conceal the ends of the quills in order that the binding, even when various colors were used to form the design, might look as though it was one band. Different colors on the different strands of the fringe were so arranged that when the strands hung in place, the meeting of the colors made the figure.

Fine, flattened quills closely woven into a long and very narrow braid was wound around the wooden stems of pipes. Different colors were sometimes so disposed along the length of these braids that when they were wound around the stem, they made squares or other figures. Careful calculations as well as deft fingers were required for this style of work.

The Omaha method for pipestems (Ref. 2) was as follows:

Two long threads were doubled, making four threads. The free ends were wound about a stick and fastened to a stationary object. The doubled ends were made fast to the belt of the worker. A few inches of the doubled ends were left unworked for fastening to the pipestems. The quills were woven one at a time in and out over the four threads. Two threads formed one column. The ends of the quills were fastened between the two threads of a column. The new quill was fastened in the same place by the blunt end.

The weaving of quills is very simple. Warp threads are strung on a weaving bow. The quills are flattened and passed through like a ribbon over and under the warp threads. When the wefts are driven close together, all threads are concealed.

With the introduction of beads, quillwork began to decline. The art is rapidly dying out, and it is doubtful whether any woman at the present day could duplicate the fine embroidery of a hundred years ago.

Bibliography

1. DENSMORE, FRANCES. *Chippewa Customs.* (Bulletin 86, Bureau of Ethnology.) Washington, D.C.: Government Printing Office, 1929.
2. FLETCHER, ALICE C., and LA FLESCHE, FRANCIS. *The Omaha Tribe.* (27th Annual Report, Bureau of American Ethnology.) Washington, D.C.: Government Printing Office, 1911.
3. LYFORD, CARRIE A. *Quill and Beadwork of the Western Sioux.* Washington, D.C.: U.S. Office of Indian Affairs, Education Division, 1940.

Suggested Reading

DOUGLAS, FREDERIC HUNTINGTON. *Porcupine Quillwork,* Leaflet 103, Denver Art Museum, Dept. of Indian Art, December, 1941.

MERWIN, B. W. "The Art of Quillwork," *Museum Journal,* Vol. IX, No. 1. Philadelphia: Univ. of Pennsylvania, 1918. Pp. 50–58.

ORCHARD, WILLIAM C. *The Technique of Porcupine-Quill Decoration Among the North American Indians,* Vol. IV, New York Museum of the American Indian, Heye Foundation, 1916.

—————. "Indian Porcupine-Quill and Beadwork," *Introduction to American Indian Art* (Collected and published by the Exposition of Indian Tribal Arts, New York), 1931, pp. 3–13.

SKINNER, ALANSON. *An Illinois Quilled Necklace,* Vol. X, New York Museum of the American Indian, Heye Foundation, 1920.

8

Jewelry

As was pointed out in Chapter 3, the instinct to adorn one's person comes very early in the culture of man. From primitive times, the Indian used whatever material he found in his environment for such purpose. Some of these substances we might question as suitable media, and for several reasons.

First, our White ideas of beauty are usually limited to sheer physical value; innate loveliness is at best a secondary consideration. Next, we are not a race willing—or perhaps able—to consecrate ourselves to an endeavor which requires the slow laborious effort necessary to work certain products of nature. The Indians had no such reluctance. The wampum and other shell ornaments of the Northeast Indians represent almost inconceivable patience and skill; the mosaic treatment of earrings and pendants in which tiny inlays of turquoise and mother-of-pearl were set are all evidence to a type of mind that is not often found in the Whiteman.

In the Southwest from ancient times, the Pueblo men had access to turquoise from the nearby mines. The drilling of this semiprecious stone is a delicate task. It requires a special tool and, with slight adaptation from the early form, is used today in many of the villages, especially at Zuñi.

Ruth Underhill (Ref. 4), an authority on Pueblo crafts, has given us the best description of the process of this type of drilling.

They chip a bit of turquoise or shell to about the right size and then drill a hole through it before shaping it into a bead. . . .

The tool used is the pump drill . . . which is a shaft of wood about four feet long with a sharp point fastened to the lower end. Once this point was a sliver of flint, but now it is metal, perhaps the tip of an old file. Some distance above the point there is a disk of wood, pottery, or stone, which acts as a flywheel to keep the shaft turning after it has been given a push. Above the disk and about halfway along the length of the shaft is the device for pushing. It is a stick of heavy wood about two feet long, through the middle of which the shaft passes. We may call it the crosspiece. The ends of the crosspiece are attached to a long buckskin thong, just as the ends of a bow are attached to a bow string and the thong is threaded through a hole in the top of the shaft.

To start work the driller twirls the crosspiece around the shaft by hand, thus causing the two strings to twist tight around the rod and pulling the crosspiece up higher. The point of the shaft is on the bit of turquoise he wishes to drill and he holds it there with one hand. With the other he pushes down on the crosspiece. This untwists the strings and causes the shaft to whirl. The whirling does not stop when the strings are untwisted for the flywheel keeps the shaft going, thus twisting them up in the other direction. Now the driller pushes down on the crosspiece again and the whole operation is repeated. If he pushes gently and regularly the drill will work with almost the precision of a machine. . . .

The bead usually made is shaped like a small thick button about one sixty-fourth to three-eighths of an inch thick, and one sixteenth to one quarter of an inch in diameter. To shape the bits of turquoise or shell in this way the worker strings his drilled fragments on a string with a knot at one end. He pushes them tight against the knot, holding them down with his thumb and winding the extra string around his hand. Then he proceeds to shape them, first by knocking off rough edges with a hammer, then by rolling his column of beads back and forth over a sandstone slab. He may roll them with his free hand or with another piece of sandstone, or he may knot the string at both ends, hold it upright and roll between two pieces of sandstone. The sandstone is kept wet and some grit is sprinkled on it.

Another form of Pueblo jewelry which goes back to ancient times is done by gluing with pinyon gum chips of turquoise, jet, or shell to flat pieces of wood or to abalone shell in the form of pendants, earrings, and other small ornaments.

Jewelry of this type is still made by various Pueblos; but silver has now come into general use for handsome articles of decoration, especially among the Navaho and some of the Pueblos, notably Zuñi. However, most of the Pueblos still have a few excellent artisans in this craft.

Navaho and Zuñi Jewelry

When the Indians of the Southwest first began to work in silver, they used the silver peso of Mexico as their material. It was more malleable than our own silver dollar. When the peso became unobtainable, they turned to our silver dollar until such use was declared illegal; they then resorted to commercial slugs of silver which they shaped to fit the proposed design. This they are still doing, sometimes even buying the silver in sheets.

The Navaho has made silversmithing his own art and has developed a remarkable technique that produces beautiful designs. Esthetic integrity is deep-rooted in all Indians, and it is characteristically evident in their jewelry. The real artist is back of each piece—it seems impossible for a Navaho or Zuñi Indian to do his work without love of the beautiful as his basic impulse.

It is difficult for a Whiteman to understand how the Navaho Indian, living a nomadic life and having a minimum of possessions, could turn out the completely beautiful and entirely durable jewelry that he has made for several generations. From the beginning, his tools have been necessarily few and simple. A piece of iron picked up somewhere along the railroad track or an old horseshoe was his anvil. On this, matrices of different sizes were made with a round-headed bolt. A hard stone served as a hammer. His crucible was a bit of pottery hollowed out in the desired size and shape.

Until recent years, the Navaho made much of his jewelry in molds. These molds were carved out of native sandstone, greased with suet, and the warm silver was poured in and allowed to harden. Some of this type of jewelry is still made, and it is much more highly prized than that made by more modern methods. Especially are the hollow beads made in this way. They are formed in two halves, then soldered together so expertly that usually the join cannot be detected. In the earliest days of the craft—the seventies and eighties—the Navaho soldered his pieces with silver dust mixed with his own saliva.

As the trader became more common, it was possible for the Navaho to trade for hammers, pliers, scissors, and punches; and he learned to build and use a simple forge. For polishing, he now has sandpaper and emery paper; but he employs these only for

Figure 60. Crucible and molds.

168

the finishing touches. For the earlier stages of the work, he uses powdered sandstone, sand, or ashes. Frequently, he still makes his own dies from bits of scrap iron. Each man has his own designs, which he presses into the silver form he has heated. Many buttons are made by the Navaho, not indeed as fasteners, but as pure decoration on their moccasins, leggings, dresses, belts, and pouches. The designs of these buttons are beautifully varied.

As a silversmith, the Navaho is particularly identified with the concho belt, a strip of leather on which are strung large disks of silver. These disks are usually elliptical in shape and magnificently designed. They are so large and so well fitted that they entirely cover the leather strip which holds them in place.

Contrary to expectation, when the Navaho acquired Whiteman's tools, the sheer beauty of the pieces turned out by these artists did not deteriorate. Indeed, until the White tourist invaded the country, the designs of Navaho jewelry remained pure and authentic. Excellent pieces are still being made by those Indians who have not been too much influenced by White standards, and excellent pieces are all we are here concerned with. The marvel of Navaho jewelry is that the artist can, when he pleases, abandon sheer simplicity, yet keep the feeling of strength and freedom from affectation.

There is an essential difference between the silver work of the Navaho and that of the Zuñi. To the Navaho, the silver itself is the compelling force. He will, for instance, make a silver bracelet with only a single turquoise set in the center; or he will ornament it merely with an engraved or embossed design, without any color other than the soft rich silver itself. The Zuñi bracelet is more likely to be a row or perhaps several rows of turquoise set in silver, which is subordinate to the rich blue of the stones. To the Navaho, a necklace of plain beads is thoroughly satisfactory; to the Zuñi, small pieces of flawless turquoise, painstakingly worked, will be fashioned in a fine, serrated silver setting.

Within the past couple of decades, considerable jewelry is being put out which is a combination of the Navaho and Zuñi methods. It consists of inlays of pieces of shell, turquoise, coral, and jet (larger than the old mosaic work) in substantial settings of silver. The designs are almost always conventional forms of gods or other symbolic delineations. These are sometimes very

Figure 61. Objects in silver.

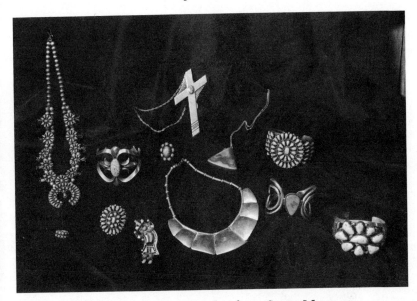

Figure 62. Modern jewelry from Seton Museum.

striking and beautiful; but the real collector of Indian jewelry still clings to the oldtime, simple, masterful designs with little extraneous ornamentation.

Bibliography

1. ADAIR, JOHN. *Navaho and Pueblo Silversmiths*. Norman, Okla: Univ. of Oklahoma Press, 1944.
2. MATTHEWS, WASHINGTON. *Navaho Silversmiths*. (2d Annual Report, Bureau of American Ethnology.) Washington, D.C.: Government Printing Office, 1911.
3. SLOAN, JOHN, and LA FARGE, OLIVER. "Jewelry," *Introduction to American Indian Art* (Collected and published by the Exposition of Indian Tribal Arts, New York), 1931, pp. 33–39.
4. UNDERHILL, RUTH. *Pueblo Crafts*. Phoenix: Education Division, U.S. Indian Service, 1945, pp. 119–23.

Suggested Reading

COLTON, MARY-RUSSELL FARRELL. "Hopi Silversmithing, Its Background and Future," *Plateau*, Vol 12 (July 1, 1939), pp. 1–7.
HARRINGTON, M. R. *Iroquois Silverwork*, Anthropological Papers, Vol. I, Part VI. New York: American Museum of Natural History, 1908.
HODGE, F. W. *Turquoise Work of Hawikuh, New Mexico*, Leaflet 2 New York Museum of the American Indian, Heye Foundation, 1921.
McGIBBENY, J. H. "Hopi Jewelry," *Arizona Highways*, Vol. 26 (July, 1950), pp. 18–25.

NEWMAN, DAVID L. "Modern Developments in Indian Jewelry," *El Palacio* (Published by the School of American Research, the Univ. of New Mexico and the Museum of New Mexico), Vol. 57 (June, 1950), pp. 173–80.

SIKORSKI, KATHRYN A. "Recent Trends in Zuñi Jewelry," Master's thesis, Univ. of Arizona, 1959.

————. "Zuñi Jewelry," *Arizona Highways*, Vol. 35 (August, 1959), pp. 6–13.

TANNER, CLARA LEE. "Navaho Silver Craft," *Arizona Highways*, Vol. 30 (August, 1954), pp. 16–33.

WOODWARD, ARTHUR. *A Brief History of Navaho Silversmithing.* 2nd ed. Flagstaff: Museum of Northern Arizona, 1946. Bulletin 14.

9

Basketry

Basketry is certainly one of the most ancient of crafts, if not indeed the very earliest. It is the mother of all loom work. It seems to have been forced upon the aborigines by sheer necessity. Not only carrying vessels were made by some form of the weaving of fibers or roots, but the very shelters in which they lived were wicker work or some closely allied form of interweaving.

Basketry in some way entered into clothing, furniture, family life, and religion of the American Indians; indeed, it supplied a tremendous number of domestic needs literally from the cradle to the grave.

In all tribes, the making of baskets was woman's work, from seeking out the material to the finished product.

The Indians, in making baskets, used all three of nature's kingdoms—animal, vegetable, and mineral. To start with the mineral, in some tribes clay was used to line baskets and make them fireproof. Many of the dyes came from the mineral kingdom, and stones and shells were frequently used in the decoration. From the animal kingdom, besides the teeth and wings of insects, certain tribes used the wool of goats and sheep. The undressed skins of rabbits were often cut into strings and used in making baskets. Sinew was the thread used in many places as the most serviceable sewing material. In the highly developed basketry of certain regions, feathers played an important part. But the vegetable kingdom provided by far the greatest proportion of

the materials for baskets. Roots, stems, bark, leaves, fruits, seeds —all parts of most plants were used for the craft in some way.

The women learned by continual practice the seasons for gathering of the material. They seemed to know instinctively how to dry, preserve, and prepare the parts of the plants which they would use, and how to achieve both usefulness and beauty in the manufacture of the products. The tools were necessarily few; indeed, at first, they had nothing but the fingers and the teeth. Later, there came a stone knife, a bone awl, and shells or stones for polishing.

The women early learned the use of natural dyes made from both vegetal and organic materials, though some tribes were long satisfied with the natural colors of the material they used. There was enough diversity in the red and black of bark, the white of grass stems, the pale yellow of peeled rushes, and the brown of root bark. Probably the first inkling of dyes came from the black or dark gray which was the result of burying in mud. The more developed use of dyeing was a natural growth with experience.

Technique

Baskets are of two kinds, woven and coiled. In woven basketry, there is a definite warp and weft; the several varieties result in different appearances.

The first of these is what may be described as checkerwork. It is used largely for the bottom of baskets, especially in the North Pacific tribes. Its greatest use, however, all over the country, is in matting. Here the warp and weft, both of the same width and thickness, are interlaced singly, passing over and under one another. Either may be called the warp or the weft. This type of weaving is apt to be of coarse material, often bark. Where fine yarn or thread would be used, the result would be a simple form of cloth. This checkerboard technique can also be used to produce an openwork effect by leaving spaces between the warp and the weft elements.

In twilling, which is another form of weaving in basketry, each thread of the weft passes over and then under two or more warp threads, creating a diagonal pattern. By varying the widths or by using color, endless different effects may be obtained. If the weft

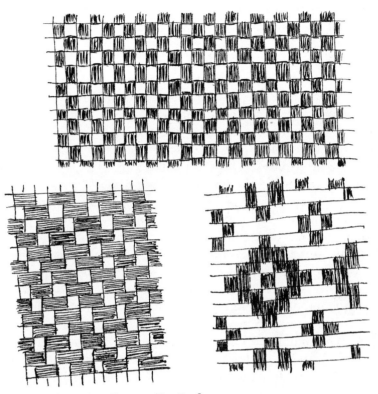

Figure 63. Basketry weaves.

passes over one warp thread and then under two, and in the next
line passes over a different warp thread and under the next two
threads, a different appearance will be the result. Over one and
under three or under four would be other variations. Still other
effects can be had by the use of substances of different widths for
warp and weft or even entirely different materials.

The next type of basket weaving is wickerwork, in which the
warp is inflexible and the bending is done in the weft. The only
difference between this and the checkerboard is the fact of the
rigid warp.

There is then what might be called wrapped work, in which
the warp may be either fixed or flexible. The weft is wrapped
around each thread as it is laced through the warp, making what
might be called a series of back-stitches.

Twined work is the most intricate of woven basketry. In this,

the warp is rigid as in wickerwork, but two or more threads are used simultaneously as weft. One of these passes behind each warp thread and one or more in front. On the next row, the front thread becomes the back, and vice versa. It is, in effect, braiding.

Coiled basketry is the second main type of basketry. This is actually a form of sewing. In this type, some tool to be used as a needle is necessary. The sewing material itself is often cedar or spruce root, but in some regions the use of stripped leaves or roots, grass stems, and even twine are common. Whatever the material used, it must be kept as pliable as possible, so it is kept soaked in water while the basket is being made.

Coiled baskets may be of any size, from ½ inch in diameter to several feet across. The work is done by sewing or whipping together, in a flat or ascending coil, a continuous foundation of rod, splint, shredded fiber, or grass. The stitching material may be of roots so finely shredded that the sewing is all but invisible, or it may be as much as ½ inch wide. The stitches pass around the foundation of sticks and interlock with the coil of the preceding row. Various methods of sewing are used to produce different effects. The simplest form of coiled basket is made with the stitches interlacing without catching into the foundation coil itself. A further development of this is the method by which a stitch passes around the foundation, then is caught under the stitch of the preceding coil. The foundation itself in this type is usually a single stem and the sewing thread a splint of hard wood, except in the finer work. The Pomo Indians do much of this type; they use the roots of plants and soft stems of willow. When thoroughly soaked, these can be crowded together so as to entirely conceal the foundation. In some of the tribes, two rods are used in the foundation. They lie one on top of the other. The stitches pass over two rods in progress and under the upper one of the pair below. In this method, each stitch encloses three stems.

When a basket is made without a foundation, a small rod is used to obtain uniformity of the meshes. It is slipped in and out as the work progresses. The simplest form of this type of basket is merely a series of coiled fibers, each one hooked into the one underneath to produce an openwork effect. This type is not common in North America, though the Indians of the Mackenzie

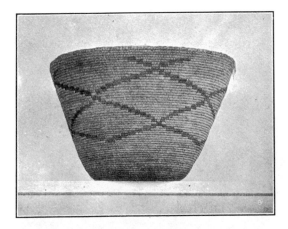

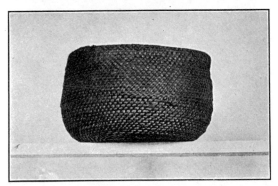

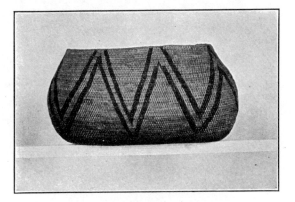

Figure 64. Miwok coiled baskets.

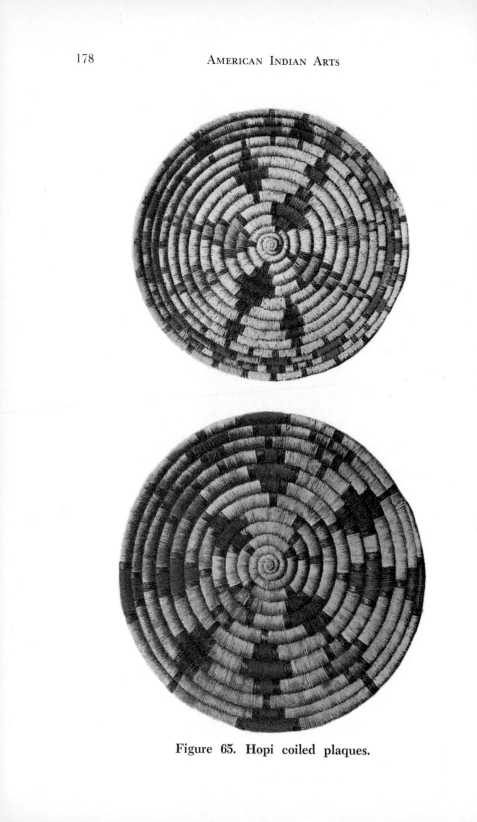

Figure 65. Hopi coiled plaques.

River Basin make a more complicated related form. The Pima carrying basket, a variety of this work, is made on a rude framework of sticks. The network is a continuous thread of agave fiber in loose interlocking stitches.

Form

The form of a basket is greatly influenced by the kind of natural material available in a particular locality. Flat forms are the simplest, of course. In this category, we find mats, trays, and plaques. Various sizes and shapes are possible; the earliest form was undoubtedly flat. Because so much early basketry probably was of the coil variety, the trays and plaques turned out circular. Square-cornered mats must have come later.

Without changing the essential method of manufacture, the shallow plate would come next. The prayer ceremonials necessitated a receptacle which could hold the sacred meal. In some parts of the country, food was served in this type of basket.

The next step was to deepen the plate or dish into a bowl. In some, the bottom was flattened, and soon the body of the bowl itself was straightened until the cone and cylinder were achieved. But in the early stages, the body was never curved inward. Because seeds and water had often to be hauled, the bottle neck developed in the course of events. Bottles could be made watertight by the application of various gums present in the region, by plastering with clay, or by closeness of texture.

Borders of differing weaves often encircled the baskets. Handles and lugs were added where the use of the basket required them.

Ornamentation

As a prelude to the discussion of ornamentation, I cannot resist quoting from Otis T. Mason (Ref. 3) whose *Aboriginal American Basketry* has never been excelled. He says:

As you gaze on the Indian basket maker at work, herself frequently unkempt, her garments the coarsest, her house and surroundings suggestive of anything but beauty, you are amazed. You look about you . . . for models, drawings, patterns, pretty bits of color effect. There are none. Her patterns are in her soul, in her memory and imagination, in the mountains, water courses, lakes and forests, and in those tribal tales and myths which

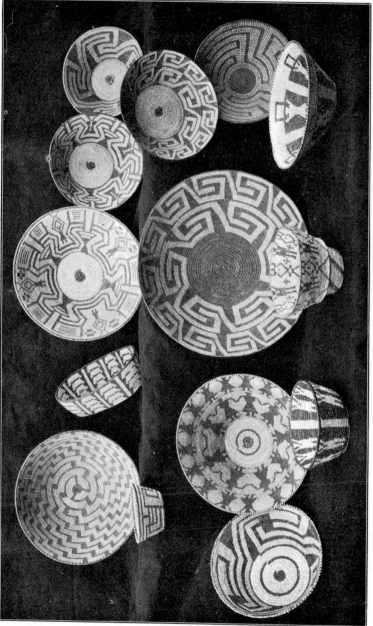

Figure 66. Pima basketry.

dominate the actions of every hour. She hears suggestions from another world.

There is no doubt that the Indian woman, when she started to make a basket, had no thought in mind other than the function of the finished receptacle. If it turned out a thing of beauty, it was because of the innate artistic ability of the woman—not, perhaps, as an individual but as a member of an ethnic group. Anyone who has studied Indian baskets must acknowledge both the skill and the esthetic quality of the Indians. In general form and in the color and design of the ornamentation, we find the highest order of beauty. But, be the shape or the use what it may, we find universally that the basket was strongly made, symmetrically formed, artistically designed, ornamented, and embellished for eternal satisfaction.

Bibliography

1. DIXON, ROLAND B. *Basketry Designs of the Indians of Northern California.* (New York: American Museum of Natural History), 1902, Bulletin XVII.

2. EMMONS, GEORGE T. "Basketry of the Tlingit," *Memoirs III,* Part 2. New York: American Museum of Natural History, 1903.

3. MASON, OTIS T. *Aboriginal American Basketry.* (Report of the National Museum.) Washington, D.C.: Smithsonian Institution, 1904.

4. PEPPER, GEORGE H. *Ancient Basket Makers of Southeastern Utah,* Supplement to American Museum Journal of Natural History, Vol. II, No. 4 (April, 1902), Guide Leaflet No. 6.

5. RUSSELL, FRANK. *The Pima Indians.* (26th Annual Report, Bureau of American Ethnology.) Washington, D.C.: Government Printing Office, 1904.

6. SLOAN, JOHN, and LA FARGE, OLIVER. "Basketry," *Introduction to American Indian Arts* (Collected and published by the Exposition of Indian Tribal Arts, New York), 1931.

Suggested Reading

BLANCHAN, NELTJE. "What the Basket Means to the Indian," *Everybody's Magazine,* November, 1901, pp. 561–70.

DODGE, K. T. "White Mountain Apache Baskets," *American Anthropologist,* n.s., Vol. 2 (January, 1900), pp. 193–94.

DOUGLAS, FREDERIC HUNTINGTON. *Southwestern Twined, Wicker and Plaited Basketry,* Leaflets 99–100, Denver Art Museum, Dept. of Indian Art, 1940.

————. *Styles of Southwest Coiled Basketry,* Leaflet 88, Denver Art Museum, Dept. of Indian Art, 1939.

JAMES, GEORGE WHARTON. *Indian Basketry.* Pasadena: Privately printed, 1901.

JEANCON, JEAN ALLARD, and DOUGLAS, FREDERIC HUNTINGTON. *Hopi Indian Basketry,* Leaflet 17, Denver Art Museum, Dept. of Indian Art, 1931.

KROEBER, A. L. *Basketry Designs of the Mission Indians.* New York: American Museum of Natural History, July, 1922. Guide Leaflet No. 55.

ROBINSON, ALAMBERT E. *Basket Weavers of Arizona.* Albuquerque, N.M.: Univ. of New Mexico Press, 1954.

TANNER, CLARA LEE. "Apache Basketry," *Arizona Highways,* Vol. 22 (August, 1946), pp. 38–39.

TSCHOLIK, HARRY, JR. "Navaho Basketry," *American Anthropologist,* n.s., Vol. 42 (July–September, 1940), pp. 444–62.

WILLIAMSON, ADELAIDE. "San Carlos Apache Basketry," *Arizona Highways,* Vol. 15 (August, 1939), pp. 12–13, 31.

10

Pottery and Pipes

Pottery

Ceramic art was an outgrowth—perhaps accidental—of basketry but very soon came into its own as a special field of expression. There is no doubt that pottery was a native development and was universally practiced to some extent. Many of the more cultured American tribes were skillful potters. The Peruvians are generally regarded as having taken the lead in this art, but the Colombians, Central Americans, and Mexicans were not far behind, and some excellent work was done also in Brazil and Argentina.

In the United States, the art had made very considerable advance in two culture centers—the Pueblo region of the Southwest and the great mound area of the Mississippi Valley and the Gulf States. Over the remainder of North America north of Mexico, the potter's art was either limited to the making of rude utensils or was practically unknown. The Pueblo tribes of New Mexico and Arizona and, to a lesser extent, some of the adjacent tribes, still practice the art in its aboriginal form, and the Cherokee and Catawba of North and South Carolina have not yet ceased to manufacture utensils of clay, although the shapes have been much modified by contact with the Whites. The Choctaw of Mississippi and the Mandan of the middle Missouri Valley have but recently abandoned the art.

Pottery is not among the early arts practiced by primitive peoples. Nomads are not potters because of the fragility of the utensils, but sedentary life encourages its development.

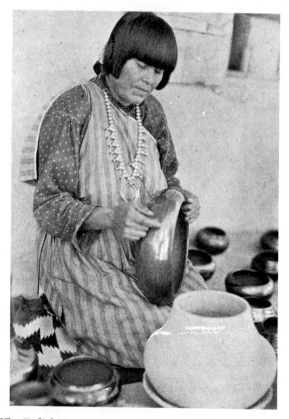

Figure 67. Polishing pottery. (Photograph by Harold Kellogg.)

The clay used was mixed with various tempering ingredients, such as sand or pulverized stone, potsherds, and shells; the shapes were extremely varied and generally were worked out by hand, aided by simple modeling tools. The method of building a vessel varied with the different tribes.

COILED WARE

Probably coiled pottery is the most common form of manufacture. It has been used by many widely separated groups, al-

though there is considerable diversity in the treatment of the coil. Almost universally, coiling has been used simply as a feature of construction; in a few tribes, it has also been used as a means of embellishment.

In the earliest periods, pots and other vessels were undoubtedly made by sticking together small masses of clay. A flat dish or a very shallow cup can be made quite adequately by this method, but to use this procedure for a tall bowl would result in a weak utensil. By natural steps, the ropelike coil was evolved. In some tribes, they were welded together without overlap; in others, the imbrication is quite evident, and is decorative as well as useful.

Coiling by the Louisiana Indians. In all cases of ceramic art, the first requisite is a supply of suitable clay. It must be properly cleaned and tempered, and variation of material exists naturally in different parts of the country.

A very early account by Butel-Dumont (Ref. 3) tells us that the Louisiana Indians, after carefully cleaning the clay, reduced shells to a very fine loose powder, which they then mixed with the clay. This glomerate they moistened with a little water and with their hands and feet worked it into a paste. From this, they made rolls 6 or 7 feet long and as thick as they desired.

Starting with the left hand at the center of what became the bottom of the vessel, they coiled the roll of clay around this point, describing a spiral. Occasionally dipping their fingers into water, they built this up to the desired height, while the right hand controlled the shape and flattened both the inside and the outside of the vessel. When the pot was the proper size and shape, they dried it in the shade. A fire was built and, when there were enough embers, they cleared a place in the middle. The pots to be fired were arranged in this space and covered with charcoal. The Louisiana pottery was very strong, probably due to the shell mixture which was used with the clay.

Coiling by the Utes. The Utes, who almost certainly learned their pottery methods from the Hopis, use for their tempering material an earthy substance known as marl, which they grind between two stones into a fine powder. When this is mixed with water, they knead it as we would dough. Then they roll it into a

ropelike strip about an inch in diameter and several yards in length.

Next, starting at the bottom of the vessel, they coil the clay rope, layer on layer, until they have a bottom and about 3 inches of the sides laid up. When this is partially dry, they add further coils. For joining the layers together, the Utes use a perfectly smooth paddle made of wood and an oval-shaped, polished stone. Both the paddle and the stone are frequently dipped in water (preferably salt water). The stone is held on the inside of the vessel with the left hand, and the paddle is applied vigorously with the right hand until the surface is smooth.

POTTERY OF THE ANCIENT PUEBLOS

Among the Pueblos, there seem to be no sequential periods indicated by the pottery. From the deposits of caves and burial grounds, down through the ruins of once populous villages and beneath the stone cliff houses, to the present day work of modern potters of high repute, there is little difference in methods of manufacture or styles of ornamentation.

Living conditions in the main have been the same throughout the ages. The Pueblos have been always a sedentary people, so they have been able to practice the art continuously. Their environment—arid and sunny, with few permanently flowing watercourses—forced the making of vessels suitable for the transportation and storage of water.

Clay was found in every valley, and it was a clay of suitable consistency. It was and still is very fine-grained, and, when used without coarse tempering, makes a very smooth and even vessel.

For the roughly finished coil ware, rather coarse sand was used, but for vessels with a smoother finish, very fine sand or pulverized potsherds were sometimes used. How the materials were manipulated, fashioned into vessels, and baked can be approximately determined by studying the methods still in use by the descendants of these people. We are certain that the pieces were made entirely by hand without the aid of any type of wheel, just as they are today, and almost certainly, the shallow dishes were made by shaping a single mass of clay by pressure with the fingers. But the process of building the taller vessels by the coil method probably evolved early.

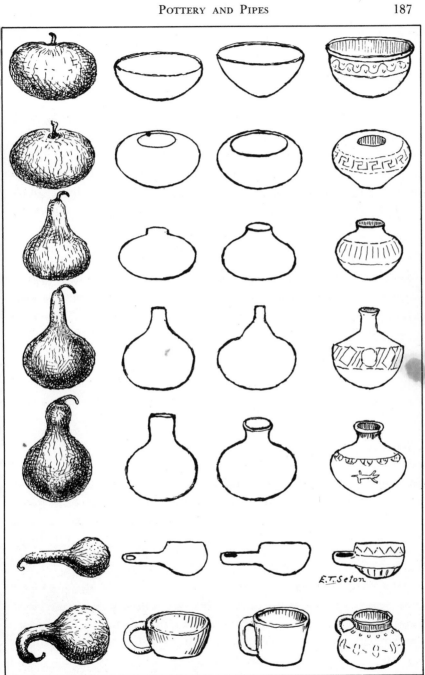

Figure 68. Evolution of pot forms from gourds.

Imbrication (overlapping) is clearly seen in very early examples of pottery; and, except where an effort was made to obliterate the overlapping edges, it formed a type of decoration which is very pleasing. Pots with smooth surfaces were frequently coated with a fine liquid clay. The pot was then polished by rubbing with a stone or other implement. This clay was white or nearly so, so that it was a natural step to decorate the surface with designs in color.

As near as can be ascertained, the methods of firing were the same as those practiced by the modern Pueblos. The light color of the ware is often clouded by dark spots due to imperfections in the firing method.

In the ancient pottery, we find a pleasing variety of color, with grays predominating. The general tone depended upon the composition of the clay used and the degree of heat applied in the firing. It may be that where red is found, it was added to the clay as coloring matter for ceremonial purposes.

Most of the decoration consisted of designs in color. The ornamental effect on Pueblo pottery depends as much on the undecorated space as on the painted lines and areas.

POTTERY OF THE MODERN PUEBLOS

Not only can most of the Pueblo women make crude pots for fireplace cooking, but they are true artists in the craft. More and more are returning to the old ways, urged on by the very modern attitude of the scientists who, in turn, are influencing the curio-seeking tourist, encouraging the manufacture of high-class merchandise, and instructing the public in higher standards.

We speak of Pueblo pottery as if it were all of a kind. In a broad sense, this is so. The clay for each village potter is found in its own locality and the difference in material greatly affects the quality and type of pottery produced. In most of the pueblos, the general preparation of the clay is essentially the same, the construction is by the coiling method, and the firing has been used as far back as can be ascertained. However, there are differences in detail of color and design from pueblo to pueblo.

For example, the two pueblos of Santa Clara and San Ildefonso are the best workers in polished black ware. Though it cannot

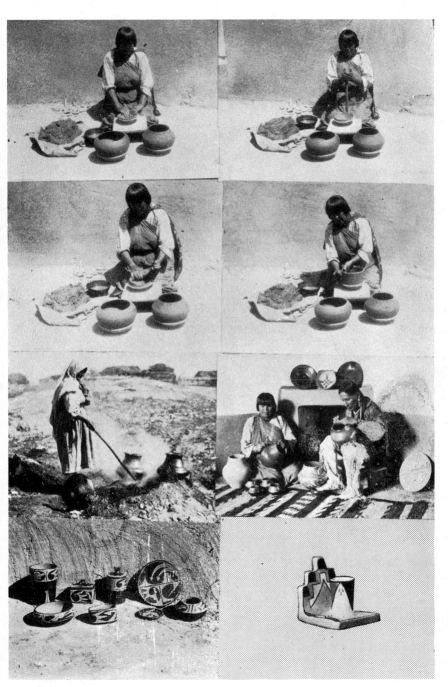

Figure 69. Stages in Pueblo pottery. (Photograph by Harold Kellogg.)

be given as an invariable rule, Santa Clara generally makes the plain shiny black ware, whereas San Ildefonso makes all black pieces, with a combination of glazed and unglazed surface in an artistic design.

For the San Ildefonso ware, the women travel some 15 miles from home to a spot where they obtain the temper. For their mineral paints, they sometimes travel 30 miles as they do for their slip, the liquid clay which they apply before firing. These materials come from sites long known to the Indians.

When the materials have been brought home, the first step in the preparation is the winnowing. The women pour the clay from blanket to blanket, allowing the wind to blow away the fine gravel. It is then sifted, until the potter knows that it is clean and ready for use. It is now mixed with temper and water, then kneaded until it is smooth and free from grit. The potter sits on the floor, with her simple materials before her—a dish of wet clay, a cloth to catch the bits that fall apart, a pan of water, and some thin, shell-shaped pieces of gourd. She knows the right consistency of the ball of clay she pats between her hands, and, with the form and decoration clearly in mind, she begins to mold the bowl.

Some of the low flat bowls are made without the coil process. A ball of clay is patted, then a hole dug into one side with the finger. From this crude beginning, the shape is perfected in a remarkably short time.

If the coil method is used, the first step is the same as for the low flat bowl. The clay is patted out into a cake about half an inch thick and fitted into a shallow dish to form the flat bottom. This is evidently a hang-over from the days when pottery was first the outgrowth of basketry, and molded within the shape. Next, our potter rolls a handful of wet clay into a long flexible sausage. This is done with the two hands held parallel and upright and the clay held between gradually hanging longer and longer beneath the facing hands. This roll is now adroitly laid around the edge of the flat base, and quickly the pot is built up to about 6 inches in height. The fingertips are frequently moistened in the pan of water and the layers of clay rubbed to hold them together and to smooth the outside, thus covering up the spaces between the rolls.

At about this stage, the real shaping begins. This is done with a piece of gourd shell, working from the inside of the pot and curving it as desired. Roll after roll of wet clay is added until the desired height is attained. Then the pot is put out in the sun for a day.

The next day, after the sun has had time to do the preliminary drying, the pots are scraped and scraped with the small polishing stones. These are usually heirlooms, and when one was lost by the potter at our college a few years ago, there was real sorrow in camp and many hours of unavailing search.

Now the slip is applied with a rag, and the pot is ready for its decoration. This is entirely free hand, and one marvels at the steadiness of hand—and of the brain that conceived the finished product. The brushes are stalks of yucca leaf, chewed to a fringe at one end. The design is applied to these black pots with a clay wash mixed with boiled bee-balm plant. This results, after the firing, in a dull black design on a shiny black background.

The firing is the next process. A good-sized wood fire is built outdoors and allowed to burn down to glowing coals. A sheet of grating is placed on the coals, and the pots—usually there are a goodly number, the work of several days—are crowded together on the grating, close but not touching one another and upside down. A circle of large flat cakes of cow dung is built around the grate and over the pots, care being taken that the dung does not touch the pots and that little vent holes are left for the circulation of air.

Then a hot fire of cedar is built around the manure. This burns with a fierce heat for about an hour; then the fire is smouldered with a tubful of horse manure which shuts out all the air and produces a dense white smoke. This turns the clay black in about half an hour. The fire is by this time pretty well burned down. The pots are allowed to cool on the grate for a while, then on the ground for a time longer. Now they are dusted to remove the ash and polished with a slightly greasy rag.

At Tesuque, only 9 miles north of Sante Fe, where tourists flock all summer long, the Indians learned long ago that they could with no effort and for a few cents sell to these ill-informed, undiscerning people little rain gods and ash trays painted with showcard colors. There must be thousands of these all through

the East. It makes little difference to the Tesuque women that the "foreigner" thought these were authentic products of the pueblo. As a matter of fact, the real Tesuque pottery is a beautiful brown ware with decoration fired in white—as fine a type of art as any to be found anywhere.

The Cochiti pottery is a soft, creamy, buff color, with symbolic designs of clouds, lightning, and rain in black. The same coloring is found in the Santo Domingo pots, but the designs are likely to be realistically floral. At Zia, the pots are lighter in color, some of them nearly white. The designs often are of animals, though not in a realistic fashion. The sun symbol used as the State insigne of New Mexico originated in this pueblo. The Acoma and Laguna pots are perceptibly thinner and more brittle. The color is nearly white and the designs are usually geometric. The pottery made in Zuñi is excellent—sturdy in quality and decorated in the best taste. It is now being made principally by the old women, the younger ones having turned largely to jewelry-making. The clay found in Hopiland is the best in all of the Southwest. When fired, the color varies from a creamy white to yellow and red-brown. The designs are in red and black in bold sweeping curves, and the result is some of the most beautiful of all pottery.

SYMBOLISM IN POTTERY

There is more of significance in the Pueblo pottery (as also in the other native crafts) than meets the eye at first glance. To the Pueblo woman, a pot is not merely a useful vessel made of raw material; a pot to her has a conscious existence. It is an entity in its own right. A pot has a voice which one may hear by striking it or by listening while it is simmering on the fire. If it breaks or suddenly cracks in the firing, the sound is the cry of its associated being as it escapes from the vessel. One knows that this being has escaped because the pot will never again resound as it did when it was whole.

By a similar analogy, encircling lines of decoration are always left uncompleted. The ends of a circle are never quite closed. The Indian will explain this to you (if she knows you will understand such thought) by telling you that this is the exit trail of life or being.

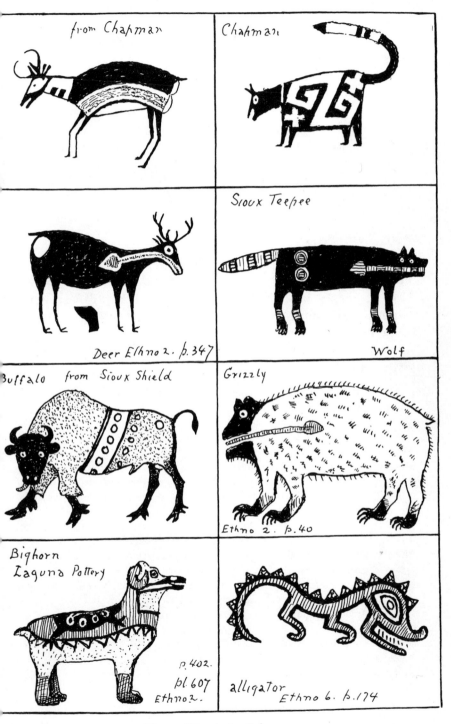

Figure 70. Animal forms.

193

The whole series of ideas is associated with the native philosophy—it is close to worship—of water. Water contains the source of life, and the vessel holds the water; therefore, the vessel is the dwelling place of the source of life, just as are wells and springs. If no exit trail is left for this source of life, things cannot grow in this arid land, and all life would be in danger of extinction.

In the painting of animals, the lifeline is always depicted. The heart is clearly drawn; then a line from the mouth down the center to the heart. A little space is left on either side of this line as the entrance trail for the breath of life.

THE TWO POTS

The psychological approach to the art, apparent in the Indian, may or may not appeal to our modern youth. But to those who have an interest in the field of metaphysics, there will be a more eternal satisfaction come out of the endeavor than can be experienced in the mere manipulation of clay.

Out of his own wide experience, Ernest Thompson Seton has written the following true story:

Some time ago, I was at a summer camp of well-to-do boys. It was suggested that they "do some pottery."

The idea was enthusiastically received. The Camp Director sent for a good pottery teacher from Boston. She got some pottery wheels from New York, some beautifully prepared clay from Trenton, New Jersey, some classical designs from Italy, some fine pottery colors from London, some beautiful sable brushes from Russia, a patent oil-burning kiln from Chicago, worked with kerosene from Oklahoma—and a dozen young enthusiasts set to work.

They were quick to learn. Each one selected a design and made a careful copy of it in the prepared clay. This was set away to dry. After some time, it was partly fired; then each little potter painted with his exquisite brush a copy of a beautiful classical decoration.

These were touched up by the teacher and dried. The kiln was then heated up and each pot was perfectly fired and finally glazed.

So each little potter got a perfectly beautiful vase to take home to his proud parents at a cost to them of $25 per vase.

At a camp not far away I again was visiting. The boys wanted to "do some pottery," and they consulted me.

I said: "Do you wish to do it in the regular school method, or in the real Woodcraft way?"

They preferred the Woodcraft way.

"Good," I said. "Now, who knows where there is any clay?"

"I know," announced one. "There is a streak of it in the railway cutting."

"And I seen a lot in the bottom of the creek," said another.

"Fine! Now we want two expeditions. One to the railroad cutting, and one to the creek, and get each a lump of clay as big as a cocoanut."

When they had returned with their loads, we went to the edge of the pond. There we picked out all the pebbles and straws, and worked up the clay with a little water till it was soft and even in grain throughout.

Now we halted for dinner, after which I said:

"Each boy needs a flat board about a foot square, a knife and something to hold about a pint of water."

The gang soon arrived with a variety of knives and water in old tomato tins.

I showed them how to roll the clay out flat on the board, and cut it into "shoe laces" about ½ inch thick, then coil these into a little saucer shape, soldering the coils together by rubbing them with wet finger tips.

When the saucers were about 3 inches wide, we set them away to dry for an hour or more.

Then, after wetting the edge, we added coils of clay till the saucers became low cups, about 4 inches wide and 2 inches high.

Again they were set aside to harden, and then a finish was given by drawing in the top of the cup a little.

While these were drying in the shade, we set about getting colors, etc.

"I want scouts to go and get some lime, some quartz, some bits of red brick, some soot and some clam shells."

Eager volunteers soon brought these. We used flat stones to grind up the colors separately, then in one clam shell we mixed some powdered quartz and lime, with clay and water so that it was like white cream.

In another, powdered brick was mixed with clay and water for red, and soot and clay with water in the last gave us our black.

"Now for the brushes. Who knows where there was a hickory tree cut down last winter?"

We soon located one, and found in the middle of the stump the usual row of stiff slivers left on the tree broken from the stump. These are seasoned heart wood. Each boy cut and rounded a sliver, then chewed the end into a soft brush. Now we were ready.

The pots had been scraped and rubbed over with slip or clay cream, till they were in good finish, and after they had dried once more, we began to paint them with our prepared colors. The designs were not very classical, but they had some relation to our camp life. Several boys used their names and camp emblems, some drew animals. No two decorations were alike. None of them were very high as art.

These final products were set aside over the stove for complete drying, and this means *bone-dry* without a trace of moisture. At least two days are needed for this.

Now we prepared for the firing. I laid the pots on the ground in rows with small logs between them, then carefully built up a 3-foot pyramid of good firewood, and set it going.

The pile blazed like a furnace. After an hour, it began to shrink a little, and I caught a glimpse of one of the pots. It was a beautiful glowing cherry red. In our impatience to see the result, I got a long pole and fished out the pot.

Alas! As soon as it was touched by the cool air, it opened out into twenty pieces. This taught us a lesson, the lesson of patience. We left the rest under the glowing pile all day.

The next morning, the fire was dead, and under the ashes we found our pots, now cool and finished—one or two broken, one or two with hairlike cracks, but half a dozen of sound, hard, ringing terra cotta with the designs burnt in red, black and white on the yellow ground of the clay, serviceable, passable pots, not only a joy, but a glory to each of the proud owners.

Now, frankly, would our Woodcraft pots compare in any way with those produced by the class with the imported and bought materials? No, not for a moment. Theirs were very good; ours, very, very poor. But the school potters had learned little and had forgotten it all in a year. My boys learned much and will never forget it. As long as they live, they will have a new and self-reliant attitude to certain forces and materials in nature. In a word—

The first class was for making fine pots.

The second class was for making fine boys, and each got what it went after.

Which do you want?

Pipes

Pipes for the smoking of tobacco surely originated in America, as did the plant itself. The materials of which the pipes were made varied according to the available supply in different localities; some were made of pottery, some of wood, bone, metal, or stone, or perhaps two or more of these materials were combined in one pipe. Some pipes were very small, weighing scarcely an ounce and holding but a thimbleful of tobacco. The smallest now used are those of the Alaska Eskimo. Others were of great size, weighing several pounds and held an ounce or more. These were probably used for special occasions, such as the signing of a treaty. They were found principally along the Atlantic Coast and inland to Ohio and Tennessee.

Just as the materials and size differed, so the shape of pipes varied from place to place. Some were made of a single piece, a single tube, the rudest type of which were made from the leg bone

Figure 71. Ottawa pipe stems.

of a deer or other animal. These were often reinforced with a piece of rawhide, which, wrapped on wet, contracted in drying and so kept the bone from splitting. One general form of straight pipe was a tubular section of stone with one end enlarged to hold the tobacco. This necessitated holding back the head in order to keep the tobacco from falling out. But this position caused the tobacco to be drawn into the mouth, so gradually there evolved the custom of inserting a small ball of pottery at the end of the tobacco section near the smoker. Gradually, the bowl was formed at a right angle or nearly so. Sometimes a bowl was removable, as was the stem.

Soapstone was the most common material for pipes, though many other stones were used. A favorite was catlinite, found principally in Minnesota. The color varies from a grayish red to a dark brownish red, sometimes mottled, producing a very beautiful effect. It is fine-grained and, when freshly quarried, is soft enough to be readily carved with stone knives and drilled with primitive tools.

Pipestems were straight, curved, or twisted; round or flat; long or short. They were often carved in interesting forms. Where wood was used, instead of boring, for which the early tribes had no tools, they split the material for the stem lengthwise, removed the heart of the wood, then put the two parts together again with something that would act as a glue or tied them together with sinew or other thread. The women in some tribes made elaborate ornaments for the stems. These ornaments were variously of beads, porcupine quills, hair, and feathers.

Many pipes were delicately engraved; others were elaborately carved and had human or animal figures forming the bowl or the stem.

THE CALUMET

The term *calumet,* originally applied to a dance, came to designate a certain type of pipe used especially in the Mississippi Valley among the Potawatomi, Cheyenne, Shoshoni, Pawnee, and Crow. The calumet had special significance. There were calumets for commerce and trade and for other social and political purposes, but the most important were those for peace and

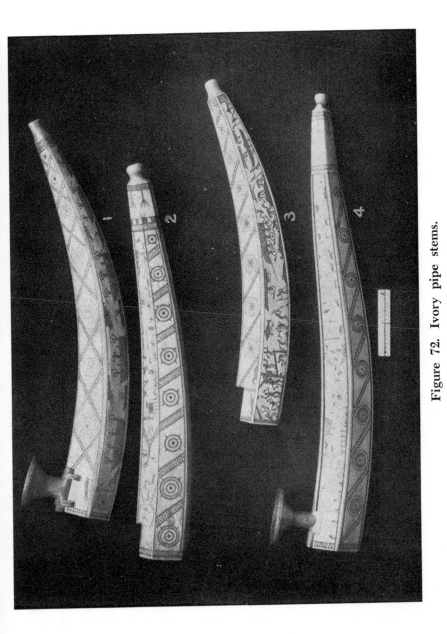

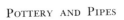

Figure 72. Ivory pipe stems.

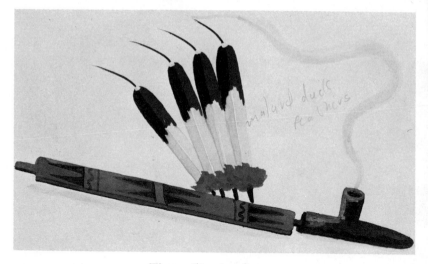

Figure 73. A calumet.

brotherhood. They were made with great ceremony and ritual and of very special materials. In the early days, elaborate carving and high polish were rarely used on calumets, but modern examples even have inlays of lead in geometrical or animal figures.

THE CONICAL PIPE

In Canada and along the Mississippi, there was a type of pipe with both bowl and stem of conical shape, the smaller end of the cones meeting at a right angle to each other. Some are perfectly plain; others are elaborately carved with figures of men and animals.

THE TOMAHAWK

The tomahawk or hatchet pipe seems to be a combination of Spanish, French, and English influence. It is made of metal. Joseph D. McGuire (Ref. 16) tells us that "it is provided with an eye to receive a handle, and a sharp blade for use in cutting wood or as an offensive weapon. The poll of the hatchet, shaped like an acorn, is hollow and has a hole in the base, connecting with an opening extending through the helve, through which the smoke is drawn. Many of these pipes were inlaid with silver in ornamental design."

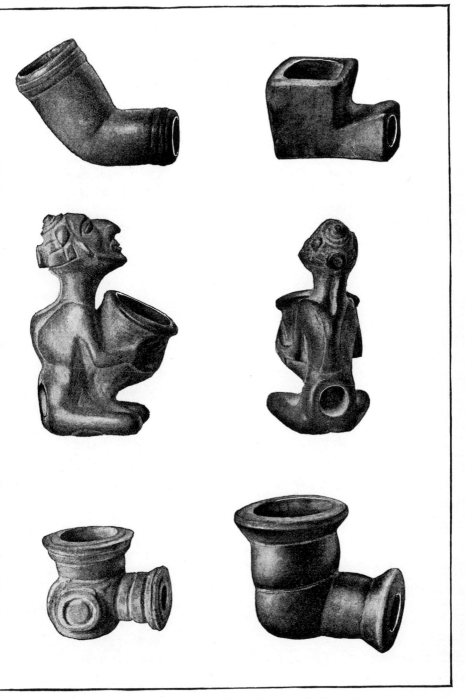

Figure 74. Pipes from Hollywood Mound, Georgia.

The Iroquois Pipe

From the region formerly occupied by the Iroquois, we get one of the most elaborately modeled of all pipes. It is of pottery, burned hard, and richly ornamented with figures of birds and animals. One specimen is in the form of the head and neck of a bird, the beak projecting from the bowl on the side farther from the smoker, the bowl formed of the bird's head, and the stem representing the neck. Stone pipes were also found in this region, including some of marble of a rich saffron color.

North of the Iroquois, there was found a pipe, the bowl of which has the form of an acorn that rests on the keel-like base which has one to five holes bored through its narrowest part. One hole was designed for holding a string to prevent the pipe from being lost in the snow; the others were for the suspension of ornaments.

The Eskimo Pipe

The Alaskan Eskimo pipe has a bowl made of metal, stone, bone, or ivory and holds only a pinch of tobacco. The large stem is curved and consists of two pieces held together by rawhide.

Bibliography

1. Boas, Franz. *Primitive Art.* Cambridge: Harvard Univ. Press, 1927.
2. Bunzel, Ruth Leah. *The Pueblo Potter.* New York: Columbia Univ. Press, 1929.
3. Butel-Dumont. *Memoires sur la Louisiane,* Vol. II, Paris, 1753.
4. Chapman, Kenneth M. "Life Forms in Pueblo Pottery Decoration," *Art and Archaeology,* Vol. 13 (March, 1922), pp. 120–22.
5. ———. "Bird Forms in Zuñi Pottery Decoration," *El Palacio,* Vol. 24 (1928), pp. 23–25 (Published by the School of American Research, Univ. of N.M. & Museum of N.M.).
6. ———. *Pueblo Indian Pottery.* 2 vols. Nice, France: C. Szwedzicki, 1933.
7. Cushing, Frank Hamilton. *Study of Pueblo Pottery as Illustrative of Zuñi Culture Growth.* (4th Annual Report, Bureau of American Ethnology.) Washington, D.C.: Government Printing Office, 1886.
8. Fewkes, Jesse Walter. *Designs on Prehistoric Hopi Pottery.* (33d Annual Report, Bureau of American Ethnology.) Washington, D.C.: Government Printing Office, 1919.
9. Gifford, E. W. *Pottery Making in the Southwest.* Berkeley, Calif.: Univ. of Calif. Press. Univ. of California Publication in American Arch. & Eth., Vol. 23 (1923), pp. 353–73.

10. GODDARD, EARL PLINY. *Pottery of the Southwestern Indians.* New York: American Museum of Natural History, 1931. Guide Leaflet 73.

11. GUTHE, CARL EUGEN. *Pueblo Pottery Making.* New Haven: Yale Univ. Press, 1925.

12. HOLMES, WILLIAM H. *Illustrated Catalogue of a Portion of the Collections Made During the Field Session of 1881.* (3d Annual Report, Bureau of American Ethnology.) Washington, D.C.: Government Printing Office, 1884.

13. ———. *Pottery of the Ancient Pueblos.* (4th Annual Report, Bureau of American Ethnology.) Washington, D.C.: Government Printing Office, 1885.

14. ———. *Origin and Development of Form and Ornament in Ceramic Art.* (4th Annual Report, Bureau of American Ethnology.) Washington, D.C.: Government Printing Office, 1885.

15. HOUGH, WALTER. "Revival of the Ancient Hopi Pottery Art," *American Anthropologist,* n.s., Vol. 19 (1917), pp. 322–23.

16. McGUIRE, JOSEPH D. *Pipes and Smoking Customs.* Report of the U.S. National Museum, Washington, D.C., 1897.

17. STEFENSON, JAMES. *Illustrated Catalogue of the Collections Obtained from the Pueblos of New Mexico and Arizona in 1881.* (3d Annual Report, Bureau of American Ethnology.) Washington, D.C.: Government Printing Office, 1883.

18. THOMAS, CYRUS. *Report on the Mound Explorations of Ethnology.* (12th Annual Report, Bureau of American Ethnology.) Washington, D.C.: Government Printing Office, 1894.

19. WISSLER, CLARK. *The American Indian.* New York: Oxford Univ. Press, 1917.

Suggested Reading

DOUGLAS, FREDERIC HUNTINGTON. *Pottery of the Southwestern Tribes,* Leaflet 69–70, Denver Art Museum, Dept. of Indian Art, 1940.

HAYDEN, JULIAN D. "Notes on Pima Pottery Making," *The Kiva,* Vol. 24 (February, 1959), pp. 10–16.

MARRIOTT, ALICE LEE. *Maria, the Potter of San Ildefonso.* Norman, Okla.: Univ. of Oklahoma Press, 1948.

SAYLES, GLADYS, and SAYLES, EDWIN BOOTH. "The Pottery of Ida Redbird," *Arizona Highways,* Vol. 24 (January, 1948), pp. 28–31.

SPINDEN, H. J. "Fine Art and the First Americans," *Introduction to American Indian Art* (Collected and published by the Exposition of Tribal Indian Arts, New York), 1932.

WORMINGTON, HANNAH MARIE, and NEAL, ARMINTA. *Story of Pueblo Pottery.* Denver: Denver Museum of Natural History, 1951.

II

Musical Instruments

Music and dance played such a large part in the life of the Indian that the subject of his musical instruments is important. The musical instruments of the Indian were not considered a means of producing music in themselves, but rather as an aid to the voice or sometimes a substitute for the voice.

In making his instruments, the Indian had to use the materials he found in his own environment—gourds, bone, hide, shells, quills of large birds, and so on. Pottery was in some cases made to be used as a musical instrument. Whatever the instrument was, it was always ornamented with designs, often symbolic.

There are only two main types of Indian instruments, percussion and wind, but the varieties within these types are many.

Drums

In the earliest times, a skin laid on the ground and beaten with the hands or with sticks was used as a drum. A development of this existed in a much later period among the Chippewa, who stretched a skin over stakes stuck upright in the ground. The Utes sewed together two large buffalo hides, which, after a thorough drying, were perforated with holes around the edge. Through these holes, a thong was laced. The players stood around the rawhide, grasping the thong with the left hand and pounding upon it with a stick held in the right.

On the Northwest Coast, a plank is often used as a drum. In some areas of this region, a long wooden box is placed on the ground, and the players sit on this and kick their heels against it in rhythm.

Where large gourds are plentiful, as in southern Arizona, the Indians cut them in half lengthwise, invert them either on the ground or on the water in a tub, and strike them with short sticks. In the desert country, a basket is often turned bottom up on the ground and beaten with either the palms of the hands or a stick or even a bundle of stiff weeds.

The real hand drum, or tom-tom, is of general distribution. It is easily carried from place to place and is used especially in solo work. It might be of any size not too large to be held with the fingers of one hand. It may have either one or two heads, though one is more usual. When the drum has one head, it is held by a handhold at the open side of the drum. This hold is made of thongs passed through the edges of the head, or it is made of the ends of the head itself, crossed at right angles at the back and tied. When two heads are used, as among the Chippewa, a loop is fastened at one side, and the drum is suspended in air. Some of the double-headed drums, especially the so-called medicine drums, have pegs fastened to cords which are stretched across the inside of the drum head. These pegs vibrate against the head when it is pounded.

Some single-headed drums may be so large that they cannot be held in the hand. They are either placed flat on the ground and the players sit around it, or especially for ceremonial use, they are suspended a few inches above the ground from curved stakes. This very much improves the tone.

In a few tribes such as the Hidatsa, a turtle shell was used as the foundation, and a hide stretched across it. In western Alaska, the Eskimos make their drumheads of the bladders of the seal or walrus. In this case, a handle 4 to 6 inches long of ivory, deer horn, or bone is attached to the frame and is usually carved.

When a tom-tom whose head is made of hide or similar material is used, it is always warmed before the fire before it is beaten. The hide absorbs moisture from the air, and, unless so treated, will give a dead thud instead of the vibrant sound so characteristic of an Indian drum.

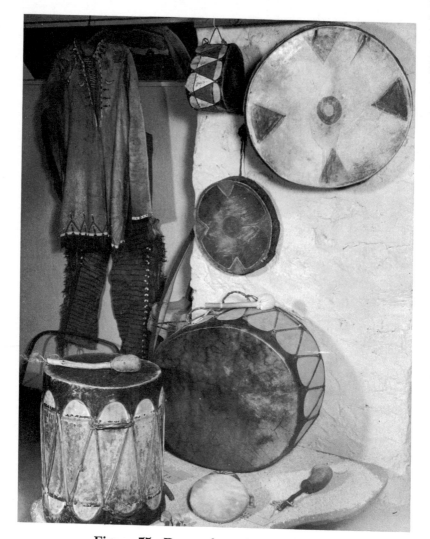

Figure 75. Drums from Seton Museum.

In certain parts of the country, especially in the Southwest, the drums are much larger, sometimes several feet across. They are made by hollowing out a section of a tree, often a cottonwood. The sections are from 6 inches to 3 feet or more in length. These tombés, as they are called, are always double-headed. Circular pieces of skin from which the hair has been removed are cut larger than the diameter of the log, dampened, and lashed by a

continuous thong, also dampened and passed through holes cut in the edge of the skin, proceeding alternately from one head to the other. The drum may thus be played on either head, the two giving different tones.

Another form of drum, usually used ceremonially, is the water drum. A log 14 to 18 inches long is hollowed out, as a rule by burning and then scraping away the charred portion, leaving walls about an inch thick. A wooden disk is fitted into one end of this cylinder, and about halfway up one side a hole about an inch in diameter is drilled with a hot iron. Into this, a stopper is plugged. The head of a water drum is deer hide, thoroughly dried, then moistened, and tightly pulled over the head by a snugly fitted hoop. Putting the hide on wet and letting it dry in place makes it stretch evenly. Water is now poured into the drum through the hole in the side to about the mid-level of the height. As the drummer pounds the head, the water splashes and the head becomes slightly wet, thus producing a very musical tone. It is also possible to tune the drum to different notes by varying the amount of water in the drum.

All of these drums are decorated, either to please the maker or to indicate ritualistic ideas.

The drumstick was to the Indian much more than just a piece of wood to thump with. It had a symbolic meaning and was used with reverence, or at least respect. The most common drumstick was a fairly straight length of any wood with a bit of resilience. One end was padded, often with a winding of rags; sometimes leather was used, making a harder head. For certain purposes, no padding was used; the stick ended in a little ball of wood. In some cases, there was a loose joint where the head met the stick. In a few tribes, a loop of willow or other pliable wood was used as a thumper.

All the foregoing information is easily put down on paper. But it is sterile and profitless unless one has the concept of the drum which was in the Indian. The very sound of the drum, with its wild, primitive quality, releases the imagination. It is impossible to listen to a good drum without realizing the spirit power which the Indian knew was contained therein. To convince the reader of the real worth of the drum, let me relate here a personal experience (Ref. 5).

As we sat and chatted with Concha, our Indian hostess, I noticed in one corner of the room, the finest, biggest drum I had ever seen. . . . My fingers itched to try its tone.

Concha, seeing me turn again and again toward the drum, said: "It is the drum of Martin's grandfather. He made it many years ago, and it knows many songs."

"May I try it, Concha?" I ventured.

"Yes," she replied, "if you sing a song into it so it can sing it back to Martin when he comes."

I lifted the drum, which was in truth half as tall as I. The padded stick in my hand seemed of its own accord to strike the top, gently. The reverberating boom came from the earth itself, up through the drum, along the stick, and into my very heart.

Then, while Concha went on with her pottery bowls, I sang a song—an Indian song, but not of this part of the country. As I finished the strain, I continued to sing, improvising as do these Indians, exploring the original melody, and playing variations upon it.

When I finished and put the drum aside, Concha softly said: "That was a good song. Martin will like it."

"Did you ever hear that song before?" I asked.

"No," she replied. "But it is a good song."

Soon after, we took our departure, leaving a message for Martin that we would try to see him again before we went back East. Circumstances, however, prevented; a sudden call came, which forced us back the next day, and we forgot all about the incident.

It was two years later when we next found ourselves on the same road, going again to see Martin. This time, it was he who met us at his door, and bid us welcome in his quiet hearty tones.

We sat for some time, talking of many things. Then, in a pause, Martin said:

"I want to show you something." He went into the other room, and returned with the Grandfather Drum. He stood before us with smiling eyes; and sang back to us, without error or flaw, the song I had sung to his wife two years before. All my variations were there, come back to me for the first and only time since I had made them.

He finished, and I wonderingly asked: "Where did you learn that song?"

"That is the song you sing into this drum long ago. A good drum, he never lose a good song; and many times Concha and I we sing together in this song when we think of you."

Rattles

There were many types of rattles, made of many materials. They had a sacred significance to the Indian, being essentially an instrument of rhythm always associated with a ritual or with

ceremonial performances. It may be argued that the drum also is a rhythmic instrument, but to the Indian there was a difference in that the rattle possessed a rebound which was lacking in the drum.

There were three classes of rattles among the Indians. The first was a container of some sort, enclosing small objects that hit together; for example, a gourd containing small pebbles or even clay pellets. The gourd was hollowed out and a stick inserted in one end to form a handle. The gourds were frequently painted red or blue and decorated with symbolic designs.

Where leather was easily obtained, the Indians made bags of rawhide sewed with thongs and often decorated with feathers or fur. The Woodland tribes made a cylinder of birchbark, filled it with pebbles or shot, and inserted a wooden handle.

A rattle which may be held in the hand and shaken is in the shape of a small shallow drum, filled sometimes with sand. If made small enough, it may be attached to a stick; it is indeed sometimes used as a drumstick.

On the Northwest Coast were the most elaborate rattles of this type. They were of wood, intricately carved, often in the style of carving on totem poles. There is a record of an interesting use of this type of rattle among the old Yaqui. Dozens of tiny bags of deerskin filled with small pebbles or coarse sand were attached to a strip of cloth and tied around the knee of the dancer, producing a rhythmic swish with the movements of the leg. A similar effect is obtained in some tribes by a fringe of seeds, hoofs, or other light pendant attached to garments.

The second type of rattle is also held by a handle, usually a stick, often wrapped with deer skin. To this, small objects are tied with thongs so that they tap together as the rattle is shaken. Various materials are used—dewclaws or triangular pieces of deer hoof, elks' teeth, birds' beaks, shells, or dried pods. Hoofs or horns of animals are sometimes pierced at the point, knotted on a thong, and bunched. Horns of the mountain sheep are fitted with clappers of the same material to form a sort of bell and are bunched on the rattle. A very sacred rattle is made by the Hopi Indians from the shell of the water tortoise. Antelope hoofs are fastened to thongs and sewed to a strip of buckskin. This is attached to the arch of the shell, and the whole is worn on the left

leg of the dancer, whose movements strike the hanging hoofs against the dome of the shell. In some tribes, little cones of tin or copper are made and strung in like fashion.

A variant of this type of rattle is used on the Northwest Coast. It is really a wooden clapper, made of a short, thick paddle split lengthwise. One blade is hinged to the handle. When hit against the body, it vibrates with a pleasing sound. Sometimes, two spoon-shaped pieces are fastened together with the concave sides facing each other, almost like a pair of castanets with a longer handhold.

Another form of rattle is the notched stick or morache. Some tribes use the jawbone of a horse or mule with the teeth still in; other groups use a long stick notched along one side. In either case, this serrated edge is rubbed with a shorter stick or a bone such as the scapula of a deer. Often, a resonator is used in connection with this type of rattle—a basket inverted on the ground, or half a gourd, or sometimes a plank laid across a ditch dug in the earth. The end of the notched stick is rested on the resonator, and a small stick or bone scraped up and down it in rhythm with the song or dance.

We must include here strings of bells as a form of rattle. In the early days, these were hoofs of animals into which tiny clappers were tied. Now, ordinary sleigh bells are used. Fastened to strips of leather, these are worn as part of the costume, sometimes strung across from one shoulder to the opposite hip, sometimes around the waist, sometimes down the outside of the leg from hip to ankle, or sometimes around the leg just below the knee like a garter.

These bells must necessarily conform to the action of the dancer, whereas the other types of rattle may be shaken in an entirely different rhythm.

Wind Instruments

There are but two wind instruments among the Indians—a flute and a whistle. A flute is made from a section of soft, straight-grained wood as long as the distance from the inside of the elbow to the end of the middle finger. This is split down the middle and each half is hollowed out except near one end, so that when

Figure 76. Flute and its parts.

the two halves are put together, there will be a bridge across the inside diameter.

Frances Densmore (Ref. 3) has described the making of the mouthpiece:

> The organ-pipe mouthpiece is ingeniously formed as follows: A square opening is cut through the side of the tube just above the bridge, into the wind chamber, and another is cut below the bridge, into the sounding tube. A block is so fashioned and slightly cut away on its lower surface that it covers the upper opening and directs the air in a thin sheet downward against the lower, sound-producing edge of the square hole below the bridge.
>
> To make this edge of the hole smooth and sharp—that is, to form a suitable lip for the pipe—a piece of very thin birchbark or other substance such as sheet lead or iron is placed between the tube and the block.
>
> The junction between the birchbark and the tube is sometimes made airtight by a gasket of silk cloth; often the joint is closed by resin or other cement.
>
> When the flute is completed, the joints along its length are sealed with resin or glue and the parts are held together by several windings of thong or other material. The block is held firmly in position by a winding of thong.

Just as the length of the flute is determined by the measurement of the owner, from elbow to fingertip, so the holes are bored, not according to a scale, but spaced in a manner convenient to the player's hand.

In the Southwest, especially among the Zuñi, flutes are made of pottery, and in Arizona of cane. Flutes are used very frequently in courting, substituting for the voice of the bashful lover.

The whistle differed from the flute in that the whistle had no stops. It was often made of the wing bones of birds, sometimes of the quills of large birds, and, in a few tribes, of wood or pottery. An opening was made in one side of the bone or quill, and a lump of pitch or resin was inserted to force the wind over a sharp edge in the bone, vibrating the column of air to form the sound.

Similar to this class of instrument was the bull-roarer or rhombus, a rectangular slat of wood, often lightning riven, varying in length from about 6 inches to perhaps 2 feet and in width from ½ to 2 inches. This was suspended at one end by a cord, and occasionally a wooden handle is attached to the cord. The

cord was usually measured from the heart to the tips of the fingers of the outstretched right hand. The bull-roarer was the prayer stick of the thunder and was painted with symbolic designs, as were the ceremonial supplicatory sticks of the people themselves. It was a sacred implement, associated nearly always with the rain, wind, and lightning. It was whirled rapidly about the head, creating a whizzing or roaring sound.

Stringed Instruments

There were very few stringed instruments among the Indians. The Maidu of California did have a musical bow, connected with sorcery in its use. The Apache fiddle, almost certainly adapted from the Mexican violin, was a roughly cylindrical section of a small tree and had only one or two strings. The decoration painted on it is the most interesting part of the instrument.

Bibliography

1. BURTON, FREDERICK R. *American Primitive Music.* New York: Moffat, Yard & Co., 1909.

2. BUTTREE, JULIA M. *Rhythm of the Redman.* New York: The Ronald Press Co., 1930.

3. DENSMORE, FRANCES. *American Indians and Their Music.* New York: Woman's Press, 1926.

4. FLETCHER, ALICE C. *Indian Story and Song.* New York: Small, Maynard & Co., 1900.

5. SETON, JULIA M. *Pulse of the Pueblo.* Santa Fe, N.M.: Seton Village Press, 1939. Pp. 18–20.

Suggested Reading

ALEXANDER, HARTLEY BURR. *The Ritual Dances of the Pueblo Indians.* Denver: Denver Art Museum, 1927.

CURTIS, NATALIE. *The Indians' Book.* New York: Harper & Bros., 1907.

FERGUSSON, ERNA. *Dancing Gods.* New York: Alfred A. Knopf (a division of Random House, Inc.), 1931.

12

Owner Sticks
and Pictorial Arts

Owner Sticks

Many years ago, we were visiting our friends, the Crow Indians in Montana. They were assembling for a festival, a national dance. Carts, buggies, and covered wagons were arriving every hour, and the Chief of the camp, a man delegated by old Plenty-Coups, was allotting a camp ground to each as he arrived. Their goods were dumped at the assigned place; then the men drove off with the wagons to get firewood, and the women went to bring water. We thought the piles of household stuff neglected and exposed to any chance marauder.

Tom La Farge, who had married an Indian woman and was now a member of the Crow tribe, had been our interpreter on many occasions, and we chanced to remark to him now, "Those Indians don't seem worried about leaving their goods unguarded."

"No," he answered. "You see, they are absolutely honest; and at every pile of goods, there is one of the owner sticks."

He led us to the dumps. Stuck in the ground beside each pile of goods was a slender rod, beautifully decorated at its upper end with bands of quillwork.

"That's Running Bear's owner stick," he said. "Everybody knows it and respects the notice it gives."

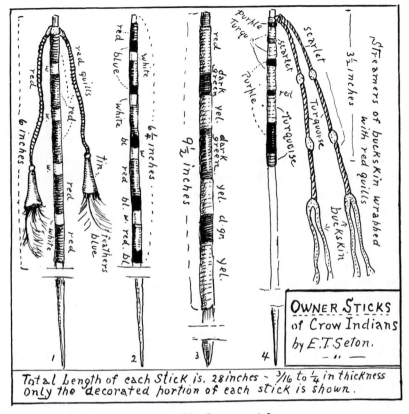

Figure 77. Owner sticks.

We went from one pile to another. In nearly every case we found an owner stick mounting guard to notify any who called that this place was pre-empted, and the goods piled here were not abandoned but awaiting their owner's return.

Tom further told us that the owner sticks were also used when a pile of firewood had been gathered in the woods, or birch bark, or wild rice, or acorns, or horse-hay—in fact, any kind of property that might otherwise look abandoned or without owner.

There was only one important occasion when the owner stick was not used. That was when the hunter had killed some large animal, such as a buffalo or a deer. Then the quite sufficient owner stick was the hunter's arrow left in the carcass. Of course, the arrow also had marks on it to show who its owner was; and I

think, but I am not sure, that that mark was the same one he used on his owner stick.

We were able to buy some of these owner sticks before we came away (Fig. 77). Each was about 28 inches long, ¼ inch or less in thickness, and decorated with bright-colored bands of quills in most cases, though one was covered with bands of colored grasses.

A USE FOR OWNER STICKS

Every teacher knows—and every parent knows but will not admit—that children will "borrow" property which does not rightfully belong to them. It is a trait which practically all outgrow, but which can be very disturbing while it holds sway.

In our camps, we avoid all talk of this propensity and treat it in various other ways. The most successful method we have found is based on the Indian custom of using owner sticks. On the first day of camp, we explain what owner sticks are and tell the story of the Crow Indians and their goods. Being a personal experience, it makes an impression.

Now we ask each member, child or adult, to fashion an owner stick. Each must find the material himself, and there are no rules except that the stick shall not be decorated with feathers, which are reserved for prayer plumes, and that its length be the length of the owner's arm from the elbow to the tip of the middle finger. With a little help from an instructor, each member returns with a finished owner stick within an hour or so. This is planted in the ground outside the habitation of each camper to let us know who lives there.

Next, we ask each to make a miniature owner stick 6 inches high and fitted into a base with a hole in it. A slice of a branch of a tree will do or sometimes an empty spool. This miniature is decorated exactly as is the full-size stick.

In the craft classes, often when a period is over, it is inconvenient, or at least time-devouring, for each worker to have to gather up all his tools and other paraphernalia. Yet, in the old days, if these things were left, they had a tendency to disappear before the next class. Now, however, each member piles his things on the table and places beside them his miniature owner stick. The result is one we never accomplished with mere words,

no matter what ethical lesson they carried. There is a force in that little custom which is binding. No needle, no awl, no pencil is ever "borrowed."

Pictorial Arts

Personal adornment is undoubtedly a primitive instinct and was probably the earliest reason for painting the body in various ways. Among the Indians such decoration of the body was used also to mark individual, tribal, or ceremonial distinction. In like manner, clan beliefs were so indicated, as were interrelationship and personal bereavement. The use of paint on the body was common in both religious and secular ceremonies and in gala dress to celebrate any occasion. Paint was also used as protection against wind or sun.

TATTOOING

Tattooing was a more or less logical development from painting the body. This custom prevailed to a greater or lesser extent all over the country, especially in the Northern tribes. Among the men, the tattooed figures, as well as having a decorative purpose, indicated personal or tribal distinction, usually an achievement or a special office or sometimes symbolizing a vision from the supernatural powers. In some cases, the tattooing on the women signified the achievement of husband or father; but more often, it indicated little more than social position—marital status, for example.

Originally, sharp flint points were used to prick the skin. The ink was made of some charred vegetal product or sometimes the charcoal itself.

Tattooing reached its highest state of excellence among the Haidas. In this tribe, the marks were heraldic designs, similar to the carvings on the columns used outside the houses of the chiefs. On the men, the tattoo marks were generally placed on the back between the shoulders, on the breast, on the front of the thighs, and on the legs below the knee. On the women, they were placed on the breast, on both shoulders, on both forearms, and on both legs below the knee. The designs employed symbolized ideas; they did not depict them realistically.

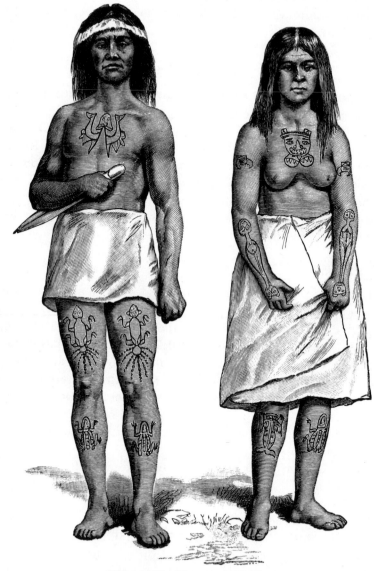

Figure 78. Tattooed Haidas.

PAINTED SKINS

Many tribes, especially among the Plains groups, painted on dressed skins, often buffalo robes. Each year was depicted by some sign which, in the memory of the tribe, designated that

period. The designs of the events were drawn in a spiral. These people reckoned their years by winters, and the decorated robes were called Winter Counts. The drawings on the Winter Counts were conventional and extremely simple, as a rule in outline only or with very little filling in of the figures. Many of the drawings were of animals; and, rather than make the full figure, the artist emphasized the prominent features, which soon came to stand for the animals themselves.

PAINTED TEPEES

The skin tepees of the Plains tribes were often tastefully adorned with heraldic and religious symbols painted in brilliant colors. The designs were similar to those on the Winter Counts. If the family were a wealthy one, owning many skins, they gave their tent an inner lining reaching halfway up the poles and perhaps all the way around. Tied to the poles and weighted to the floor, it made an excellent windbreak. Here the men might let their fancy run free in decoration. Generally, they painted their own exploits, and this wall cover often showed vivid pictures of battles and horse stealing.

Outside the tepee stood the man's shield on a tripod, always turned so that it faced the sunrise. The shield was made of rawhide, soaked, dried, and smoked until it was like wood. This the warrior painted with symbols of his visions.

BONE WORK

Certainly the most artistic examples of engraving are those of the Northwest Coast tribes. These tribes engraved on slate and on metal; the Eskimo primarily used ivory and bone, and other tribes used shell. The hardness and toughness of these materials made them desirable for implements and utensils, and the high polish of which they were capable made them much prized. The small bones, the teeth, and the claws of animals were often strung as beads and pendants, were used as rattles, or were sewed to garments as decoration. Frequently they were carved and engraved in an attempt at beauty outside of their utilitarian purpose.

In the North, large bones, such as the ribs of the whale, were used in the construction of houses and other shelters, boats, sleds,

and armor. Bows, arrows, spears, harpoons, and knives were made of bone, ivory, and antlers. The pictorial engraving on all these things was extremely clever. Horn was also used for spoons, and other small household articles, and these were often richly embellished.

SHELL

All over the country, shells were a favorite material for artifacts. They were used in their natural state as well as being cut up, ground, perforated, or engraved. The shells of mollusks were probably used as utensils at a very early date, since they were natural vessels for food and water. As time went on, the form was modified, thus enlarging their usefulness. In order to more easily transport these vessels, perforations were made where they did not occur naturally, so that they could be strung on cords and suspended from the neck.

Shell would then be introduced into sections of the country where it was not normally found, and so in such regions it gradually became a commodity of value. Its usefulness little by little gave way to other considerations.

Merely notched or drilled, shells were frequently strung as necklaces or other types of personal ornament. Cups and spoons were easily shaped from the whole shell of the clam or mussel, and small implements such as knives and fish hooks could be readily formed. Early writers have reported in numerous accounts that the two valves of small mussels or clams were used as tweezers for plucking out hair.

Along the Atlantic Coast, clam shells, especially the hard-shell clam of a varied purplish color, were made into small cylindrical beads and woven into necklaces and belts. Much labor and skill were necessary in the manufacture of these. They were largely the work of the women. After being strung or woven into the form known as wampum, they were used as a medium of exchange in colonial times. On the West Coast, the abalone was used as inlay in wood or other material with great effect.

Originally, the natural luster of shell or simple polishing was enough to satisfy the esthetic taste of the user, but, as time went on, designs were engraved on the articles meant for personal

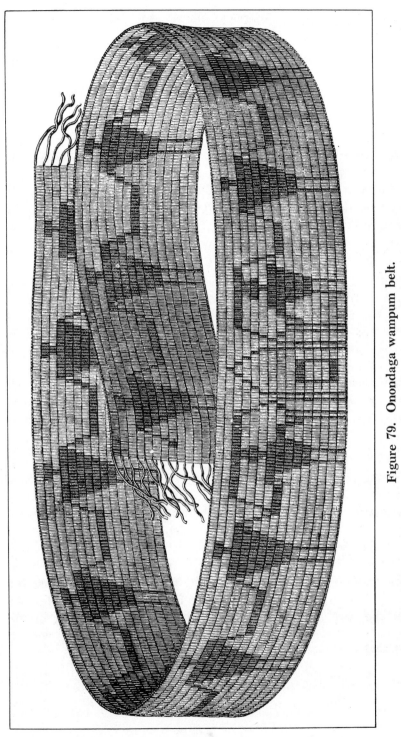

Figure 79. Onondaga wampum belt.

adornment. Almost certainly these decorated gorgets were worn as insignia or amulets, and the designs were undoubtedly mystic symbolic devices.

METAL

Metallurgy was extensively practiced in prehistoric times. The metals used were gold, silver, iron, and especially copper. It is generally thought that copper came into use among the Northern Indians as a result of the discovery of small masses of the metal in the debris deposited by the glacial ice. At first, these nuggets probably were used for ornamentation just as were stones of similar size and shape but soon the copper was being shaped by hammering. The soft quality of the metal and the pleasing color led to its use in personal ornaments, such as beads, pendants, pins, earrings, and bracelets.

Remarkable examples of metal work are to be seen in the *repoussé* figures which were taken from the mounds of Georgia and Florida. In other mounds have been found examples of plating with thin sheets of copper. The work was probably accomplished by placing a sheet of metal on a yielding surface, such as buckskin, and pressing the design in with a sharp-pointed bone.

WOOD

The Indians have always been skillful workers in wood. Strangely enough, a large local supply did not seem to be necessary for the flourishing of the art. In some regions where wood was scarce, tribes did more and better work with what was available than did tribes who lived near dense forests.

The Northwest Coast Indians excelled in woodworking. The carved cedar poles known as totem poles are among the most picturesque of their products. One form of totem pole was the outside house pole which might be 3 feet or more in circumference at the base and 50 feet high. This pole stood in front of the house at the mid-point of one side. A door was made close to the base.

The inside house pole stood directly behind the fire and indicated the place of honor. A third class of pole was used as a grave post and was usually carved with the crests of the family.

The house poles, both inside and outside, might also be carved with the family crest or might represent a human figure or a story. The idea that these carvings represent idols is wholly erroneous. They are in essence ancestral columns, or, if a story is told by them, they embody the traditions and folklore of the people.

Small examples of totem poles are made now for sale, but the artistry of the carving is still excellent.

Another form of wood carving are the katchinas of the Hopi Indians. The term *katchina* is applied either to the supernatural beings impersonated by men wearing masks or to the little wooden carvings made in imitation of men. These carvings, like the house posts of the Northwest Coast, have been mistakenly supposed by some observers to be idols. They were in no sense worshiped as such, though they were made in the likeness of the gods as conceived by the tribe.

These dolls are made in the kivas by the priests as gifts for the children and are presented on the morning of the last day of the great Spring festival. They are carved of the soft cottonwood of the region, cut and painted in exact delineation of the elaborate headdresses, decorated face, body, and clothing of those who represent the supernatural beings.

STONE

In pre-Columbian times, the Mound Builders produced stone work of great interest—the human form and pipes carved with animals, birds, and reptiles, so well executed that even the species can often be recognized.

The human forms are, it is thought, not in any sense portraits of actual persons but mythic beings.

Before the arrival of the Whiteman, the carving tools were largely of stone, though copper and bone were also used to some extent. Brittle materials were shaped by fracturing with stone hammers. Harder stones were pecked with these same stone hammers and sometimes sawed and drilled with wood and bone or copper tools. Soft stones were cut with stone saws, chisels, and knives, and the shaped product was ground and finished by rubbing.

PAINTING

The first crude attempts at portraiture, whether of an idea or an object or person, were the pictographs and petroglyphs. In America at least, these are still not only in existence, but in actual use. Pictography may be defined as that form of thought-writing which seeks to convey ideas by means of picture-signs or marks more or less suggestive or imitative of the object or idea in mind. They may be made on any material, while petroglyphs are always on stone of some kind, though of the same significance.

Unlike much Indian art, pictograph and petroglyphs show very little mysticism; they are objective representations and, as such, are the beginnings of pictorial art. The greater part of them are mnemonic records, though occasionally they were meant to convey a message or to record a fact. There are still over a hundred petroglyphs of animals, dancers, and ceremonies on the walls and caves of the Rito de los Frijoles in New Mexico; and not only in that State, but all over the country may be found paintings on rocks depicting stories of the life of the ancient people.

The style of these early petroglyphs is suggestive of the best Persian or Chinese art. To the Indian, painting is symbolic and sacred. Until recent years, his painting was a phase of a religious ceremony, a prayer, a recognition of the Great Spirit of which he was an integral part. Pictorial art for its own sake came later in the Indian's culture and advanced to a high degree of excellence. It reached its greatest development in the Southwest. It is natural that this should have been so, since these Indians have for centuries been sedentary. Living in permanent villages and farming successfully, they have enjoyed the leisure which produces a higher form of civilization than is possible with nomadic peoples.

This art attracted no attention until as late as 1901, when Kenneth Chapman found the Navaho youth, Api-Begay, drawing ceremonial figures on the ends of cardboard boxes which he had obtained from the trader at Pueblo Bonito in New Mexico. By ordering and paying for as many pictures as the unrecognized artist would make, Chapman made the young man realize that there was at least commercial value in these drawings. By 1910,

(a)

(b)

Figure 80. Indian paintings: (a) animal dance; (b) peace dance.
(By permission from the Laboratory of Anthropology, Santa Fe, N. M.)

Figure 81. Petroglyphs from the Sierra Nevada.

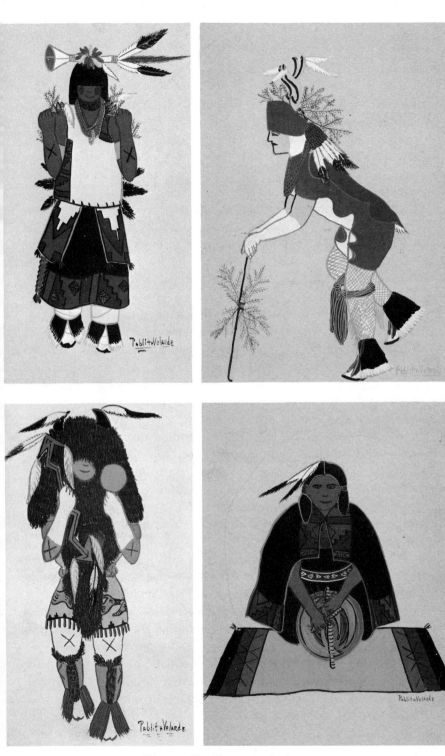

Figure 82. Dance paintings.

Dr. Edgar L. Hewett, director of the School of American Research, had found Crescencio Martinez of San Ildefonso drawing, for his own amusement, figures of Buffalo Dancers, Eagle Dancers, and the like, also on the ends of boxes, the only smooth background he could find. Dr. Hewett quickly provided the artist with crayons and paper. This was the beginning of an art movement in that particular pueblo which has continued to the present and which has made the people there self-supporting.

Other discriminating artists and appreciative laymen encouraged such Indian painters as Awa Tsireh, Quah Ah, Oqwa Pi, Fred Kaboti, Ma-Pe-Wi, and others, a number of them women. Soon these artists were brought to the attention of critics in Chicago, New York, and even in Europe, where exhibits were shown.

The Santa Fe Indian School has done much to encourage this movement. Such understanding friends of the Indian as Elizabeth De Huff, Dorothy Dunn, Amelia Elizabeth White, and Marble Morrow have been in the vanguard. The school is soon to become a great center for Indian arts and crafts and will justify the struggles of the early protagonists.

Though the idea of a picture as such is borrowed from the Whiteman, though the materials the Indian now uses are largely those of the White artist, though the possibility of earning a living by painting is due to contact with the Whiteman, the technique and psychology are entirely Indian. One is intrigued, in seeing this Indian art, to realize that the portrayal is amazingly modern. The Indian sees that way because of his long ancestral training in abstract design.

The Indian artists have evolved a curious, flat style that is entirely decorative. There is a complete absence of backgrounds and foregrounds and no perspective. Few if any of them make any attempt to present pictures in the classic manner, yet they are not abstract in the style of so many of the White moderns. Their work generally presents subjects in conventionalized, yet recognizable, forms. Though numerous well-known White artists have attempted to catch the qualities that appear to be natural with the Indians, none of them has been successful.

We are apt to speak of this painting of the Indians as an achievement in a previously unknown medium. This is not

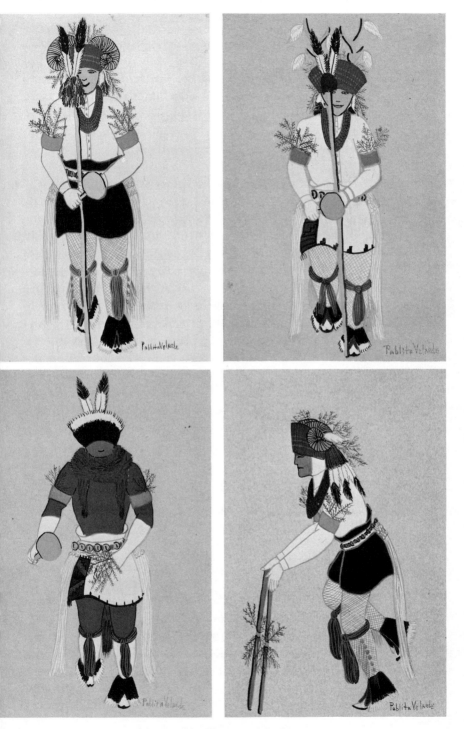

Figure 83. Dance paintings.

wholly true. To be sure, paper and canvas are new background materials, but the Pueblos, at least, have been using water colors for centuries. They did not, of course, purchase them from an art supply house, ready to be used at a moment's notice. But they have used native earths, minerals, or vegetable pigments mixed with water and are still far from giving up the ancient form of these, as is evidenced in some of the murals shown at the Indian School at Santa Fe.

Their work has been spoken of as naive and unsophisticated. This it surely is not. It is based on organized principles of composition and technique, possibly instinctive or, as is appearing more and more possible, fully understood and taught by the old men of the tribe. The only naiveté in the work of these artists is, as Alice Corbin Henderson (Ref. 5) has said, "the unspoiled purity of their vision—the naiveté, that is, not of the amateur, but of the genuine primitive, whose vision is still uncorrupted by any false canon of art, shop-talk or commercial end."

Perhaps some of the magic effect of these paintings is due to the fact that the Indian painter cannot conceive of art as an individual expression. He thinks of it in tribal or communal terms. He does not understand the competition of one artist against another. To again quote from Miss Henderson (Ref. 5):

In the beginning, these artists signed their pictures only when they were asked to do so. And competition had so little entered their minds that one artist, when he found that his signed work had come to command a higher price than the work of a younger friend, was perfectly willing to add his signature to work which he considered quite as good as his! It was hard for him to understand that in our world this was not ethical. The idea of buying a painting for its signature did not occur to him any more than it would occur to him to look for a signature on a bow and arrow or a pair of moccasins. I think it would have been quite impossible to explain that in our world paintings are often bought for their signatures alone!

We hear much talk of the sacrifices our White artists have often made for their art. Probably very few have had to face a problem as serious as have these Indians. The Pueblos have been little influenced at heart by the interference of the Whiteman and are still steeped in their ancient lore and cults. It is a sin against the gods to depict their ceremonies—to paint images of the ancient ones is to court disapproval and disaster. These youthful artists,

educated in White schools, yet keeping the teachings of their fathers fast in their hearts, have had many a struggle to know what is right. And, in instances where. they have persisted in portraying the dances, ceremonies, and inner life of their people, they have suffered expulsion from their homes and their villages, and have been forced to live their lives in alien surroundings. Who among us shall say which side is right?

It would be possible to give biographies of dozens of these painters—how they began their studies in the new medium, how they were encouraged by this or that White artist who understood and believed. But, somehow, I cannot see the results of their work other than in the spirit in which they have done it—an expression of a communal, a tribal, a racial art without relation to the individuals who have produced it.

SAND PAINTINGS

Sand painting, a form of painting peculiar to the Indian, has undoubtedly been practiced since prehistoric times but remained unknown to the Whiteman until about one hundred and seventy-five years ago. In a simple form it was used by the Cheyenne and Arapaho in the early days and is still used during the Sun Dance ceremony of the Cheyennes. The Hopi also make sand paintings. But it reached its highest development among the Pueblo and Navaho tribes, and it has continued in use among these, though even the Pueblos have given up the practice to a large extent. We shall, then, confine ourselves to the art as practiced by the Navaho.

The Navaho make these sand paintings almost exclusively in connection with religious ceremonies, and it is only within very recent years that the paintings have been displayed off the reservation. Some of the sand paintings are as much as 12 feet in diameter. They represent in conventional forms various gods and ideas of the Navaho cosmogony. We find lightning, rainbows, mountains, plants, and animals, all of which have a mythic signification. These paintings are used very largely in healing ceremonies.

Sand pictures differ from all other painting in the fact that they are done with sand instead of water or oil colors. Only five

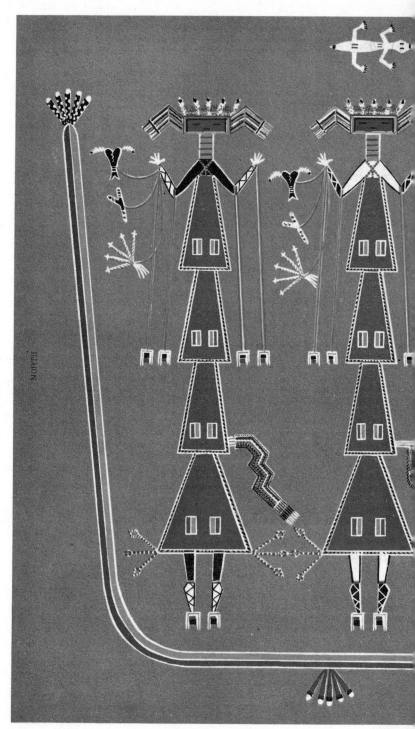

Figure

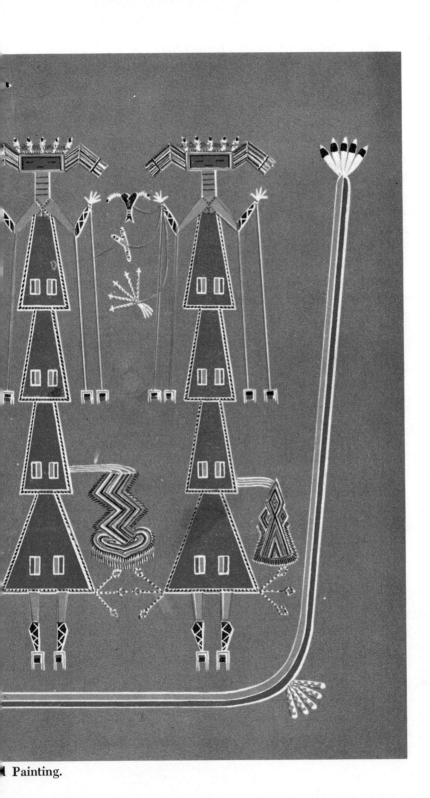

Painting.

colors are used, corresponding to the five sacred colors of Navaho mythology. Instead of canvas as a background, the floor of a Medicine Hogan, or sacred lodge, is used. On a carefully cleared space is thrown a quantity of natural-color sand which has been ceremonially gathered by the young men. This is smoothed and leveled to a depth of 2 or 3 inches with the battens which are used by the women in their weaving. The colored sands for the designs are prepared well in advance of the ceremony. Finely powdered sandstone of white, yellow, and red are used. Powdered charcoal mixed with a little sandstone makes the black, and black and white mixed gives what the Navahos call blue but what is really a gray. The colored sands are kept separately in little bark dishes within easy reach of the painter. (Recently I have seen a painter use a tin muffin pan.)

The work starts as near the center of the whole design as possible. Without any visible guide to the pattern, the artist picks up a small quantity of sand of the required color between his first and second fingers and his thumb. He moves his hand along the unseen design, allowing the sand to trickle from his fingers. Little by little, he moves toward the periphery of the picture, taking care not to step on any finished portion.

The Navaho sand paintings are extremely complicated, consisting of delineations of the ancient gods and the forces of nature. The process is ceremonial, as is the product. The artist does not see it through the eyes of the eventual beholder but as a living entity. In painting a god, for instance, he draws the naked body first, then puts on the clothing.

The work is often directed by the shaman of the tribe, the wise man who has all his life lived the rituals of his people. The artists themselves have been initiated into the mystery of the ceremony and have had to memorize every little detail of the drawing with its significance. A sand painting takes many hours to complete. Then the proper ceremonies are performed over it, after which, with song and ritual, it is destroyed. The painting is not permitted to remain after sunset. The sand is gathered in blankets, carried away to some distance, and scattered.

A type of sand painting can be made fairly easily. A board or a piece of cardboard can be covered with a thin layer of glue, and sands of various colors applied in any conceived design. Any

paint supply house can provide powders in a variety of colors which can be mixed with the sand.

I have seen and made a number of these sand paintings which are quite beautiful. Since the sand is firmly glued to the board, these paintings can be hung on the wall. In order to get the benefit of the attitude of the Navaho, the designs should be conventionalized, as are most of theirs. Indian sand paintings should not be copied, but their methods be studied as a means of approach to both the artistic side of their natures and their ritualistic attitude toward life.

Bibliography

1. APPLETON, LEROY H. *Indian Art of the Americas.* New York: Charles Scribner's Sons, 1950.

2. DRUCKER, PHILIP. *Indians of the Northwest Coast.* New York: McGraw-Hill Book Co., Inc., 1955.

3. EARL, E., and KENNARD, E. *Hopi Katchinas.* Locust Valley, N.Y.: J. J. Augustin, Inc., 1938.

4. EWERS, JOHN C. *Plains Indian Painting.* Stanford, Calif.: Stanford Univ. Press, 1939.

5. HENDERSON, ALICE CORBIN. "Modern Indian Painting," *Introduction to American Indian Art* (Collected and published by the Exposition of Indian and Tribal Arts, New York), 1931.

6. HEWETT, EDGAR LEE. "Native American Artists," *Art and Archaeology,* Vol. 13 (March, 1922), pp. 103–12.

7. HOLMES, WILLIAM HENRY. *Art in Shell of the Ancient Americans.* (2d Annual Report, Bureau of American Ethnology.) Washington, D.C.: Government Printing Office, 1883.

8. INVERARITY, ROBERT BRUCE. *Art of the Northwest Coast Indians,* Berkeley, Calif.: Univ. of California, 1950.

9. MALLERY, GARRICK. *Pictographs of the North American Indians.* (4th Annual Report, Bureau of American Ethnology.) Washington, D.C.: Government Printing Office, 1886.

10. *Picture Writing of the American Indians.* (10th Annual Report, Bureau of American Ethnology.) Washington, D.C.: Government Printing Office, 1893.

11. NEWCOMB, FRANC JOHNSON. *Sandpaintings of the Navajo Shooting Chant.* Locust Valley, N.Y.: J. J. Augustin, Inc., 1937.

12. VAILLANT, GEORGE C. *Indian Arts in North America.* New York: Harper & Bros., 1939.

Suggested Reading

ALEXANDER, HARTLEY BURR. *Pueblo Indian Painting.* Nice, France: C. Szwedzicki, 1932.

ARMER, LAURA ADAMS. "Navajo Sand-Paintings," *American Anthropologist,* Vol. 33 (October, December, 1931), p. 657.

DAVIS, LINZEE W. KING. "Modern Navajo Water Color Painting," *Arizona Highways,* Vol. 32 (July, 1956), pp. 10–31.

DOCKSTADER, FREDERICK J. *The Katchina and the White Man.* Bulletin 35. Cranbrook Institute of Science, Bloomfield Hills, Mich., 1954.

EVANS, WILL. "Sand Paintings," *Southwestern Lore,* Vol. 17 (December, 1951), pp. 52–55.

JEANCON, JEAN ALLARD, and DOUGLAS, FREDERIC HUNTINGTON. *Indian Sand-Painting, Tribes, Techniques and Uses,* Leaflet 43, Denver Art Museum, Dept. of Indian Art, 1932.

TANNER, CLARA LEE. "Contemporary Indian Art," *Arizona Highways,* Vol. 26 (February, 1950), pp. 12–29.

WINGERT, PAUL STOVER. *American Indian Sculpture.* Locust Valley, N.Y.: J. J. Augustin, Inc., 1949.

Index